D1479274

Decadent Subjects

PARALLAX RE-VISIONS OF CULTURE
 AND SOCIETY

Stephen G. Nichols, Gerald Prince, and Wendy Steiner
SERIES EDITORS

Decadent Subjects

The Idea of Decadence in Art,
Literature, Philosophy, and Culture
of the *Fin de Siècle* in Europe

Charles Bernheimer

EDITED BY

T. Jefferson Kline
and Naomi Schor

The Johns Hopkins University Press
Baltimore and London

© 2002 The Johns Hopkins University Press
All rights reserved. Published 2002
Printed in the United States of America on acid-free paper
9 8 7 6 5 4 3 2 1

The Johns Hopkins University Press
2715 North Charles Street
Baltimore, Maryland 21218-4363
www.press.jhu.edu

ISBN 0-8018-6740-1

For Olga

Contents

Illustrations

Editors' Preface

The certainty of my death, rather than defining the meaning of my life as a conscious creation, shows rather that my life has no meaning apart from its biological function. My self has no distinctive identity: I am merely an instrument of nature's luxuriant productivity and impersonal violence.

Such thoughts are enough to give me nausea. . . . One way of understanding the nausea I am feeling is that it arises from my sense that . . . my death is not my own; it belongs to the general economy of life. I am, as it were, betrayed and abandoned by my own death. . . . So my task, if I wish to cure myself of nausea, is to gain control over my death, to wrench it away from nature. I have to be able to use death as a creative principle whereby I make my life my own.

It is nothing short of breathtaking to come across such a passage in reading the manuscript of a friend who has just died—indeed it returns to the word "passage" the full power of its ambiguity. Charlie Bernheimer has passed on, and in his wake left two immemorial works: the present volume and the "work" of his last three months of life in which he "made his life his own." In the bittersweet task we have faced of bringing to publication this posthumous work, we have been struck repeatedly by what might in another's text have been self-consciously maudlin insertions of self-pity but what in Charlie's manuscript ring a chord of uncannily prophetic insight.

Both of us had this experience: on November 21, 1997, the phone rang, Charlie Bernheimer's irrepressibly buoyant voice announced that he had disastrous news. He had just learned that he had terminal cancer of the liver and pancreas and could expect to live only three months. (Indeed, he died exactly three months to the day of that call, on February 21, 1998.) In the short time he had had to face this news, Charlie had already decided that his death was not a judgment based on some psychological or moral failing. Indeed he found amusement in the striking *lack* of irony that prevented him from dying from a "decadent" disease of venereal origins. He calmly accepted the news as an act of fate pure and simple; ever the Nietzschean, he embraced it: *amor fati.* It became increasingly evident that he had quietly decided that rather than exhausting himself in futile medical distractions, he would devote his remaining energies to making the most of the last three months he was given to live. He proceeded without fanfare to divide his time between his devotion to his family, his extraordinary generosity (of both gifts and time) to his students and colleagues, and a race against the clock to finish the present volume. Not once did he complain to his students that he now had no time for them, or to his colleagues and friends that their problems and lives had faded in importance, dimmed by the necessity of completing his scholarly project. On the contrary he seemed to spend *more* time than before with his students, and to display even more than his usual interest in his friends' lives and families. Although in the introduction to these pages he bemusedly portrays a self that has "not shouldered the responsibilities of adulthood . . . not repressed and sublimated [his] instinctual appetites in the service of the dynamic progress of civilization," we all watched in admiration as this friend shouldered the greatest of responsibilities and seemingly repressed every fiber of egotism in his concern for others. Five days before he died, he shared with one of us the thought that, were he given a reprieve, he would devote the rest of his life to the love of his friends. When we met to memorialize him, we all expressed our awe that in his exemplary death he had in fact done just that. He had in-

deed "used death as a creative principle whereby he had made his life his own."

Flaubert occupied a central place in Charlie's life's work and is the occasion of one of the most astonishing passages in the book, which demonstrates just how multilayered is the figure of decadence, grafting irony onto the uncanny, opening up abysses within abysses, and death onto death. On a rainy gray day in Paris, as Charlie recalls in note 19 to his chapter on *Salammbô,* he goes to the Musée Carnavalet, on an errand for his friend and colleague Eugenio Donato. The latter had asked Charlie to take a photograph of Flaubert's death mask to serve as the cover illustration for Donato's forthcoming book on Flaubert and decadence. With his customary graciousness and generosity, Bernheimer pays homage to his senior colleague's "radical" grasp of the force of death in Flaubert's writing, where death becomes the ultimate referent, always already buried in the crypt. Here then the final irony intervenes: Eugenio dies, and his heirs unwittingly dispose of the film. Bernheimer never sees the photograph that Eugenio had requested of him, and Eugenio's posthumous book, *The Script of Decadence,* appears with a plain blue cover. And in the lineage of decadence, Bernheimer has gone to join Eugenio in death. Flaubert, as Bernheimer reminds us, was fascinated by the mask of death. Just as Flaubert was constantly drawn back by the face of his dead friend Alfred de Poitevin, and as Bernheimer was drawn to contemplate Flaubert's death mask, now it has been our turn to see the light go out of Charlie's eyes and watch the mask of death steal over his countenance.

Indeed, the pages of this volume are remarkably full of suggestions that there are connections between his topic and his life, seeing decadence as "a force that would invade me and perhaps master me," and the book as "a performance from which it would be wise for my friends to keep at a distance lest it contaminate them with destabilizing energies." In attempting to define decadence, he discerned in it, as others had done, analogies to the body's fate: growth, decay, and death—clearly a sense of loss in relation to a projected image of an

earlier vigor. Decadence evoked, Charlie wrote, "the opening of a semantic wound, a contaminating crossover." In his chapter on Nietzsche, he noted, almost in anticipation of his own situation, that Nietzsche "uses decadence to refer to his own physiological ills." Elsewhere he noted that "what is most original about his thinking is due to his experience of illness," and added, "the concept [of decadence] comes to the fore in the last year before his collapse." "The philosopher-artist," Bernheimer noted, "mines his illness as a resource for adventurous original speculation." Indeed Bernheimer was to build the most important part of his analysis of Nietzsche's decadence on the figures of waste and decay as, on the one hand, "necessary consequences of life not to be fought . . . without [which] we would fall ill," and on the other hand, "the contagion of the healthy parts of the organism . . . a body inscribed by its decadence . . . as an inherent illness that cannot be cured." But what is ultimately decadent about Nietzsche's thought, Bernheimer would argue, is that philosopher's inability to decide between physical decadence as a figure of health or of disease!

Such figures of disease and death punctuate Bernheimer's monograph and lend it a rare originality. True meditation on death is indeed rare in writings on decadence that tend all too often to dwell on the prurient rather than the metaphysical dimensions of the subject. Of Mirbeau, he muses, for instance, "It is as if the artist had intended to bury a corpse and had instead revived it and found its life to be his own." Of Lombroso, he notes, "Death offers him a wonderful gift." Later he finds Lombroso's primary dream to "exist in death's life, a space we have seen to be a fundamental focus of decadent fantasy." Bernheimer succeeds, in sum, not only in a scholarly analysis of the decadent, but dares to enter a dynamic that he knows to be a dangerous one where few have trod: "He who attacks decadence is implicated in the very decadence whose conquest he celebrates." This volume is not the first to contain explicit links between his private and scholarly lives or indeed to allow the personal to peek out from the scholarly. As Bernheimer demonstrates in his introduction, his writing gestures toward—but never succumbs to—the personal.

Speaking of his celebrated art historian father's suicide in the introduction to *Flaubert and Kafka* (1982)—"my father took himself away"—he does so with an elegant modesty, a *pudeur* that sets his personal interventions apart from the exhibitionist and often quite trivial confessions of his peers. But above all, what is uncanny in this volume is the unconsciously prophetic nature of these authorial "confessions." Indeed, virtually every one of the allusions to disease that we have noted was included in chapters of the work completed *before* Bernheimer had any inkling of his own cancer. Unless, of course, one believes that the mind knows in some subliminal fashion what the cells are doing long before symptoms appear and diagnoses are rendered. The one chapter that remained to be completed at the time of Bernheimer's death, the analysis of Freud, contains no such reflections on contagion and/or death—subjects that might have tempted another author so acutely aware of his own imminent passing. It is in witness of this more recent restraint, on the one hand, and the earlier uncanny analysis of disease on the other, that we salute our late colleague.

Throughout Charles Bernheimer succeeds in these pages in accomplishing what others had not, a coherent and moving picture of *fin de siècle* decadence, first by suspending "our desire for coherent sense making," and then by situating the notion of decadence within "the dynamics of paradox and the ambivalence that it sets in motion." In Nietzsche, then, Bernheimer discovers not only a notion of decadence as "pathological . . . disorganizing and fragmenting individuals and societies," or of decadence involving "a subjectivity in which the self recognizes its own unknowability," or even of decadence as "an aesthetic of superficiality and artifice," but most intriguingly as a "stimulant that bends thought out of shape, deforming traditional conceptual molds." Flaubert's decadence can be understood as a breakdown of differences between historical and unhistorical, paradoxically locating the historical itself as a "destruction of history . . . a form of historical nihilism." Flaubert ends up, in Bernheimer's analysis, mobilizing a "detached neutrality on a stupefying middleground incapable of historical perspective . . . where differences have

collapsed into uniform mediocrity," where the "heterogeneous is homogenized," and where "confrontation becomes duplication of the same, . . . an irritating irresolution." Repeatedly in naturalism (whether Zola's or Hardy's) Bernheimer records an explosion of notions of character and difference, which, coupled with a fear of woman's sexualized body expressed as a rampant, omnivorous nature, lead to a core vision in which "man is reduced to a mere functionary . . . needed only to assure nature's continuing production of herself."

And last but not least, in the many faces of Salome, Bernheimer discovers a drama in which "the self is shattered in its encounter with the other," undermining any distinction between self and other. In her veiling, he sees "a vehicle of productive nonrecognition" undermining "mimetic apprehension." Here metaphors become "verbal masks that mirror literary constitution [in which] rhetorical display is dissociated from its object." Hence decadent language serves to "sever the mimetic bond of language to nature" privileging reflexivity and intertextuality and ending in "the thrill of collapsing differences."

When he turns to social and psychological diagnosticians, Bernheimer discovers more of the same: Lombroso betrays a "slippage of terms" that mobilizes "a fantasmatic crossing of the bright field of difference that collapses into its constitutive polarities." In a worldview in which "the norm becomes the analogy," all differences seem to be erased, notably between genders, between genius and criminal, and ultimately between life and death. For Freud, that slippage is shown to occur in a disavowal of the difference between unfounded theory and observation. In Freud's work, Bernheimer discovers that "a norm is projected from the perspective of which the decadent world is judged as such; simultaneously this norm is shown to have no justification for its authority, yet it is not abandoned." Freud's fetishistic castration theory functions as a kind of symptom for decadent thought as a (highly fragmented) whole: decadence is resolutely antiteleological and antimetaphysical, yet it cannot do without "the illusion of a telos, the mirage of a truth." Sadly, Charlie's death intervened before he could complete his essay on Freud. Thus, although the chapter reads as a finished work, there was more planned. We

have thus added in an appendix to the volume the outline of this essay to give to the reader a sense of the scope of what was intended.

Sadly, too, Charles Bernheimer died without leaving us a conclusion to this remarkable set of essays. Perhaps no conclusion was planned, since the critical position taken throughout the volume sees decadence as a penelopean fabric that "seems to undo itself in the very process of its making," in which "separate units are animated at the expense of the overall effect." The analysis of decadence becomes an endeavor in which "we must suspend our desire for coherent sense making," one which allows "no conclusive insights" and "whose profundity is dynamic and conflictual."

There are a few conclusions that seem, from the present perspective, almost inevitable, however unpleasant they might appear: if decadence as a mode of thought constantly mobilizes ambiguity as a force subversive to coherent thought and truth; if decadence destabilizes history and leads to the collapse of differences not only in culture but in language itself, putting into play an unceasing movement of difference; if decadence breaks down subjectivity, erasing the distinction between self and other: if all of these constitute the distinctive marks of decadent thought, then we cannot avoid the conclusion that much of French thought in *this fin de siècle* conforms to a decadent model. Deconstruction, Lacanian psychoanalysis, and the idea of the postmodern itself all mobilize just such erasures of difference and engender a ceaseless play of repetition.

Again, we cannot know what Charlie Bernheimer intended as a projection of nineteenth-century decadence, but we can infer that, in collapsing our own *fin de siècle* onto a previous one, he has achieved a very Flaubertian collapse of history. At his most coherent, Charlie Bernheimer achieves what Nietzsche would call "a vital resource for adventurous original speculation" and a "stimulant that bends thought out of shape" to envision a new understanding of our history and ourselves.

* * *

Editors' Preface

Naomi Schor wishes to thank Ryan J. Poynter and Bruce Hayes for their help, and both she and T. Jefferson Kline wish to thank the Johns Hopkins University Press editors for their patience and understanding. Special thanks are due to Jimmée A. Greco, our indefatigable copyeditor.

<div align="right">Jeff Kline
Naomi Schor</div>

The news of Naomi Schor's tragic and untimely death reached me during the final preparations to bring this book to press. The irony of losing my co-editor for a project that was already posthumous is almost too much to comprehend or bear. Naomi, as our entire profession knew, was a paragon of dedication, intelligence, and elegance. Her intense involvement in this project was yet another testament to the generosity and graciousness she displayed to so many. I mourn her passing.

<div align="right">Jeff Kline</div>

Decadent Subjects

Introduction

"So you're going to Berkeley to write your book on *decadence*. What a perfect setting for it."

"What do you mean?"

"The sun, the wonderful food, the natural beauty. You'll have a great time."

"But decadent types prefer artificial light to sunlight, they abhor healthy food and are notoriously against nature. So why do you think of Berkeley as decadent?"

"Well, I was just thinking of how you could indulge yourself: hot tubs, wine, women, the good life."

"But I'll have to resist all that if I'm going to get my book written."

"Go for it! Decadence in writing and decadence in life, the decadent mind in the decadent body."

"And what do you imagine that decadence in writing might be like?"

"Oh, I don't know—something extravagant, unconventional, quirky, personal yet stylish. A sort of *fin de siècle* performance."

"Well, I'd like to do that. But I'm not sure just what would be decadent about it."

"Maybe you'll find out by the time you're done."

This conversation, which occurred pretty much verbatim, is typical of the responses I got from the people who asked about the subject of my book. My interlocutors, whether academic or not, tended to see connections between my topic and my life. Decadence was not something associated only with the culture of museums and libraries. Without having any very clear idea of just what it was, they considered decadence a force that would necessarily invade me and perhaps master me. And that would be a good thing, the sentiment seemed to be. Or was it that my friends felt that it would be a good thing particularly for me, a kind of loosening-up of my scholarly inhibitions? It might be a little farther than they themselves would want to go, however. I was encouraged to indulge myself, but my friends remained on a kind of moral high ground from which they would be pleased to observe my perilous decline into sensuous hedonism and critical perversity. Let me be decadent, let me transgress, let me go for it, I would be an embodiment of the desires they could not act out. Why not? Well, I was more mobile—I could pick up and move to Berkeley for a year—I didn't have a family to worry about, I was not financially strapped. In other words, I was not really a good citizen to begin with. I had not shouldered the responsibilities of adulthood, I had not repressed and sublimated my instinctual appetites in the service of the dynamic progress of civilization. The decadence I was so enthusiastically advised to embrace was perhaps no more than the overt manifestation of my degenerate nature.

In my friends' endorsement of decadence, I felt that envy was mixed with disapproval. Envy for the potential unraveling of my stable identity through the subversive force of perverse desire. Berkeley imagined as a place of sensuous pleasure and erotic adventure, where the self's bourgeois coherence—and its expression in writing—would explode and disintegrate. Decadence imagined as a kind of liberation of unconscious drives, as an extravagant, theatrical performance on the edge of morality and sanity (Berkeley—Bezerkeley). But a performance from which it would be wise for my friends to keep at a distance, lest it contaminate them with destabilizing energies. The no-

tion of decadence seemed to elicit at once a desire to subvert the traditional moral code and a need to affirm the values of that code. The opposed responses were so closely linked that the negative judgment did not seem to come from outside the affective sphere of decadence but to be integral to it. To judge decadence as bad would not assure one's immunity from its seductions since such judgment seemed to be a part of what defined the phenomenon. To judge decadence as good would transform it into something else, since the negative evaluation was needed for decadence to retain its constitutional ambivalence.

Whereas there was a lot of uncertainty among my friends about what decadence might actually be as an object of study—the history of civilizations, the symptomatology of a certain psychic state, late-nineteenth-century works of art—there was a striking similarity in the kind of emotional response the idea generated. It was appealing but dangerous, liberating but perhaps too much so, pleasurable but self-indulgent, exciting yet perverse and destructive. Independently of any specific content, their notion of decadence challenged fundamental presuppositions about identity, sexuality, ethics, and social norms. Few were indifferent to the topic, even if they didn't know precisely what was stimulating their emotive engagement.

As I pondered my subject prior to beginning to write, I came to feel that my friends' response, in its lack of clear focus and paradoxically contradictory valuations, expressed something fundamental about decadence. Indeed, after years of reading, studying, and teaching literary and artistic works commonly called decadent, I was still unsure as to just what made them classifiable as such. The content of decadence was so multifaceted that no clear outline was discernible. Yet something provocative and compelling was shared by these works, of this I was convinced, and the challenge of writing my book would be to articulate the varieties of this provocation without reducing its cause—psychoanalytically, historically, or otherwise—to any specifically decadent agent.

The difficulty of meeting such a challenge was well illustrated for me by the frustration and even anger expressed by Richard Gilman in

his book of 1979, *Decadence: The Strange Life of an Epithet*.[1] So irritated is Gilman by what he sees as the irresponsible vagaries of this word's multiple meanings that he wishes that it could be banished altogether from the lexicon. Surveying uses of the term from Greek and Roman times to the present, Gilman finds that it has no specific referent, that "there is nothing to which it actually and legitimately applies" (158). People use the concept of decadence, he complains, as if it had epistemological validity, as if it described and made intelligible actual phenomena in the real world. But this, in Gilman's view, is just what decadence does not do. It has no objective existence. He sees it, rather, as a poetic metaphor that replaces the factually real with wish-fulfilling illusions about the way the world moves and means. For example, we like to think of the decadence of a civilization on the model of the old age of an individual because of the explanatory appeal of the analogy to the body's fate. But there is no evidence, Gilman demonstrates, that civilizations inexorably follow an organic pattern of robust growth followed by stagnation, decay, and death. They undergo assaults, lose economic vigor, are subject to weak rulers—all of which are arbitrary events that could well happen otherwise. The notion of decadence as applied to civilizations is an anthropomorphic reduction that substitutes the pattern of human growth and aging for a pluralistic and overdetermined process. The Romans themselves were the first to explain their history in this manner. They interpreted the fate of their empire as a story of decadence because of their sense of loss in relation to a projected image of their earlier vigor. But this loss, Gilman argues, cannot be measured in any concrete, historically specific terms. Late Roman art was different from, rather than inferior to, its classical predecessor. Thus Rome's sense of its decline was a fictional construct built on the premise of a preceding ideal performance. Change, brought on largely by factors over which Rome had little control, was interpreted poetically, metaphorically, as degradation and loss.

This perception seems precisely right to me, and I have no quarrel with Gilman's claim that "*all* the forms in which we think we detect the phenomenon of decadence are products of the word's prior uses

and not stable realities of the objective world" (14). Gilman, however, deplores this condition, whereas I find that it helps give the term its valuable subversive agency. He wants a clear demarcation between what he calls the "proper sphere" of aesthetic creation, "one of whose purposes is to relieve us of the burden of the world's facticity, its givenness" (161), and the proper sphere of science and history, which is the illumination of that facticity, "the discovery of actualities, real processes or conditions" (161). What so outrages him about the notion of decadence is that he sees it as a metaphor—and hence a vehicle for wishes, hypotheses, dreams—that pretends duplicitously to offer access to reality. The concept of decadence is a fraud, a poetic invention masquerading as an epistemological tool. Gilman considers it representative of a class of words that "injure meaning and bring about confusion" (50), symptoms of linguistic degradation and social decay.

This view might seem to be confirmed by the dialogue I quoted above in which my interlocutor associates decadence with the warm sun, gourmet cuisine, and natural beauty of northern California. On the face of it, these associations seem entirely wrong, as I pointed out to my friend. For Gilman, such (mis)usage corrupts meaning and is a sign—he would wince at this—of the decadence of the language. But I would argue that the particular associations that a speaker may have with the concept of decadence are not what is important and culturally productive about this concept. It is not the referential content of the term that conveys its meaning so much as the dynamics of paradox and ambivalence that it sets in motion. Its meaning is the injury of the kind of meaning Gilman is looking for. Fundamental to the opening of this semantic wound is precisely the contaminating crossover that dismays Gilman, the slippage from poetic metaphor to historical fact, from aesthetic dream to real life, from a book about decadence to a decadent existence. Think of Dorian Gray slipping up to the attic to look at the picture that embodies the disintegration of his soul: the aesthetic crosses over into the real and takes on its temporality, whereas the real, by the magic of Dorian's wish not to age, takes on the timelessness of art. Significantly, once this semantic

wound is cured, and Dorian is definitively differentiated from his portrait, not only does he die but the book itself ends. This, for decadence, is the consequence of dividing the aesthetic from the real.

But, of course, the dead Dorian does not properly belong to the real world. Reality in literature is a fictional construct. As is decadence itself, Gilman argues. His complaint is that decadence's unreality is not generally recognized because the term is defined in complementary opposition to social norms that are considered natural, good, and right, most importantly to the idea of progress. Decadence gains its false reality, Gilman declares, from its negative position on a continuum whose positive pole is the equally false reality of cultural advance. "If the ideas of progress and decadence," he writes censoriously, "are really two sides of an illusion, then their persistence is an illustration of the power of language and thought to keep the nonexistent in imaginary existence" (160). Good for language and thought, I am tempted to retort. In his anger over the failure of decadence to signify anything concrete, Gilman is insensitive to the way it signifies precisely by means of this apparent failure. He attributes to the notion of decadence a mimetic and epistemological claim that, in my opinion, it does not make and then castigates the concept for not performing its supposed mission.

Indeed, Gilman's impasse itself signals the necessity to return to those authors and artists whose work constitutes the topos of the decadent, to understand how one can articulate the varieties of the provocation of "the decadent" without reducing its cause to any specific agent. Let us turn, then, to an analysis of the works of Nietzsche, Zola, Hardy, Flaubert, Wilde, Moreau, Beardsley, Lombroso, and Freud to discover the many ways in which these works put into play medical diagnostics, sexuality, oedipal trauma, the disintegration of the subject and the limits of the human to suggest many unsuspected avatars of the death drive.

I

Nietzsche's Decadence Philosophy

About no other subject was Nietzsche as sure of his unique expertise as about decadence. "Nothing has preoccupied me more profoundly than the problem of *décadence,*" he asserted in the late work *The Case of Wagner* (CW, 155).[1] "I am in questions of *décadence* the highest instance that now exists on earth,"[2] he boasted to a correspondent a few months later. Made in 1888, the last year before his collapse into insanity, these claims have sometimes been thought to reflect Nietzsche's intellectual decay, as if his preoccupation with decadence as a subject reflected his decaying mental condition. Nietzsche's thoughts on this subject he claimed to know better than anyone are so riddled with contradictions, critics maintain, that they fail to coalesce into any useful insight. Contradictions are, of course, characteristic of Nietzsche's reflections on any of his key concepts, and readers of his books are used to the multiple twists and turns that characterize his dynamic thought. But in the case of decadence, so bewildering are his many conceptual revisions that, despite his claim that the problem is central to his philosophy, critics have by and large not placed it at the center of their interpretations.[3]

In this chapter I will defend Nietzsche's claim to special authority in questions of decadence. I will defend it, however, not by elucidat-

ing Nietzsche's definition of the idea but by showing that he reacted with unique vigor to its stimulating force as an intellectual *agent provocateur.* It is, thus, unlikely that readers of this chapter will come away with a clear sense of what Nietzsche meant by decadence. He had no such clear idea himself. My purpose is to help readers appreciate how the concept's semantic mobility found in the transformative velocity of Nietzsche's thought a wonderfully responsive vehicle of expression. The profundity of Nietzsche's meditation on decadence is dynamic and conflictual. It does not arrive; it keeps moving. At the end of this chapter, I will outline nine key moments in Nietzsche's reflection, each of which suggests a significantly different view of what decadence is, none of which can be cited as Nietzsche's conclusive definition of the concept.

Puzzling at the outset is the fact that Nietzsche always uses the French term *décadence* rather than the German *Dekadenz,* a usage that Walter Kaufmann's translations do not respect. One might suppose that Nietzsche intends through this usage to suggest his closeness to a sophisticated sensibility cultivated by certain artists and writers in France in the recent seventies and eighties. Nietzsche's intimacy with *décadence* would then imply a connection between his philosophy, which he calls a "filigree art" full of "nuances" (EH, 223; in French in the original), and avant-garde French aestheticism. But this is only the first of many, mostly misleading, interpretive trails: Nietzsche has very little to say concerning French decadence, about which he is not particularly well informed, and he uses the French term, with its suggestion of cultural difference, even when he is referring to his own physiological ills—his susceptibility to horrible migraines, gastric ailments, and eye troubles are all symptoms, he tells us, of his *décadence.*

Banal and reductive as such references to physical ailments may appear to be, Nietzsche nevertheless designated "the body and physiology" (WP, 271) as the "starting point" for his entire philosophy. So we are justified in beginning an analysis of his ideas on decadence from a physiological perspective. Such a beginning, however, is multiple and complex. Indeed, Nietzsche attributed his fundamental philosophical project, to revalue values, to the reversal of perspectives

that the body's varying states of health and sickness had taught him. "Looking from the perspective of the sick," he observes, "toward *healthier* concepts and values and, conversely, looking again from the fullness and self-assurance of a *rich* life down into the secret work of the instinct of decadence—in this I have had the longest training, my truest experience; if anything, I became master in *this*. Now I know how, have the know-how, to *reverse perspectives:* the first reason why a 'revaluation of values' is perhaps possible for me alone" (EH, 223).

I want to begin now by viewing decadence from the point of view that Nietzsche here associates with "a rich life." In this perspective, the body appears as an organized organic whole and decadence as an ongoing process of the elimination of waste: "Waste, decay, elimination need not be condemned," he notes, "they are necessary consequences of life, of the growth of life. The phenomenon of *décadence* is as necessary as any increase and advance of life: one is in no position to abolish it" (WP, 25). As applied to history, what this means is that societies do not go through periods of prosperity and health followed by periods of decline but that "*décadence* belongs to all epochs of mankind: refuse and decaying matter are found everywhere: it is one of life's processes to exclude the forms of decline and decay" (WP, 184–85). From this perspective, decadence has a necessary and beneficial place in the economy of life. It is not a problem in itself—it becomes problematic only if it threatens to exceed its limits and infect the organism as a whole: "*Décadence* itself," Nietzsche observes, "is nothing *to be fought:* it is absolutely necessary and belongs to every age and to every people. What should be fought vigorously is the contagion of the healthy parts of the organism" (WP, 25–26).

According to this unusual notion of decadence as a sort of natural excretory function, it is clear that no one in his right mind would want to be free of decadence. Decadence is a biological process that assures the organism's health, whether this organism be an individual or a society. Indeed, if your decadent functions should cease you would fall ill. The important thing is for the organism to be healthy as a whole so that it can effectively contain its naturally diseased parts. When Nietzsche calls himself "healthy *im Grunde,*" he is read-

ing his own physiology in just these terms. Because he believes that "there is no pathological trait in [him]" (EH, 257), he is able to treat his sickness as "an energetic *stimulus* for life, for living more" (EH, 224). Given that he embodies health (including its decadent functions), any other perspective on life is, by implication, contaminated. "As *summa summarum* [sum total]," he writes, "I was healthy; as an angle, as a specialty, I was a *décadent*" (EH, 224).

While Nietzsche insists, somewhat defensively, on his own fundamental health, he upbraids the rest of us for having allowed decadent poison to spread through our bodies, thereby infecting the entire social order: "The body perishes when an organ is altered," writes Nietzsche, "There is no solidarity in a society in which there are sterile, unproductive, and destructive elements" (WP, 32–33). It is as if the entire society were made up of specialized angles, of splinters and fragments. Paul Bourget uses just such imagery of decomposition to describe a society in decadence, and a corresponding style of decadence, in a passage of his 1881 essay on Baudelaire that Nietzsche borrows, without acknowledgment, for his analysis of Wagner. A society, says Bourget, should be thought of as an organism made up of a federation of lesser organisms, which are in turn a federation of cells, that is, of individual citizens. For the total organism to function properly, the lesser organisms have to subordinate their energies to the good of the whole, just as the cells have to subordinate theirs to the benefit of the lesser organisms. If this hierarchical order fails, anarchy and decadence ensue as individual life thrives at the expense of the whole. "The same law," writes Bourget, "governs the development and decadence of that other organism, language. The style of decadence is one where the unity of the book decomposes to give way to the independence of the page, where the page decomposes to give way to the independence of the sentence, and where the sentence decomposes to give way to the independence of the word."[4] While judging such fragmentation as catastrophic from a political and moral perspective, Bourget is able to recognize its innovative potential in psychological terms: decadence, he suggests, may stimulate new creativity of a morbid, melancholy, refined, sensual kind.

In contrast to Bourget, for whom the metaphor of organic de-composition offers an insight into the psychological sources of an aesthetics of the future, Nietzsche uses the same image to justify condemning decadent art and the modernity it expresses. In the context of an analysis of the way Wagner typifies decadence, Nietzsche writes: "What is the sign of every *literary décadence?* That life no longer dwells in the whole. The word becomes sovereign and leaps out of the sentence, the sentence reaches out and obscures the meaning of the page, the page gains life at the expense of the whole—the whole is no longer a whole." But this is the simile of every style of *décadence:* every time, the anarchy of atoms, disintegration of the will, "freedom of the individual," to use moral terms—expanded into a political theory, "*equal* rights for all." Life, *equal* vitality, the vibration and exuberance of life pushed back into the smallest forms; the rest *poor* in life. Everywhere paralysis, arduousness, torpidity or hostility, and chaos: both more and more obvious the higher one ascends in forms of organization. The whole no longer lives at all: it is composite, calculated, artificial, and artifact (CW, 170). Here we seem to be in a traditionally moral world of good and evil: life that dwells in the whole is good; the decadent impulse that fragments, atomizes, and disorganizes the whole is bad. The whole is formed by a natural, organic process; what disrupts it is artificial, calculated, and hostile. No longer does Nietzsche make an effort to include as inherent to life "the forms of decline and decay" (WP, 184). His model, like Bourget's, derives from contemporary biology, especially from Claude Bernard, and from then-current theories of heredity and degeneration.[5] When he says that paralysis is everywhere, he intends his diagnosis to refer to all of contemporary society. "The sensibility of the majority of men is pathological and unnatural," he observes, going on to generalize that "mankind is corrupt morally and physiologically" (WP, 32).

At this point Nietzsche, the teacher of life's affirmation, seems to be as negatively critical of life as are the moralists whom he berates for condemning life from a position they mendaciously claim to be outside it. Such antinatural morality is, he maintains, "the very in-

stinct of *décadence,* which makes an imperative of itself. It says: '*Perish!*' It is a condemnation pronounced by the condemned" (TI, 491). The projection of moral goals—which causes a division of the world into an unchanging universe of truth and an apparent one, this one, that is changing, false, and hence "ought not to exist" (WP, 317)—is, he declares, "a dreadful tool of *décadence*" (WP, 316). Moralists urge men to disdain their bodies and neglect their self-interest, all in order to save their souls (see EH, 292, and TI, 535–36). Nietzsche urges his readers to reject this condemnation of life and to mark a division not between life and an afterlife but between two kinds of life, one impoverished and sickly (i.e., decadent), the other ascending and rich.

This distinction, however, becomes confused because of the difficulty one may have in distinguishing between Nietzsche's condemnation of decadence as fragmentation and his affirmation of vital processes such as "change, becoming, multiplicity, opposition, contradiction, war" (WP, 315). The notion of an organic whole, in terms of which Nietzsche considers the majority of mankind to be pathological, serves the same function structurally as the notion of becoming, which the majority of mankind is too weak to affirm. Wholeness (health) is to fragmentation (decadence) as becoming (health) is to morality (decadence). The logical contradiction in this parallel is evident, but Nietzsche is not perturbed by it. Most important to him, it seems, is that decadence remain as the critical term of condemnation in those structures of paired oppositions that are crucial to his thought—despite his distaste for their metaphysical artifice.

Thus Nietzsche approves of the healthy man's "instinctive aversion *against décadents*" (CW, 192). We have come a long way from his tolerant declarations that decadence "is nothing *to be fought*" and that "one is in no position to abolish it." He now applies these judgments only to himself and to the few others who are constitutionally healthy and hence capable of what he calls "self-overcoming" (CW, 155). In *The Case of Wagner,* the self that he claims to have overcome is the one who was "a child of this time; that is, a *décadent*" (CW, 155) and who identified with Wagner as the embodiment of this typically modern sensibility. In Nietzsche's analysis, Wagner's decadent genius

is characterized by pathological manifestations such as hysteria, nervous excitability, histrionics, mendacity, visual restlessness, sensationalism, aesthetic fragmentation, effeminacy, and more. Nietzsche deploys the well-known psycho-medical rhetoric of degeneration with gusto, acknowledging his indebtedness to it while asserting that he is now the stronger for having both experienced and resisted its temptations.[6]

Nietzsche's resistance to decadent modernity was motivated, he tells us, by a desire to attain "the eye of Zarathustra, an eye that beholds the whole fact of man [die ganze Tatsache Mensch] at a tremendous distance—below. For such a goal," he comments, "what sacrifice wouldn't be fitting? what 'self-overcoming'? what 'self-denial'?" (CW, 155). It is not clear just why Nietzsche puts these terms in quotation marks, but it may be because he is aware of their function in just the kind of moral teaching he rejects. Nietzsche's vocabulary of sacrifice and self-denial has a distinctly Christian ring to it: it is as if decadent mankind were "fallen" and the philosopher's self-overcoming gave him access to a transcendent perspective far above the fallen world. Indeed, in the first paragraph of *The Case of Wagner* he writes with ironic self-consciousness, "If I were a moralist, who knows what I would call it [his resistance to the decadence exemplified by Wagner]? Perhaps self-overcoming.—But," he adds, "the philosopher has no love for moralists. Neither does he love pretty words" (CW, 155).

Why then, we may ask, does the philosopher ventriloquize the moralist just at the moment when he is claiming no longer to be one? Perhaps the moralist has not been overcome after all and is masquerading as the philosopher. Such a thought should not be uncongenial to Nietzsche, since he acknowledges being fully implicated in the play of forces he analyzes and the history he narrates. "Most of the conscious thinking of a philosopher," he remarks, generalizing from his own case, "is secretly guided and forced into certain channels by his instincts" (BGE, 11). Perhaps Nietzsche's self-overcoming is driven in part by his "instinct of *décadence*" that divides the world into true and false parts. He distances himself so far from humanity

that he identifies with life as a whole and condemns the majority of mankind in its name. "Life itself recognizes no solidarity," says Nietzsche, "no 'equal rights' between healthy and degenerate parts of an organism: one must excise the latter or the whole will perish—sympathy for *décadents,* equal rights for the ill-constituted—that would be the profoundest immorality, that would be antinature itself as morality!" (WP, 389). Nietzsche as a spokesman for "life" arrogates the authority to distinguish between what is natural and what anti-natural and to condemn decadent body parts and decadent individuals alike to be forcefully removed from the infected organism. "The weak and the failures shall perish: first principle of *our* love of man. And they shall even be given every possible assistance" (TI, 570).

Remarks such as the ones just quoted about excision are disturbing, for they could easily be taken as encouraging a racist eugenics, not to say the possibility of genocide. One reason that Nietzsche's thinking goes awry here is that he has excluded from his picture of the healthy, natural, whole organism those "instincts of *décadence*" that elsewhere he claims to be necessary and inevitable in all men. He now considers degenerate mankind the enemy of his will to power. Thus he declares: "Thesis: the *instincts of décadence,* which, through the moralists, want to become master over the instinctive morality of strong races and ages are 1) the instincts of the weak and underprivileged; 2) the instincts of the exceptions, the solitaries, the abandoned, of the *abortus* in what is lofty and what is petty; 3) the instincts of those habituated to suffering, who need a noble interpretation of their condition and therefore must know as little as possible about physiology" (WP, 228–29). Here his strategy is quite blatant and profoundly disquieting in its implications: physiology, he suggests, serves the elite class of artist-philosophers, of which he sees himself as the foremost exemplar, to diagnose decadents as such. However, his implicit claim to have mastered the knowledge necessary for such unequivocal diagnoses is subject to his own insight that knowledge is no more than "error concerning oneself, will to power, will to deception" (WP, 330).

Nietzsche's error about himself concerns, of course, the fact that

his own instincts are those of an exception and a solitary habituated to suffering, of a decadent, that is. His assertion that his instincts are fundamentally healthy is evidently "a noble interpretation of [his] condition," born, I would wager, of weakness and self-doubt. Ultimately, that weakness overtakes him entirely and expresses itself in megalomania. (He signs a letter to August Strindberg of December 1888 "Nietzsche Caesar.")[7] Despite his admonition to himself "not to confuse the *décadence* instincts with *humanity*," [8] this is exactly what he does. He is repeating just what he attacks in the moralists, depreciating the actual world in favor of one that ought to be. That desirable world may not be transcendent or even truthful in his view, but Nietzsche nevertheless grants it an essential ground, health. Thus, despite his wish to the contrary, he is no different from past philosophers, of whom he writes: "It is a self-deception on the part of philosophers and moralists if they believe that they are extricating themselves from *décadence* when they merely wage war against it. Extrication lies beyond their strength: what they choose as a means, as salvation, is itself but another expression of *décadence;* they change its expression, but they do not get rid of decadence itself" (TI, 478).

Now I realize that by thus quoting Nietzsche against himself I may appear to be setting myself up as his superior, as if my insight were greater than his, which I know full well it isn't. But I do want to register my critique of a certain trend in Nietzsche's thinking and to connect that trend with his attempt to overcome decadence. My point is that his effort to extricate himself from decadence leads him to betray what is strongest about his philosophy, its adherence to perspectivism, becoming a revaluation of values. As I propose to show in the second half of this chapter, another strand of Nietzsche's thinking could have provided him with a way of valuing decadence positively. But he was apparently unwilling to move in this direction.

The body and physiology—this "starting point" for Nietzsche's philosophy is evidently not a point but rather a complex field of intersecting forces. My first critical narrative took off from a rather stable location in this field, stable by virtue of its clear distinction between

health and decadence. My second narrative will begin in a much more fluid and shifting place. It is the paragraph that Nietzsche writes as a direct response to the question he puts to himself, "The body and physiology the starting point: why?":

> We gain the correct idea of the nature of our subject-unity, namely as regents at the head of a communality (not as "souls" or "life forces"), also of the dependence of these regents upon the ruled and of an order of rank and division of labor as the conditions that make possible the whole and its parts. In the same way, how living unities continually arise and die and how the "subject" is not eternal; in the same way, that the struggle expresses itself in obeying and commanding, and that a fluctuating assessment of the limits of power [fliessendes Machtgrenzenbestimmen] is part of life. The relative ignorance in which the regent is kept concerning individual activities and even disturbances within the communality is among the conditions under which rule can be exercised. In short, we also gain a valuation of *not-knowing,* of seeing things on a broad scale, of simplification and falsification, of perspectivity. The most important thing, however, is: that we understand that the ruler and his subjects are of the same kind, all feeling, willing, thinking—and that, wherever we see or divine movements in a body, we learn to conclude that there is a subjective, invisible life appertaining to it. Movement is symbolism for the eye; it indicates that something has been felt, willed, thought. (WP, 271)

Most striking about this passage is, of course, the fact that it answers a question about the body with a meditation about the subject (both, it should be noted, unmarked by gender). The body teaches us to see the subject right, Nietzsche declares, a claim similar in many respects to Freud's statement that "the ego is first and foremost a bodily ego" (SE 19, 26). At the outset of the passage Nietzsche seems to be elaborating, once again, a model of the body as an organic unity with a hierarchical organization of the parts in relation to the whole. The notion of a communality (*Gemeinswesen*) suggests the familiar organicist analogy between the body's constitution and that of a society. But it soon becomes clear that his identification of the body with the subject itself actually dissolves any hierarchical structure the

subject may initially have appeared to have. Nietzsche's language is impressionistic and referentially obscure. It is impossible to determine just what organ or psychic function might be represented by the ruler's position. But his point concerns, precisely, the instability, flux, even invisibility of bodily processes. Ruler and ruled are not fundamentally different and are involved in an ongoing struggle that requires that the limits of power be constantly reassessed. Hence there can be no fixed exercise of authority, no firm ground on which to establish mastery and control. Physiology offers anything but a positivist source of knowledge. It teaches ignorance, nonknowing, *Unwissenheit.* A condition of the regent's rule is acceptance of his perspective as one among many provisional and shifting points of view, each uncertain and transitory. "All our so-called consciousness is a more or less fantastic commentary on an unknown, perhaps unknowable, but felt text," Nietzsche observes in *Daybreak.*[9]

No body fantasized in this manner could possibly be declared healthy or ill *im Grunde.* Its *décadence* instincts could not be excised, permanently subordinated, or phobically projected onto the weak and deprived. The ground that previously served Nietzsche to judge decadence as such has now become invisible. This body is inscribed by its decadence—not as some neatly controlled biological function of waste removal but as an inherent illness that cannot be cured and that is, as Jeffrey Wallen puts it, "inextricably linked to subjectivity itself."[10] "All of us have," Nietzsche writes in *The Case of Wagner,* "unconsciously, involuntarily [wider Wissen, wider Willen] in our bodies values, words, formulas, moralities of *opposite* descent—we are, physiologically considered, *false*" (CW, 192).

Nietzsche—I want to be clear on this point—does not use the term *décadence* to describe this unconscious falsity. Yet many of his negative descriptions of decadence would require only a slight change of perspective for them to be positively transvalued. Thus his critical view of the decadent fragmented body could be transformed into a positive view of the body as a complex field of competing interpretations and valuations.[11] In the preface of 1886 to *The Gay Science* Nietzsche describes himself as a lifelong convalescent who profits from

his fickle health by the way it pluralizes and transfigures his thought: "A philosopher who has traversed many kinds of health, and keeps traversing them, has passed through an equal number of philosophies; he simply *cannot* keep from transposing his states every time into the most spiritual form and distance: this art of transfiguration *is* philosophy" (GS, 35). Indeed, Nietzsche associates the philosopher's "inability *not* to react" (TI, 519) with the most typical of decadent behaviors, hysteria.[12] Mining his illness as a resource for adventurous, original speculation, the (decadent/hysterical) philosopher artist transposes the body's nonknowing into written "symbolism for the eye." Such, at least, is one way of reading Nietzsche's ambition as a thinker.

His practice fulfills this ambition in many respects. It is often hard to know how to define the "subject-unity" of his later books since the reigning idea is only temporarily more authoritative than any number of other thoughts expressing different, even contradictory perspectives. The books are composed as a kind of communality of numbered sections, each with its own "subjective, invisible life." Although the numbering suggests a logical sequence, the logic of the continuity is often difficult to discover. The sections are usually made up of paragraphs, but sometimes only of brief epigrams or poems. Sections are collected into larger units, labeled "parts" or "essays," and the last book, *Nietzsche contra Wagner,* is composed entirely of selections from his previous writings. *Ecce Homo* contains chapters whose titles are those of Nietzsche's previously published books, of which he gives critiques here. And, of course, there is the famous *Will to Power,* a book Nietzsche never wrote as such, which was constructed in various quite different versions after his death, and that does not exist at all in the latest authoritative edition of his collected works. Thus the body of Nietzsche's texts appears to be decomposed in much the way he found characteristic of decadent style. Indeed, *The Case of Wagner,* the book into which Nietzsche inserted as his own Bourget's analysis of decadence, is itself a fragmented artifact, made up of a preface, twelve numbered sections of various lengths, a postscript, a second

postscript, and an epilogue. Thus Nietzsche's critique of Wagner could be read as decadent for the same reasons that Nietzsche finds Wagner to be decadent: separate units are animated at the expense of the overall effect, idiosyncrasy takes the place of coherent argument, histrionic exaggeration undermines serious conviction. Surely here "the whole no longer lives at all: it is composite, artificial and artifact." From this perspective, Nordau is right to find Nietzsche exemplary of the *fin de siècle* degenerate, whose incoherent, hysterical self is incapable of producing logical argumentation. Many of Nietzsche's books are indeed, as Nordau says, "a succession of disconnected sallies, prose and doggerel mixed, without beginning or ending."[13]

At this point, we might expect Nietzsche to perform one of those reevaluations of values that he claimed as his philosophic specialty and to embrace decadence as the most suitable aesthetic expression of a biological body in perpetual convalescence and of a textual body in perpetual transfiguration. We might well think that he had done just this when we read certain passages at the end of the preface to *The Gay Science* that echo statements on aesthetics by the foremost proponents of the decadent sensibility in the *fin de siècle*. Dismissing the histrionic passions of Romantic literature and music, Nietzsche describes the kind of art suitable for convalescents as "a mocking, light, fleeting, divinely untroubled, divinely artificial art that, like a pure flame, licks into the unclouded skies. Above all, an art for artists, for artists only!" (GS, 37). The notion of artifice, which Nietzsche valued negatively in regard to decadent style "in which the whole no longer lives," here has positive associations with creative play performed at a salutary distance from nature. His prescription for art is strikingly close to the one Oscar Wilde offers in "The Decay of Lying": "Art takes life as part of her rough material, recreates it, and refashions it in fresh forms, is absolutely indifferent to fact, invents, imagines, dreams, and keeps between herself and reality the impenetrable barrier of beautiful style, of decorative or ideal treatment."[14] Furthermore, at the end of the preface Nietzsche gives his highest possible praise to a recipe for life that he associates with the healthiest of civi-

lizations, that of ancient Greece, but that sounds perfectly Wildean to our ears: "What is required," he writes, "is to stop courageously at the surface, the fold, the skin, to adore appearance, to believe in forms, tones, words, in the whole Olympus of appearance" (GS, 38).[15] Granted, Nietzsche's "whole Olympus of appearance" is an expression of exuberant life: artistic production for him gives existence an aesthetic dimension, whereas Wilde wishes Art to constitute a barrier against Life. Thus Nietzsche distrusts the "art for art's sake" principle because it "debases [and] impoverishes the real" (WP, 168), whereas Wilde often seems to embrace it for precisely that reason ("Art is our spirited protest, our gallant attempt to teach Nature her proper place," he declares[16]). But both agree about the fundamental precept that, to use Nietzsche's phrase, "art is *worth more* than truth" (WP, 453), or, to use Wilde's formulation, "Lying . . . is the proper aim of Art."[17]

Wilde published "The Decay of Lying" in January 1889, just when Nietzsche was succumbing to his mental illness. But the ideas Wilde formulated in this text as brilliant paradoxes were widely disseminated throughout Europe in the mid-1880s. Nietzsche could have associated his thinking with this cultural movement had he wished to do so. As I noted earlier, his use of the French word throughout his writings of 1887 through 1888 could be thought to refer to the group of writers and artists in France who, from at least 1885 on, defiantly applied this term to their work. But the national identities Nietzsche associates with *décadence* are as slippery as every other perspective from which he views this concept. When he declares his gratitude to his own *décadence,* he does not associate it with anything French but with Wagner, "one of my sicknesses" (CW, 155) and "the great benefactor of my life" (EH, 250). His greatest praise for a contemporary French cultural production is for Bizet's *Carmen* (1875), which he views—with some irony, one suspects—as a wonderfully healthy work, whose music, unlike Wagner's, "is pleasant, it does not *sweat*" (CW, 157).[18] So the most *décadent* musician is German and the least *décadent* is French! The question of *décadence*'s nationality is further complicated by Nietzsche's refusal to view Wagner as German at all

(CW, 182n.). Despite Wagner's Teutonic zeal, Nietzsche claims that the composer's morbid value for the early refinement of his philosophical sensibility was as an "antitoxin against everything German" (EH, 249), a poison taken against the effects of a worse poison. This antitoxin has a French flavor: Baudelaire, Nietzsche claims, has "a kind of Wagnerian sensibility,"[19] as does Victor Hugo (CW, 173, 179, 182). These French connections suggest that Nietzsche's models for *décadence* (Delacroix is another—EH, 248) belong to the period of high Romanticism and its immediate aftermath, rather than to contemporary Parisian culture ("Wagner sums up romanticism, German as well as French," he observes—WP, 67). The French contemporaries he calls "charming" and "delicate psychologists" (EH, 243)—figures such as Paul Bourget, Pierre Loti, Gyp, Meilhac, Anatole France, Jules Lemaître, and, singled out for special praise, Guy de Maupassant—are simply popular authors of the day, not figures who had a significant impact on him (with the possible exception of Bourget).[20] Thus *décadence* "belongs" in no particular place; it is neither foreign nor domestic.

But of one thing Nietzsche remains sure: decadence is a disease that must be resisted for the sake of health and ascending vitality. In this regard nothing has changed from the point we reached at the end of part 1 of this chapter. Nietzsche cannot imagine an "aesthetics of *décadence*" (CW, 190) that would do anything other than reflect declining and resentful life. He is unable to transpose the notion of decadence into "the most spiritual form and distance." It remains intractably physiological, impervious to hysterical conversion. Why?

One possible answer, formulated in just the epigrammatic style Nietzsche would have liked (which, of course, oversimplifies the issue): decadence for Nietzsche is a woman.[21] His hysteria is generated to a significant degree by his revulsion for the female body. Hence he associates his creativity with the achievement of a safe distance from its decadent origins.

This process is revealed in the following way: Here is Nietzsche's description of how "we artists" experience love:

> When we love a woman [ein Weib, a derogatory term], we easily conceive a hatred for nature on account of all the repulsive natural functions to which every woman is subject. We prefer not to think of all this; but when our soul touches on these matters for once, it shrugs [as it were] impatiently and looks contemptuously at nature: we feel insulted; nature seems to encroach on our possessions, and with the profanest hands at that. Then we refuse to pay any heed to physiology and decree secretly: "I want to hear nothing about the fact that a human being is something more than *soul and form*." "The human being under the skin" is for all lovers a horror and unthinkable [ein Greuel und Ungedanke], a blasphemy against God and love. (GS, 122)

Here is the psychological key to why Nietzsche praises life that "stops courageously at the surface." He has simply reversed motives: the superficiality he calls courageous is actually motivated by fear of "the human being [der Mensch] under the skin." Notice how, in the course of the above paragraph, *das Weib* becomes *der Mensch*. As he talks about woman's "repulsive natural functions" (such as menstruation, I presume), they become representative in his fantasy of all human physiology. This association obviously makes very problematic the starting point he claims for his philosophy, "the body and physiology." For if it is true, as Nietzsche argues, that "[one's] genius is in [one's] nostrils" (EH, 326), then he must feel considerable *ressentiment* at the re-sniffing his philosophy requires (the pun is Eve Sedgwick's)[22] and be quite anxious to move away from this smelly immediacy.

Now, I realize that Nietzsche's reference in this passage is specifically to men in love. But there are plenty of other passages in his works where he makes similar observations about men's view of women without qualifying it as caused by love. Love simply exacerbates a man's sensitivity to what he has always seen, that is, as he writes in *Beyond Good and Evil,* that woman's "*nature . . .* is more 'natural' than man's" (BGE, 169). Particularly terrifying is that this nature *moves,* it "seems to encroach on our possessions." It is like an infection, an illness, a physiological decadence. No wonder that he

believes that "Woman has always conspired with the types of *déca-dence*" (WP, 460) and that he copied approvingly into his notebook for 1888 Baudelaire's remark: "La femme est naturelle, c'est à dire abominable."[23] As Theodor Adorno has pointed out, insofar as aversion from women is fundamental to Christian dogma, Nietzsche is subjecting his thought to an ideological system he claims to abhor: "The fact that Nietzsche's scrutiny stopped short of them [feminine natures], that he took over a second-hand and unverified image of feminine nature from the Christian civilization that he otherwise so thoroughly mistrusted, finally brought his thought under the sway, after all, of bourgeois society. He fell for the fraud of saying 'the Feminine' ['Weib'] when talking of women. Hence the perfidious advice not to forget the whip: femininity ['Weib'] itself is already the effect of the whip."[24]

Physiology as female nature is an *Ungedanke*. This term covers everything about man that is not "soul and form." It is something quite different from the *Unwissenheit* Nietzsche valued when he derived his picture of the subject's (dis)organization from an ungendered physiology and praised not-knowing as a valuable artistic talent (GS, 37).

Unwissenheit can be productively thought of as an epistemological tool. *Ungedanke* is a horror beyond thought. Woman becomes thinkable only after she has been denatured. Then she can be transfigured into a trope of male creativity. For this to happen, what is necessary above all is distance: "The magic and the most powerful effect of women," Nietzsche writes, "is, in philosophical language, action at a distance, *actio in distans,* but this requires first of all and above all—distance" (GS, 124).[25] Once physical distance from woman's decadence has been achieved, then she can be appreciated as a welcome poetic effect in the distance. So removed is she then from her "repulsive natural functions" that the philosopher can imagine taking them over for himself, becoming *mütterlich* with "the pregnancies and deliveries of his spirit" (GS, 326).[26] Indeed, the question of woman is crucial to the production of "an art for artists," that is, an art produced by men for the benefit of similarly inclined men. Such artists

do not desire to uncover truth, Nietzsche says; their wisdom is shown by their appreciation of the "veils, . . . riddles and iridescent uncertainties" (GS, 38) that obscure the naked truth of nature. "Perhaps truth is a woman," he speculates, "who has reasons (*Gründe*) for not letting us see her *Gründe*. Perhaps her name is—to speak Greek—*Baubo*" (GS, 38). Kaufmann translates the second *Gründe* like the first as "reasons," but Nietzsche no doubt intended to exploit the double meaning of *Gründe* that this translation obscures. What truth veils is woman's fleshly ground, her biological rationale, her physiological essence, just what the figure of Baubo reveals: the female genitals. The woman who "has her reasons" for veiling this sight is to be mistrusted, for she may well be trying to flatter men by collaborating with their need to lie about her. Nietzsche brings out this point in *Beyond Good and Evil,* where his version of women's relation to truth is more classically misogynist: "What is truth to woman?" he asks. "From the beginning, nothing has been more alien, repugnant, and hostile to woman than truth—her great art is the lie, her highest concern is mere appearance and beauty. Let us men confess it: we honor and love precisely *this* art and *this* instinct in women" (BGE, 163). The task of the philosopher-artist, who knows the connection between woman's art of deception and her repulsive nature, is to steal this art and make it his own. Thus he becomes feminine to the extent that he obscures female nature and uses artifice *in distans* to enhance "the surface, the fold, the skin."

Such behavior is unmistakably fetishistic in Freudian terms. In a later chapter, I will show that these terms are both fundamental tools for the diagnosis of decadence and also crucial manifestations of it. For the moment I want simply to note that the Nietzschean philosopher-artist acts like the Freudian fetishist, veiling the supposed "fact" of castration so as to maintain a childish fantasy of universal phallic sexuality. And I want to associate Nietzsche's apparent monosexual fantasy with certain homosexual signifiers detectable in his work.[27] Here *The Case of Wagner* is particularly revealing, for Nietzsche's analysis of this man, Wagner, whom he says he loved (EH, 317), whom he identifies as his own illness (CW, 155), and whom he calls

"a seducer on a large scale" (CW, 183), suggests that Wagner was a feminized man. He was, says Nietzsche, "in his old age by all means *feminini generis*" (CW, 191). Thus, to love Wagner was to love the other in the same, to love woman in the transvestized form of a hysterical man. Moreover, Nietzsche argues that Wagner's work itself promotes the collapse of sexual difference. By focusing on the goal of redemption, his operas lure their audience away from the actuality of "the deadly hatred of the sexes" (CW, 159)—well dramatized, Nietzsche argues, by Bizet—toward a single ideal, the Eternal Feminine. Thus Nietzsche declares: "The female Wagnerian—the most charming ambiguity that exists today; she *embodies* the cause of Wagner [die Sache Wagners]—in her sign his cause triumphs" (CW, 185).

This is Wagner's form of *actio in distans:* his *Sache*—his thing—is a function of the sign. And the sign embodied, reified and sexualized, is characterized by fluid and mobile ambiguity. Wagner "is distinguished by every ambiguity, every double sense" (CW, 183). The charm of this ambiguity is that it avoids the *Greuel und Ungedanke* of the castrated body by treating castration theatrically, as an agent of semiotic transformation. Nietzsche condemns this charm as decadent deception and calls Wagner's sexuality "incredibly pathological" (WP, 555). But he also recognizes his immense attraction to this fetishizing pathology, beyond which may lie a homosexual fantasy. It is hard, indeed, in reading Nietzsche's characterization of Wagner, not to agree with Eve Sedgwick that he is, with a degree of consciousness impossible to determine, "tap[ping] into and refresh[ing] the energies of emergent tropes for homosexuality without ever taking a reified homosexuality itself as a subject."[28] Wagner is presented as physiologically false, as "the greatest example of self-violation in the history of art" (CW, 180). This negation of physiological determinism enables Wagner—the actor, the liar, the magician, the hysteric—to overcome sex as a fixed identity and become a kind of gender-mutant, a man *feminini generis.* Nietzsche claims to despise such a loss of those clearcut "natural" differences that stimulate the cruel, egotistic war between the sexes. But underlying this condemnation is a positive valuation: the subversion of sexual difference offers the gain of "soul and

form," an *actio in distans* whereby "the surface, the fold, the skin" becomes an attractive locus for male artists to celebrate "the veils, . . . riddles and iridescent uncertainties" (GS, 38) that obscure repulsive female nature.

Thus we reach the conclusion of my second account of Nietzsche's meditation on decadence. It is not so much a conclusion as a temporary resting place, one provisional perspective subject to replacement. "There is *only* a perspective seeing, *only* a perspective 'knowing,'" Nietzsche writes in *The Genealogy of Morals,* "and the *more* affects we allow to speak about one thing, the *more* eyes, different eyes, we can use to observe one thing, the more complete will our 'concept' of this thing, our 'objectivity' be" (GM, 119). According to this reasoning, the many perspectives I have analyzed from which Nietzsche observed decadence should enable me now to offer an "objective" description of it. Let me briefly rehearse some of the "different eyes" through which Nietzschean *décadence* has appeared in this chapter:

1. Decadence is a natural excretory function of healthy individuals and societies.

2. Decadence is pathological, a sign of weak instincts. It disorganizes and fragments individuals and societies.

3. Decadence is the expression of morality's condemnation of life. "Truth" is decadent.

4. Modernity, exemplified by Wagner, is decadent, as is the majority of mankind.

5. Nietzsche is decadent in (certain of) his own terms because he wages war against decadence rather than extricating himself from it.

6. Decadence is indistinguishable from subjectivity. The body is decadent in the same sense that the subject is unknowable.

7. The experience of decadence is indispensable to the philosopher, whose sensibility is refined by illness.

8. Decadence is a woman, repulsive and unthinkable, except at a distance.

9. Nietzsche is decadent from today's perspective because he defends an aesthetic of superficiality and artifice and because he deploys fetishistic strategies and emergent homosexual tropes.

Can one agree that these perspectives together construct something like an objective picture of decadence? I think not. Reading through this list, one feels bewildered, confused, even exasperated. It is tempting to conclude that Nietzsche, far from being an expert in questions of decadence, couldn't get anything straight on these matters and merely rationalized his intellectual disorder by appealing to a theory of multiple perspectives.

But I have maintained otherwise. I have claimed that he is justified in boasting of his decadent expertise. So, you may well ask, in what do I think his special insight consists? Not in any one of the perspectives I have just enumerated, that much is clear. What Nietzsche teaches me is that decadence is a stimulant that causes a restless movement between perspectives, the goal being the attainment of a position outside decadence that would enable one to judge it as such. Decadence characteristically posits some mode of knowledge, some standard of ethics, some conception of health that would put an end to the slippage among perspectives and permit a clear perception of itself to emerge. We have seen that Nietzsche appeals repeatedly to such normative ideas and that these appeals often seem to betray the most radical and innovative aspects of his philosophy, such as the valorization of becoming, multiplicity, nonknowing. We have also seen that these appeals never succeed conclusively in stabilizing his understanding of decadence.

The perspectives among which that understanding slips are not arbitrary, however. Nietzsche's meditations brilliantly evoke the primary contextual relations put into play by the decadent idea. To name a few: the analogy between biological organisms and societies, the connection between moral standards and instinctual drives, the relation of subjectivity to the body, the link between illness and wisdom, the association of gender to philosophy and aesthetics. Nie-

tzsche shows how all these topics are interconnected, and his name for the force that binds them is decadence. So variable is the referent of this name, however, that it will be of problematic use to us in the rest of this book. I will not be able in subsequent chapters to refer to "Nietzsche's idea of decadence," for that idea is constantly in motion, always elsewhere than in the present of his writing. Moreover, this quality will also be true to a significant degree of my own work. As I suggested in my introduction, I do not propose to offer a totalizing definition of decadence in this book, for I do not believe that any such definition is possible. My chapters are discontinuous, somewhat in the manner of the nine Nietzschean perspectives I summarized above. This discontinuity, I argue, is both what gives decadence its peculiar dynamism and what generates its peculiarly frustrating epistemological irresolution.

Before I move ahead, however, I want to examine briefly how Nietzsche's views were received during the *fin de siècle* period, especially by those writers associated with a sensibility labeled "decadent" at the time. It would be interesting to know which of the nine perspectives I outlined above—and there are more, of course—seemed the most relevant to them. Unfortunately, this question cannot be precisely answered, since Nietzsche's works became available in this period in a rather haphazard manner, and how Nietzsche was read had a lot to do with what was accessible to be read, in translation especially. In France, there was next to no discussion of Nietzsche until late 1892, when excerpts from *Zarathustra* appeared in French in *La revue blanche* and a translation by Daniel Halévy and Robert Dreyfus of *The Case of Wagner* was published.[29] Despite the anti-Wagnerism of the latter book, early interest in Nietzsche came largely from the pro-Wagner camp (represented, for instance, by Téodor de Wyzewa, who, influenced by Lombroso, considered Nietzsche's critique of Wagner to be a self-destructive gesture typical of genius[30]) and, in the 1890–1895 period, from anarchist sympathizers. Not surprisingly, the Nietzsche these people admired was not the advocate of decadence as a necessary experience for creative thought but rather the social ther-

apist, enemy of both egalitarian democracy and socialist idealism. Between 1895 and 1898, articles about Nietzsche appeared in periodicals such as *Mercure de France, La revue des deux mondes,* and *La revue blanche,* often focusing on questions raised by the publication in 1895 of the now largely discredited biography by Nietzsche's sister, Elisabeth Förster-Nietzsche. Despite this book's defense of Nietzsche's health, critics used Nietzsche's own emphasis on physiological decadence to stigmatize him as a degenerate madman and thereby to contain, if not dismiss, the disturbing impact of his thought. This tendency lessened after 1898, when *Zarathustra* and *Beyond Good and Evil* appeared in translation and the intelligent—if overly timid and systematizing—analysis by Henri Lichtenberger, *La philosophie de Nietzsche,* was published. Subsequently, new translations of Nietzsche's works by Henri Albert appeared on a yearly basis and academic studies proliferated.[31]

Lichtenberger's book exemplifies the approach current in France in the late 1890s to the theme of decadence in Nietzsche. On the one hand, he feels the need to defend Nietzsche's philosophy from the accusation that it is the product of a sick, deranged mind; on the other hand, he presents the work as a denunciation of decadence that can serve to revitalize French society. Putting aside the rhetoric of degeneracy as inapplicable to Nietzsche's writings, Lichtenberger interprets Nietzsche as a vigorously affirmative, liberating thinker who shows the way out of Schopenhauerian pessimism, Christian suffering, and moral fatigue. This was also the importance of Nietzsche for the Gide of *Les nourritures terrestres* (1897) and *L'immoraliste* (1902), but Gide found that Lichtenberger had diluted the philosopher's passionate intensity. Nietzsche, Gide wrote in 1898, had "made himself mad" by pushing reason to its extreme limits and exuberantly glorifying life as tragedy.[32] Associating Nietzsche with Dostoyevsky, Gide prepares the way for the existentialist appropriation of Nietzsche. Well before that occurred, however, Nietzsche's thought was appropriated to serve French nationalism: since he frequently contrasted German barbarity to French sophistication, his work could be used to attack his own

country. As the French became more and more alarmed about German militarism, however, Nietzsche was increasingly perceived as an alien after all, and an apologist for Prussian power politics. By the time of the First World War, French intellectuals had ceased to claim him as one of their own. Nietzsche offered the English little reason to make a similar claim, since he called them "the people of consummate cant" (TI, 521) and despised both their philosophy and their music. Yet the English, after a slow start, developed a more subtle understanding of Nietzsche's relation to decadence than did the French. The reasons for the initial hesitancy are more material than intellectual. Although *The Case of Wagner* (published with *Nietzsche contra Wagner, Twilight of the Idols,* and *The Antichrist*) and *Zarathustra* both appeared in English in 1896, the editions were so expensive, poorly distributed, and badly translated that they were little read. Moreover, Nordau's *Degeneration,* published just a year earlier, prejudiced the public against Nietzsche. Various problems interfered with plans for additional translations, and it was not until 1907 that Oscar Levy began to publish a complete works, of which the final volume appeared in 1913.

If, however, Nietzsche's books were mostly inaccessible in the 1890s, English readers did have the benefit of an excellent short introduction to his thought by the extraordinary Havelock Ellis—criminologist, sexologist, literary and cultural critic—published in three installments in the summer of 1896 in the short-lived avant-garde magazine *The Savoy* and subsequently collected in his volume *Affirmations* (1898). Like Lichtenberger, Ellis starts out by defending Nietzsce's psychological health. "It is evident," he writes, "that [Nietzsche] is no frail hectic flame of a degenerating race. There seems to be no trace of insanity or nervous disorder at any point in the family history, as far back as it is possible to go."[33] Having asserted Nietzsche's basic physiological health (on the evidence furnished by Nietzsche's sister's idealizing biography), Ellis goes on to present Nietzsche as "one of the greatest spiritual forces which have appeared since Goethe" (2), praising him as a freethinking individualist dedicated to the joys of self-mastery and the supple dance of the intellect.

What Ellis appreciates about Nietzsche are the qualities of aesthetic decadence that his philosophy displays rather than the overcoming of social decadence that his work advocates. Indeed, he is uneasy with the late Nietzsche's condemnation of the age's moral decline and endorsement of a master morality to be exercised by self-chosen supermen. What this late work lacks for Ellis are the decadent aesthetic qualities he admires in the books of the middle period, such as heterogeneity and the subordination of wholes to their parts (like Nietzsche before him, Ellis had read Bourget). He even responds positively to Nietzsche's claim that these qualities derive from illness, to which, says Ellis, Nietzsche owed "a poignant sensibility, a penetrating impulse to reach the core of things."[34]

Ellis's primarily aesthetic appreciation helped save Nietzsche from the political uses to which his thought was put in France and made his philosophy appealing to many writers associated with the late decadent and symbolist movements in Ireland and England. Ellis's close friend Arthur Symons, editor of *The Savoy,* read Nietzsche in the original and, belying Nietzsche's disparagement of the typical Englishman's lack of musical taste, admired the German's thoughts on music, dance, and rhythm. He also noted, surprisingly, similarities between Nietzsche and Pater and, less surprisingly, between Nietzsche and Blake (the latter interested Yeats as well).[35] George Moore, Vernon Lee, Edward Garnett, James Joyce, George Bernard Shaw, and D. H. Lawrence all came under Nietzsche's influence in the 1900s.[36] In 1903 Yeats read and annotated Thomas Common's proselytizing book of excerpts from Nietzsche's works, *Nietzsche as Critic, Philosopher, Poet, and Prophet* (1901), and from then on Yeats's thought is suffused with Nietzschean themes and ideas (such as the superman, master/slave morality, and the mask). Thus it would appear that Nietzsche was wrong about France being the natural milieu for his *décadence* philosophy to bloom (at least in the *fin de siècle.* The extraordinary resurgence of interest in Nietzsche in France in the 1960s and 1970s is a cultural phenomenon in itself). By reading Nietzsche as a therapist for the nation's malaise, the French failed to see what he valued about illness and were forced to disclaim him when

they perceived that illness in the shape of the Prussian will to power. By reading Nietzsche as an aesthetic decadent, the English were able to assimilate Nietzsche into an established mode of artistic creation, which the stimulation of his ideas helped to keep alive long after its French counterpart had given way to new intellectual trends.

Flaubert's Salammbô: *History in Decadence*

Commenting in 1888, at the end of his productive life, on his youthful essay "On the Uses and Disadvantages of History for Life" (1874), Nietzsche declared proudly: "In this essay the 'historical sense' of which this century is proud was recognized for the first time as a disease, as a typical symptom of decay."[1] This is a characteristically grand claim, justifiable perhaps if one were to substitute for "recognized for the first time" a phrase such as "analyzed extensively for the first time." Well before Nietzsche, Flaubert had recognized that an excess of historical awareness was a burdensome characteristic of nineteenth-century consciousness. Traveling in Egypt in 1850, he wrote back to his friend Louis Bouilhet: "Wretched that we are, we have, I think, a good deal of taste because we are profoundly historical, accept everything, and adopt the point of view of whatever we are judging [nous plaçons au point de vue de la chose pour la juger]." "But," he asks rhetorically, "do we have as much innateness [innéité] as we have comprehensivity? Is a fierce originality even compatible with so much breadth?" (C1, 645).[2] "Excess of history has attacked life's plastic powers,"[3] observes Nietzsche, as if confirming language's worst fears.

When Nietzsche wrote "On the Uses and Disadvantages of His-

tory for Life" at the outset of his career as a philosopher, the idea of *décadence* had not yet attained the central importance to his thinking that it would have in his final years. Yet this 1874 essay can be read as his first extended meditation on this subject. Indeed, its analysis of "historical culture" is particularly useful in explaining how Flaubert's (anti)historical vision in *Salammbô* can be understood as decadent. So I propose now to return to Nietzsche and to add a few more perspectives to our already complex awareness of his multiple viewpoints on decadence. As to my choice of *Salammbô* to exemplify a decadent attitude to history, I hope my analysis will make clear in what sense it is justified. Numerous figures of the *fin de siècle* acknowledged the formative influence of Flaubert's novel. To name a few: Swinburne delighted in the famous scene of what he called a "mystic marriage" between the princess and her sacred black python;[4] the lapidary imagery of Mallarmé's *Hérodiade* is indebted to Flaubert's Carthaginian decor; Huysmans's des Esseintes praises *Salammbô* for its evocation of an exotic era of barbarity and opulence; Gustave Moreau's painting style appears to imitate Flaubert's verbal style in this novel;[5] and so forth. *Salammbô* was a stimulating resource for just about every *fin de siècle* figure who found creative opportunities in the idea of decadence. My argument here is that a certain attitude to history is fundamental to that idea as Flaubert presents it, and I want to argue further that this attitude corresponds precisely to the one Nietzsche accuses of undermining the vitality of his age.

Nietzsche blames what he considers the biological degeneration of the race on an excessive preoccupation with history and the past. "It is possible to value the study of history to such a degree that life becomes stunted and degenerate," he writes (UM, 59). The word "stunted" returns later in a phrase that evokes standard imagery of decadence: those who consider themselves epigones, he says, "live as pale and stunted late descendants of strong races coldly prolonging their lives as antiquarians and gravediggers" (UM, 104). A decadent age, Nietzsche suggests, is one so obsessed with historical culture that this "over saturation" (UM, 83) becomes a "malady" (UM, 120). He lists five consequences of this malady, all of which find expression in

Salammbô. First, a split occurs between subjectivity, made up of a chaotic accumulation of undigested knowledge, and the outside world, to which nothing in the subject corresponds and on which he has no effect. The decadent subject thus becomes a "walking encyclopedia" (UM, 79), incapable of judging one fact as any more or less important than any other. "One goes so far, indeed," Nietzsche observes, "as to believe that he to whom a moment of the past *means nothing at all* is the proper man to describe it" (UM, 93). This confusion of a supposed objectivity, which is really passive indifference, with justice is the second consequence of the historical drive. The third is the disruption of the instincts of a people. They lose faith in the future, in the life-enhancing illusions of love that veil the barbaric mass of facts. Consequently they see themselves as epigones and are convinced that the world is coming to an end. Fifth consequence: the age develops an ironic self-awareness that leads to a cynical denial that anything could be any different than the way it is. Life is dominated by historical science, which uproots and mummifies it.

Nietzsche spends far less time suggesting how to deal with the decadent historicism of his age than he does diagnosing its symptoms. He recommends "the unhistorical and the suprahistorical [as] the natural antidotes to the stifling of life by the historical, by the malady of history" (UM, 121) and offers the following definitions: "With the word 'the unhistorical' I designate the art and power of *forgetting* and of enclosing oneself within a bounded *horizon;* I call 'suprahistorical' the powers which lead the eye away from becoming towards that which bestows upon existence the character of the eternal and stable, towards *art* and *religion*" (UM, 120). Forgetting is necessary in order not to be paralyzed by the infinitude of knowledge and so as to recapture a youthful optimism that limits the horizon of possibilities and focuses energies creatively. Religion and art, about which Nietzsche has little to say here, are the products of a healthy culture that, like the Greek, uses the past to nourish a vital thrust into the future.

There is, of course, more to Nietzsche's essay than this summary suggests. My purpose is not to give a full analysis of the essay or to

critique its positions. Rather I want to focus on what I take to be the center of his interest, the degeneration of historical insight as a lamentable sign of cultural decadence. As I noted earlier, Flaubert intoned a similar lament in 1850, blaming the comprehensive historical sense typical of his age for undermining the sources of original invention. He was still suffering at this time from his friends' condemnation of the first version of *La tentation de saint Antione,* which he had written, so he told Louise Colet, in a lyrical overflow of inspired creativity. But, as I discuss elsewhere, *La tentation* is actually based entirely on printed and graphic sources.[6] Flaubert relied on the resources of the library for almost every detail of this book that he described as the voluptuous overflow of his spontaneous imagination. Thus, already before 1850 he had abandoned the romantic ideal of "fierce originality," whose loss he nevertheless bemoans, in favor of a new kind of inspiration that originates outside himself, in the already said, the already published. Nietzsche calls this reliance on erudition "an idolatry of the factual" (UM, 105) and castigates its decadent retrospection. Flaubert's attitude is more ambivalent. While he recognizes early in his career the decadence of the historical culture of his age, his evolution is toward a progressively more radical aesthetic representation of just that decadence. Notorious for hating his times, Flaubert is in this respect their truest mirror. In 1863, a year after *Salammbô* was published, he declared: "History, history and natural history! those are the two muses of the modern age!" (C3, 353).

"Why do you tell us in your letter that you are working on nothingness?" the Goncourt brothers asked Flaubert in the summer of 1860 while he was in the midst of writing *Salammbô.* "History, my dear friend, is perhaps the real nothingness because it is death" (C3, 1093). The Goncourts contrasted "the autopsy of the past" that they had performed in *Les maitresses de Louis XV,* with its "smell of mummies," to what they imagined to be Flaubert's novelistic project, "to build something that one brings into being on the basis of something that does not exist" (C3, 1093). The novelist creates new life whereas the historian chronicles the death of life, that seems to be the distinction

the Goncourts are proposing. Flaubert's response makes it unclear just how he conceives his book, as a novel or as history. "*Reality* is an almost impossible thing in such a subject," he tells them. "In order to be real, one would have to be obscure, talk about gibberish and stuff the book with notes; and if one sticks to a literary and properly French tone, one becomes banal" (C3, 94, 95). History makes for obscurity, the novel makes for banality. So how will reality be constructed in this book? "The flag of the Doctrine will be frankly carried this time, believe me!" he assures the Goncourts. "Because it [*Salammbô*] does not prove anything, it does not say anything. It is neither historical, nor satirical, nor humorous. On the other hand, perhaps it is stupid?" (C3, 95).

The doctrine Flaubert mentions here refers no doubt to the aesthetic ideas he shared with the Goncourts: authorial impersonality, objectivity of tone, moral neutrality. But his statement is not only the affirmation of an aesthetic. It is also the negation of any context of value and meaning. "Ca ne prouve rien, ça ne dit rien"—*rien,* Flaubert declares, is what his book is about. And perhaps a book that has nothing to say will be considered stupid. Flaubert does not seem to know just what terms are applicable to his project. It is easier for him to declare what the book is not than what it is. Critics often attribute his complaints about the difficulty of his writing, which accompanied all his projects after the first *Tentation,* to his stylistic perfectionism and to his fastidious search for "le mot juste." But this is a minor aspect of the matter. More importantly, Flaubert's torment arises from the fact that his sensibility as a writer and thinker fractures the aesthetic, cultural, and epistemological paradigms of his age. Not only decadence, but also modernism and even postmodernism can be traced back to him.[7] He is a great precursor figure, the most radical exemplar, as Nietzsche saw, of that European nihilism "in which the romantic faith in love and the future is transformed itself into a desire for the nothing, 1830 into 1850."[8] So it is not surprising that he should feel agonizing doubts about his creative enterprise and that he should often lack terms adequate to describe his literary projects.

This inadequacy is particularly apparent in the case of *Salammbô.*

Flaubert began this novel in 1857, the year *Madame Bovary* was published. He often spoke of it as an exotic subject, to which he had turned for relief from the disgusting mediocrity of contemporary life.[9] There is indeed an enormous distance between a little village in Normandy in the first half of the nineteenth century, where everyone knows everyone else and the big event of the day is the arrival of the coach from Rouen, and the North African city of Carthage in 241 B.C. and its brutal conflict with the huge mercenary army it had hired to fight the Romans in the First Punic War. At issue, for Flaubert first of all and for us in his wake, is the meaning of this temporal distance and cultural difference. On the one hand, Flaubert tells the Goncourts that his book is not historical and declares to Sainte-Beuve: "I couldn't care less about archeology" (OCF, 449).[10] On the other hand, in the remarkable responses he wrote to the attack on his scholarship by the archeologist Froehner and to the critique of the novel's historical value by his friend Sainte-Beuve, Flaubert defends the book's documentary veracity at great length and in minute detail. These changing, apparently contradictory perspectives are bewildering. Is Flaubert somehow equating the historical and the unhistorical? My answer is yes, and I argue furthermore that this paradoxical equation is at the encrypted heart of the decadent view of history.

"What does Mr. Flaubert's novel purport to be?" (OCF, 374), Froehner asks near the outset of his negative account of *Salammbô*. "Qu'est-ce que *Salammbô?*" (OCF, 405) echoes another critic, Alcide Dusolier, in a review appearing the same day, January 1, 1863. It is not really a novel, argues Froehner, since it relies too heavily on the account of historical events recorded by Polybius. But then it is not really history since descriptions of local customs and beliefs and of military technology overwhelm the action. Dusolier has trouble with the book as history because, on the one hand, too much is invented and, on the other, Flaubert is not always true to his sources. As to the possibility of the book's being a historical novel, Dusolier maintains, as had Sainte-Beuve earlier, that such a work must be nourished by live written and oral traditions concerning home life, familiar habits, and the like, and that no such traditions exist in the case of Carthage.

Unable to classify the book as a novel, as a work of history, or as a combination of the two, critics have searched for other descriptive terms: Sainte-Beuve calls it a prose poem (OCF, 412), Théophile Gautier an epic poem (OCF, 455). More recently Michel Butor has discussed the novel as science fiction.[11] And the sci-fi comic strip artist Philippe Druillet has illustrated three wildly fantastic albums with the story of how his alter-ego, Lone Sloane, travels through space to Carthage where he is metamorphosed into Flaubert's hero, Mâtho, and relives Mâtho's perilous adventures in extravagantly visualized scenarios.

My point is that readers of *Salammbô,* whether its author's contemporaries or ours, are uncertain how to make sense of Flaubert's book in a way that reflects his own uncertainty as to the novel's meaning, or meaninglessness.[12] One might have thought that Flaubert's lengthy answers to the critiques of Froehner and Sainte-Beuve would have clarified his goals. But the amazing thing about these texts is that they manage to leave all the important questions unanswered. They seem more like a continuation of the book's puzzle than a solution to it.

Most puzzling is that Flaubert's primary concern in his defense is that it not be thought that he invented anything. No sooner has he claimed, in response to Froehner, that his book is a novel, presented without preface or notes, than he begins what amounts to the creation of just such notes, giving precise bibliographic references in support of just about every detail whose accuracy Froehner has contested. Indeed, even before writing his response, he had prepared thirty-five pages of notes documenting his sources, only a small part of which he actually used in answering his critics (see OCF, 489–509). Detail by detail, point by point, Flaubert sets out to prove that even the most unbelievable things in his story are not the products of his creative imagination. Carbuncles formed by lynx urine? They are in Theophrastus. Bitch's milk is mentioned as an ancient treatment for leprosy in the *Dictionnaire des sciences médicales;* the Carthaginian custom of mutilating the corpses of their enemies is documented by Hendrich (*Carthago, seu Carth. respublica,* 1664); the

11,396 soldiers in Hamilcar's army is "tout bonnement" the addition of the number of men in the different corps "and not a number thrown out by chance to create an effect of precision" (OCF, 447); Tanit's veil is minutely described in Athenius 12, 50, where one learns that "it was bought for 120 talents from Denys the Old, carried to Rome by Scipio Emilius, brought back to Carthage by Caius Gracchus, returned to Rome under Heliogabalus, then sold to Carthage" (OCF, 391). Pliny tells of crucified lions, Herodotus of Lydians wearing women's dresses, Corippus (see *Johannes* and *Mém. de l'Académie des Inscript.,* vol. 12, 181) of a god called Mastiman. And so forth, and so on.

The debate with Froehner reaches its scholarly paroxysm over whether or not the statue of Moloch had seven compartments stacked one above the other to accommodate the god's victims. Froehner says this construction did not exist in Carthage but was a feature of religious practices in Gaul. Flaubert retorts that Diodorus (book 20, chapter 4) describes just such a statue in Carthage and gives as further evidence "the chaldaic paraphrase of Paul Fage, whom you don't mention and who is cited by Selden, *De diis syriis,* pp. 164–70, with Eusebius, *Préparation évangélique,* book one" (OCF, 391). Froehner rises sublimely to this new challenge. First, he quotes the very passage in Diodorus cited by Flaubert to show that it describes a statue of Saturn, not of Moloch, and that it does not mention any superimposed compartments. Then he ingeniously traces the origin of Paul Fage, apparently a Frenchman, of whom Flaubert makes the astonishing claim that he wrote in Chaldean. Flourishing his erudition like a saber, Froehner evokes a Protestant theologian of the sixteenth century named Paul Buchlein, whose German name means "little beech tree" and who was therefore called Fagius in Latin. This Paul Fagius was the translator of a certain Rabbi Simeon, who wrote in Chaldean. He—that is, the Jew Simeon—was the one responsible for inventing the seven compartments, declares Froehner in pedantic exultation. What's more, Simeon's deception was duly noted by the very Selden to whom Flaubert refers! In the face of this intimidating display, Flaubert still refuses to concede defeat. Armed

with sarcasm, he admits to "a *very* serious error" in his citation of Diodorus: Froehner should read chapter 19 of book 20 rather than chapter 4. Moreover, he should check the mythology of Dr. Jacobi, page 322 in the Bernard translation, "where he will see once again the seven compartments that so incense him" (OCF, 401).

What is going on here? What is the meaning of Flaubert's almost hysterical textual positivism? "Be assured that I did not create a fantastic Carthage," he tells Sainte-Beuve. "Documents on Carthage exist" (OCF, 451). The implication is that fantasy and document are mutually exclusive. Does this mean that no authentic document could be the fabrication of falsifying fantasy? Froehner's point is that precisely such a falsification took place in the case of the seven compartments. The pedantic archeologist has a sense of the relative reliability of different sources, whereas the scholarly novelist—and this realization dawns on the reader of his responses, overwhelmed by details, only gradually—has none. It is sufficient that Flaubert find a detail in an author of antiquity, in a "document," for him to accept it as true. At no point does he refer to an epistemological framework that would allow him to determine the value of a particular document for historical understanding.

Froehner and Sainte-Beuve both complain that Flaubert's attitude is not historical. They find something perverse in his taste for the bizarre debris of history at the expense of any vision of historical causality and evolution. The Carthaginians' war against their mercenary army, Sainte-Beuve complains, is an event in history that had no impact on history. Disconnected from the narrative at the end of which we find ourselves, the story of this brutal conflict tells us nothing about how we got where we are. "Why should I be interested in this lost war, buried in the mountain passes or the sands of Africa?" he protests (OCF, 437). Had Flaubert chosen to dramatize the duel between Carthage and Rome, then Sainte-Beuve would have felt engaged, for on the outcome of that war depended the future of European civilization. But there is no "live communication and reverberation" (OCF, 437) between the modern period and Carthage in 241 B.C. No "human sympathy" (OCF, 437) links us to the fate of this

temporally and spatially removed people. Flaubert's jaded sensibility is characteristic of "the end of every literature" (OCF, 440), Sainte-Beuve concludes, and his style is comparable to that of "the writers of the classic Roman decadence" (OCF, 441).

For Sainte-Beuve, being situated at a cultural end point is signaled by a failure to understand historical process. And he associates this failure with decadence. His Romantic perspective is echoed in our century by the materialist critique of the philosopher Georg Lukács, who accuses Flaubert of failing to understand "the real driving forces of history as they objectively worked"[13] and of transforming history from a means of dramatizing social and economic contradictions into "a collection of exotic anecdotes" (182). The appeal of this exoticism, Lukács argues, motivated Flaubert in his choice of a historical subject that would have no connection with the modern bourgeois society that he so passionately hated. But, notes Lukács in a perception that goes well beyond Sainte-Beuve's insights, "this lack of connection—or rather the illusion of such—is at the same time the subjective factor which connects Flaubert's exotic historical subject matter with the everyday life of the present" (185). Here Lukács is linking the disconnected meaninglessness of Flaubert's historical subject in *Salammbô* with the disconnected impersonality and disinterestedness of the authorial attitude Flaubert wished to assume in *Madame Bovary*. Since Lukács considers this wish a reflection of Flaubert's regrettable detachment from the material processes of historical change, he has little sympathy for it. Reading Flaubert against Flaubert, he attributes the greater success of *Madame Bovary* to the author's failure to remain distant and impersonal.

However, what Lukács interprets as a failure of historical vision may rather be an assertion that history lacks vision. What he sees as the decadence of historical fiction may be a fiction generated by history's decadence. Flaubert feels himself to be at an end—which he variously describes as that of nineteenth-century France, of the Latin race, even of the world—but he associates this ending not with a poverty of history but with its excess. Flaubert's conception of what it means to be historical destroys history as a mode of insight and un-

derstanding. To be historical, he says, is to *lose* any elevated perspective, any spatial or temporal distance from events and persons, and to adopt an entirely contingent point of view, "le point de vue de la chose." History for Flaubert is no more than its objects and exists nowhere else than in its objects.[14]

He dramatized this insight in the episode of his last novel when, in search of "truth for its own sake,"[15] the two retired copy clerks, Bouvard and Pécuchet, undertake a study of history. Echoing their creator's own opinion, they discover that history has always been written from a biased perspective, in support of one cause or another. Furthermore, they observe that, even when a historian makes a real effort to be disinterested, he still has to make choices, since everything cannot be said, and these choices distort the truth: "A certain attitude will dominate, and since it will vary depending on the circumstances of the writer, history will never be fixed" (BP, 192). The only way to "fix" it, Flaubert implies, is to abandon any attempt to interpret it as a meaningful narrative that tells the truth.

This is precisely the perspective Nietzsche ascribes to decadent historicism, which divorces history from the interpreter's desire and kills its vital role in the service of life. He remarks: "A historical phenomenon, known clearly and completely and resolved into a phenomenon of knowledge, is, for him who has perceived it, dead" (UM, 67). Flaubert's documentary positivism is actually a form of historical nihilism. The documents on Carthage *exist,* he insists. He does not claim that they are significant, that they add up to a coherent picture, that they make sense. Quite the opposite.[16] No document is more historical for Flaubert than the one that successfully resists any recuperation within a paradigm of understanding. The historical detail he is most enthusiastic about is likely to be the most difficult to assimilate, the most outrageous and incomprehensible, the most wounding to the reader's presumed wish to believe in a fundamental humanism linking past and present, and the most disruptive of the reader's desire for narrative movement. Exemplary is his delight in the "beautiful details I find in *Arab Hygiene* by Dr. Bertherand. Cataplasms of grasshoppers, venom of crow, etc. To induce labor, big women climb

onto the pregnant woman's stomach and stamp their feet. To promote fertility, lion's hair is burnt under the women's noses and they swallow filth from inside the ears of asses, etc.!" (C3, 114). *Salammbô* is crammed full of such details, for all of which Flaubert could presumably name his source. They are morcellized evidence of the *néant* of history. Heterogeneous in their origin, they become homogenized by their completely dispassionate, detached treatment in Flaubert's text.

This treatment is a function of what Flaubert, in his quaintly old-fashioned aesthetic vocabulary, calls "taste." Taste applies "la Doctrine" to the world and thereby neutralizes its signifying capacity: it neither proves nor says anything. This is the world as found in the library and the museum. These institutions are for Flaubert the very opposite of agencies of knowledge and learning. They are custodians of the meaningless results of the innumerable human efforts to create meaning. They offer documents, duly cataloged and labeled, not insights useful for the future direction of mankind. The man of taste, who "accepts everything," is a collector of these documents, a "walking encyclopedia" in Nietzsche's phrase. He has no dominant perspective that would allow epistemological or moral discrimination between textualized things.[17] As against Flaubert's recommendation that the writer have "sympathy for everything and for everyone, so as to be able to understand and describe them" (C2, 786), Nietzsche remarks critically: "To take everything objectively, to grow angry at nothing, to love nothing, to understand everything, how soft and pliable that makes one" (UM, 105). Flaubert, Nietzsche remarked toward the end of his career, can be seen as "a new edition of Pascal" because his selflessness is actually "the principle of *décadence,* the will to the end, in art as well as in morals."[18]

The self-abnegating man of taste wanders myopically in mediocrity, seeing only "le point de vue de la chose *déjà écrite.*" As Eugenio Donato puts it, he is "doomed to remain in the fog of undifferentiation, in a middle ground which subverts aim, direction, and ultimately life."[19] Detached neutrality on a stupefying middle ground—this is the domain of decadence, which could be defined as a historical moment incapable of reading itself from a historically sig-

nificant perspective. But here a fundamental paradox emerges: decadence can only be evaluated as such from a perspective that grants meaning to the historical process. As soon as Flaubert begins to explain the contemporary dilemma, he adopts a viewpoint that his conception of that dilemma renders illusory. He imagines the evolution of his own creativity as recapitulating the decadence of artistic culture since the Greeks. "What makes the figures of antiquity so beautiful is that they were original," he writes to Louise Colet in 1852, "To derive only from oneself, that is everything. How much study one has to undertake nowadays to free oneself from books! And so many have to be read! One has to drink oceans and repiss them" (C2, 86). Flaubert's point is not that repissing books is a purgative release that will promote original creativity in its wake. Rather, he is describing erudite *repissage* as the very stuff of contemporary creativity, "since naiveté is a chimera in our time" (C2, 152). Thus he judges his historicism historically. By projecting a Romantic ideal of the demiurgic imagination onto the past, he creates a temporal spectrum whose poles are imagination and taste. Typical is a letter of 1857: "The more experience I gain in my art, the more that art becomes a torture for me: the imagination remains at a standstill and taste grows. That's the trouble" (C2, 773).

More precisely, the trouble is that the man of taste, whom Nietzsche calls a "historical virtuoso" (UM, 89), cannot satisfy his taste in the present without finding that present lacking in relation to the past. This *prise-de-conscience* of the decadent sensibility is strongly masochistic in character. Nothing is more typical of Flaubert's letters during the composition of *Salammbô* than the way his boasts about the number of learned books he has read are accompanied by complaints about his method being a miserably inadequate substitute for original imagination. "The study of appearances makes us forget the soul," he tells Ernest Feydeau in July 1857. "I would give the half ream of notes I have written in the last five months, and the 98 volumes I have read, to be, for only three seconds, *really* caught up by the passion of my heroes" (C2, 749). Why, then, we may well ask, doesn't he stop reading for a while and give himself over to creative fantasy? But

no, his reflection about forgetting the soul does not cause him to abandon his obsessive scholarship and stop cramming himself with books, ever more volumes in preparation for each chapter. It often seems that he intentionally thickens the fog of printed signs around him, as if he were inviting ever more punishment. For example, with nine chapters completed and six more to go, he tells Feydeau in September 1860, "As my readings continue to increase, so, of course, do the difficulties" (C3, 115). Hardly a matter of course, one reflects. One would expect Flaubert's consultation of scholarly sources to resolve difficulties rather than increase them—otherwise, why continue reading? But Flaubert never stops, even when what he reads makes little sense to him. Here is a typical complaint: "I am lost among the war machines, the ballista and the scorpions, and neither I nor anyone else understands a thing about them. People have talked on the subject without saying anything clear. To give you an idea of the little preparatory work required by certain passages, since yesterday I have read 60 pages (in folio and in two columns) of *Poliorcétique* by Juste Lipse. There you have it" (C3, 166).

The library is not a source of meaning for Flaubert but rather the welcome locus of meaning's painful disintegration and dissemination. The more Flaubert reads, the more difficulties emerge and the less understanding is possible. Thus, as *Salammbô* nears completion, he repeatedly declares himself "full of doubts, about the whole, about the general plan" (C3, 165). He is afraid, he says, "that there are too many soldiers and that the perpetual military scenes will bore the reader to death" (C3, 167–68). But, he notes in self-defense, "that is history, I realize" (C3, 166). History, thus, is a kind of senseless excess that obstructs the flow of narrative by putting too many insignificant pieces, too many soldierly atoms, onto the literary field. Exemplary in this regard is Flaubert's observation about chapter 9, in which Hamilcar and the mercenaries chase each other around the countryside, that its pages are "stuffed with events, despite which the novel, the *story,* barely advances. The same situation drags on eternally" (C3, 113–14). This is history as written at the end of history, when cumulative repetition has disabled narrative progression and storied differ-

ences have collapsed into uniform mediocrity. This is history written from the point of view of its decadence, masochistically.

Clearly, Flaubert does not follow Nietzsche's prescription to "resolve the problem of history" (UM, 103). Rather than practice forgetting, he (re)collects what has been forgotten. He is no passive antiquarian, however. Flaubert is a rebel, not in the cause of life, as Nietzsche would have him be, but rather in the service of the "settling of accounts with [life]" (UM, 67) that Nietzsche considers an injurious consequence of history's reign. Flaubert rebels against the present not by clearing a path for the future but by filling the present with the past, thereby dissolving the difference between the two. Thus Donato is right to remark that "Carthage, the Punic Wars, and the revolt of the mercenaries do not offer Flaubert a historical reality different from his perception of his own, but, on the contrary, one which is remarkably similar" (44).

The similarity, however, is not historically meaningful. Anne Green, in her book on *Salammbô,* perceptively notes how many issues of contemporary concern are raised in Flaubert's portrayal of Carthage: the widespread sense that France was in a period of decadence ("Call it a period of transition, of decadence," is Flaubert's commonplace advice in *The Dictionary of Received Ideas*—BP, 513); the condemnation of Paris as both morally corrupt and physically diseased (the analogy with the degeneration of Carthage was frequently made); the perceived disorder in contemporary social organization; the problems of colonization, slavery, and race. It is even possible, as Green argues, that Flaubert may have seen certain political and economic parallels between the revolution of 1848 and its aftermath, and the mercenaries' rebellion against Carthage. But, as Green herself admits in her conclusion, to perceive these parallels does not really help explain the novel, because they are overshadowed by "wider issues about the relationship between past and present, between history and fiction—and, ultimately, about how we make sense of experience."[20] From this broader perspective, whatever analogies there may be between Paris around 1860 and Carthage around 240 B.C. find their common ground, as Lukács perceived, in the failure to

be historically significant.[21] This failure is enacted in the many battle scenes described in *Salammbô*. Nothing is more typical of these scenes than the way differences collapse between the disputing opponents, supposedly civilized Carthaginians and supposedly savage barbarians, leaving a monumental mass of mutilated body parts.[22] The following passage describes "a confused pile of corpses [that] covered the entire mountain, from top to bottom":

> Breastplates, pitchforks, bugles, pieces of wood, iron, and bronze, wheat, straw, and clothes were strewn amongst the corpses; here and there some nearly extinguished phallaric burned against a heap of baggage; in certain places, the ground disappeared beneath shields; the decaying carcasses of horses lay one after another like a series of little mounds; one could see legs, sandals, arms, coats of mail, and helmeted heads, kept in place by their chin straps and rolling around like balls; scalps hung on thorns; in pools of blood, disemboweled elephants lay in their death throes, still carrying their towers; there were sticky things underfoot and muddy patches, though it had not rained.[23]

This surreal landscape is reminiscent of a painting by Hieronymus Bosch. Disparate objects, material and manufactured, have equal phenomenal status on the field of death with heads, legs, and arms. The heterogeneous is homogenized; the human is objectified. It hardly matters that the corpses in this instance are those of barbarians: similar passages describe the morbid results of Carthaginian defeats. Indifferently Carthaginian or barbarian, the dismembered body emblematizes the absence of historical direction at the end of history. In one particularly gruesome episode, Flaubert imagines a kind of macabre allegory of the murderous operation of his writing. The projectiles the barbarians shoot over the walls with slingshots leave insulting epithets imprinted into the flesh of their victims, "and sometimes jokes: 'caught!' or 'I deserved it'" (S, 249).

But bodies need not be dead for the dehumanizing effects of Flaubert's descriptions to take their toll. Emblematic of the relative indifference between life and death are the corpses so tightly squeezed in a crowd of soldiers that they remain upright and, with glazed eyes

and heads swaying like bears, are carried along with the action (S, 252). Similarly, one could say that the majority of human subjects in Flaubert's novel are carried along by the flow of objects to which they are assimilated. Take, for instance, the description of the Negroes who join the barbarian army from deep within Africa: "Despite their ornaments of red wood, the dirt on their black skin made them look like blackberries that have been rolling about in the dust. They had loin cloths of bark threads, tunics of dried grass, the muzzles of wild beasts on their heads, and, howling like wolves, they shook rods fitted with rings and brandished cows' tails at the end of a stick as standards" (S, 233). The human here is merely a vehicle for the proliferation of the nonhuman. Black skin becomes just one material surface among many others—the least visible, indeed, because it is covered first with dirt and then with clothing and ornaments. The metaphor comparing the Negroes' howl to that of a wolf equates the black warriors with the bestial muzzles they wear as headgear. Race interests Flaubert not as an intriguing aspect of subjectivity but as a stimulus for generating wonderful-sounding names and exotic cultural practices and artifacts. The following passage is typical: "There were Ammonians, with limbs wrinkled by the water from hot springs; Atarantes, who curse the sun; Troglodytes, who bury their dead with laughter beneath the branches of trees; and the hideous Anseans, who eat locusts; Achyrmachides, who eat lice; and Gysantes, painted with vermilion, who eat monkeys" (S, 232). Nominal identities here are equated, as in an encyclopedia, with certain attributes or behaviors. No access is offered to a subjective inner world.

Flaubert's perception is that the subject at the end of history has no history. This perception affects first of all the collective subjects whose conflict is at the book's narrative center. Although their confrontation is motivated at the outset by a grievance—the mercenaries' claim to unpaid wages—this complaint is soon forgotten, and the motive of opposition on both sides becomes the pure desire to oppose and dominate. Neither side has any kind of moral project or political vision. The reader quickly loses sight of what is at issue in this bloody conflict. The disputing opposites, as in *Bouvard and Pécuchet,*

are entirely structural. The violence of their clash does not produce a meaningful distinction between civilization and savagery, culture and nature, or any other dualism. Instead, the confrontation turns into a duplication of the same, and barbarism is revealed to be an attribute projected onto the other to create the illusion of differential superiority. Traditionally, history tells the story of these projections as if they were evidence of a progressive civilizing process, a repeated overcoming of decadent regression. *Salammbô* subverts this narrative by exposing the operation of the projective mechanism and demonstrating the arbitrariness of the distinctions it produces. What is left is the pure principle of conflict, voided of any motivating desires.[24] At the end of history, history is revealed as the violent destruction of subjectivity. This is why we don't care who wins, Carthaginians or barbarians. No subjective claim has been made on us by either side. Flaubert is like one of those "artists in history" of whom Nietzsche writes that they make us into strolling spectators at a world exhibition, transforming even wars and revolutions into aesthetic delicacies (UM, 83).[25]

What, then, of the star-crossed lovers, Mâtho and Salammbô, whose story provides the romantic motor of the plot? It is not surprising that readers, bewildered and demoralized by the deadening descriptions of sieges and battles, should look to these figures for what one might call subjective relief. But their desire is disappointed. Mâtho is the prototype of the lovesick warrior. His passionate attachment to Salammbô is a given from scene 1. The narrator offers no insight into his character. Once he has possessed his beloved,[26] he babbles away in dreamy romantic clichés, declares himself willing to abandon his career for love, sobs like a child, and falls asleep stupidly happy—never suspecting, apparently, that a woman who has given herself to him could still have the destructive purpose he rightly ascribed to her before her surrender: "Ah, you came to take the *zaïmph*, to defeat me, then disappear!" (S, 210).

Salammbô's reaction to the loss of her virginity is hardly more complex. She blushes when she realizes that her chainlet is broken; she reflects that "an abyss" has come between her and her past; she

observes Mâtho sleeping, is tempted by the sight of a nearby dagger to kill him but drops the weapon when the unsuspecting victim stirs; after Mâtho leaves for battle, she picks up the famous *zaïmph,* the veil of the goddess Tanit that has been ravished from the temple by Mâtho and that she has yearned to see and touch, and is surprised "not to feel the happiness she had once imagined" (S, 213). That's all we ever learn of Salammbô's response to an absolutely momentous event that, were she a psychological subject, would have had to produce intensely conflicting feelings and agonizing soul-searching. Flaubert explains to Sainte-Beuve that, unlike Madame Bovary, who experiences "numerous passions," Salammbô "is immobilized by a fixed idea. She's a maniac, a kind of saint Theresa" (OCF, 444). But maniacs are not empty subjects. They are passionate in their fixation. Salammbô's emotions, in contrast, are barely given expression in Flaubert's text. This is not due to some failure of aesthetic judgment on his part. His admission to Sainte-Beuve that one hundred more pages should have been dedicated only to Salammbô (OCF, 450) is an ingenuous pose. He could have written those pages had he wanted to. He didn't because what is important about Salammbô is how little her desire counts in this book that bears her name. She is a vehicle for a spectacular cover-up, disappearing beneath the decorative splendor of her adornment, which is of greater complexity than her motivation.

This very disappearance, however, might seem to invite a psychological reading. Is not the following a striking instance of woman's function as fetish object: "Mâtho did not hear; he was gazing at her, and for him her clothes were fused with her body. The shimmer of the fabrics, like the splendor of her skin, was something special, peculiar to her alone. Her eyes and diamonds sparkled; the polish of her finger-nails was a continuation of the fine jewels that bedecked her fingers" (S, 207). Who is the fetishizing subject here? The gaze is Mâtho's, but the barbarian leader does not have enough psychological complexity for it to make sense to call him a fetishist. Besides, the process by which body parts fuse with things and the human becomes indistinguishable from the nonhuman pervades the text so generally that it cannot be identified as the perverse behavior of any

one of its protagonists. Thus the entire text comes to seem symptomatic, and the reader, unable to diagnose the symptoms in function of character portrayal, is inclined to attribute them to an imagined author.

"Flaubert's fetishism is hardly news,"[27] remarks Naomi Schor just after she has drawn a parallel between Mâtho's fascinated contemplation of Salammbô's earrings, from which drops of perfume fall, and Freud's example of the fetishist who exalts a shine on the nose. For Schor, Mâtho's fascination becomes a symptom of his creator's neurotic psychology, and the chainlet binding Salammbô's ankles—whose rupture, she insists, is of indeterminate meaning—becomes the symptomatic text's exemplary fetish object. What Schor calls the ornamentalized surface of Flaubert's text, its display of innumerable details whose relative importance the reader is unable to ascertain, thus acquires in her reading a fundamentally psycho-sexual etiology.

Now, I have no trouble agreeing with Schor that Flaubert was a fetishist—any number of passages in the letters and novels attest to this. Moreover, the portrayal of Salammbô bedecked with jewels and in rigidly hierarchical attitudes is unquestionably fetishistic.[28] I can even agree that scenes when a dreaded female energy is released could be connected to a fetishistic regime as the expression of what it fails to control. My problem with Schor's reading is that its use of a psychoanalytic model inscribes subjectivity where Flaubert has evacuated it. Mâtho gains more psychology than he has by being adduced as evidence of Flaubert's fetishistic pleasure in decorating the female body. More striking yet, Salammbô gains more desire than she has by being adduced as evidence of Flaubert's unbinding of female energy. In Schor's view, Salammbô's death is not only a punishment for having violated a taboo, but also a highly motivated act of subjective agency. By keeling over dead at the very moment of her wedding to Narr'Havas, Salammbô, Schor writes, "subverts the patriarchal order [by] refusing to play the role of object of value and exchange assigned by her father and the phallo-theocracy he represents" (125). As evidence of this refusal, Schor points to the chance loosening of Salammbô's hair as she collapses, an event that has nothing to do with Salammbô's desire but

that the critic singles out for interpretation in function, I would say, of her desire.

My point is not so much to critique Schor as to use her reading to demonstrate how hard it is not to instill subjectivity into this text that offers only detached phenomena.[29] The psychological subject at the end of history is torn to pieces, like Mâtho's flesh by the people of Carthage. The famous last sentence of Flaubert's text, "Ainsi mourut la fille d'Hamilcar pour avoir touché au manteau de Tanit" [Thus died Hamilcar's daughter for having touched the veil of Tanit] (S, 311), makes a mockery of all systems of explanation. Psychology is irrelevant—the princess does not die because she loves Mâtho and has just witnessed his flesh ripped from his bones and his heart cut out (indeed we never know just what Salammbô's feelings for Mâtho are). Is Flaubert's point, then, that cosmic forces preside over human events and that myth and religion can explain history? But the reader of this book has been confronted with almost as many mythical and religious beliefs as corpses on battlefields. Why should the particular taboo Salammbô has violated, touching the sacred veil of the goddess Tanit, be chosen for enforcement by cosmic powers? Mâtho, after all, is guilty of the same transgression, but his death at the hands of the barbarous Carthaginians is not attributed to this offense. Perhaps Salammbô's punishment reflects a bond between paternal law and mythical powers. After all, the princess is referred to in the concluding sentence as "Hamilcar's daughter." But then a point brought out by Naomi Schor comes into play: Salammbô's death actually removes her from the patriarchal order in which she was serving as an object of exchange in marriage. If Hamilcar's symbolic role is defeated at the very moment of its apparent assertion, what can be the value of the causal logic linking its authority to a higher order of meaning?

Flaubert's last sentence pulls apart the framework of identifications he used in constructing his story, Mâtho as the sun-god Moloch, Salammbô as the moon-goddess Tanit. The sentence implicitly refers to that structure, making it seem as if the cause of Salammbô's death might be understood in function of this larger framework. But this function fails to operate, and the sentence's

causality remains unconnected to any totalizing rationale. This is why it is so often remembered by readers: it teases them with the illusion of resolution while stubbornly blocking access to it. It is a "sentence-thing," causality reified and become a verbal phenomenon. One might call it a verbal fetish, in the sense that it is a textual fragment that appears to have special power to release a world of meaning. But the fetish fails in its magical task, returning the frustrated reader to the brute materiality of the verbal signifiers. Love and religion, the two forces that Nietzsche extols for their ability to create illusions that sustain life, are emptied of their vital drive and reduced to verbal ornaments on the page.

This analysis helps to explain why the psychoanalytic model of fetishism, with its basis in sexual history and the theorization of gender, is inadequate to account for Flaubert's artistic practice in *Salammbô*. It is not only woman as imagined totality that is obscured by an ornate cover-up but also every other mode of totalization to which the text both invites and blocks access: causality, subjectivity, history, the Orient, to name only the most tantalizing illusions. Flaubert's text is saturated with particulars, be they body parts, bits of motivation, fragments of causal explanation, pieces of romantic rhetoric, lists of exotic practices, enumerations of precious stones, or names of war machines. All these particulars encrust the surface of the text, which can be called ornamental only if one abandons the usual aesthetic standards implied by this term. For Flaubert, a decomposing corpse can be just as ornamental as a sparkling necklace. What is important for him is not the intrinsic value of the object but the perspective from which that value disappears. "Prose should hold itself upright from one end to the other," he told Louise Colet in 1853, "like a wall whose ornamentation goes down to its foundations, and in perspective it should form one great unified line" (C2, 373).

I have associated this perspective with decadence, decadence understood in Flaubert's radically nihilistic manner as the equalization of everything.[30] But simultaneously I have remarked that this equalization undoes the idea of decadence, which appeals to a standard of meaning that establishes significant differences. This paradox gener-

ates multiple interpretive difficulties. In this chapter, for instance, I have defined decadence both in terms of its inability to read itself historically and in terms of its inability not to offer such a reading. Decadence appears on the one hand to erode meaning, on the other to insist on its value and relevance. Aesthetically and politically, the first tendency is modern, disruptive, experimental, whereas the second is conservative and nostalgic. It is tempting to give one of these perspectives precedence over the other—hence my use in chapter 1 of the term "betrayal" to describe Nietzsche's appeal to a biomoral standard. But to be true to the irritating irresolution of the decadent idea one must, I believe, recognize the equal force of its contradictory tendencies.

Decadent Naturalism/ Naturalist Decadence

Imagine this: a great surge of vegetation is breaking through rocky soil. An army of insects is emerging from cracks in the plaster. Swarms of termites are attacking the foundations. Vines are climbing the walls and pushing in between stones, loosening them. A giant tree is shooting branches through broken window panes. Everywhere the warm sunlight promotes growth, fertility, generation. In the barnyard, chicks are hatching by the dozens, rabbits are proliferating, animal life is pullulating, noisily, with a great stench of fermenting bacteria and decomposing manure. The peasant farmers have grown up from the soil just like the plants, sucking life from the rocks, then seeming to fornicate with the earth to provide food for new life. They have married each other in incestuous unions, multiplying promiscuously like a herd of animals. All of life is in movement, in heat, close to explosion, filling up empty space, generating ever-new growth, responding exuberantly to the sun's gift of energy, pressing against all limits.

Do you feel exhilarated by this evocation of nature's fervent energy? Perhaps not. After all, one of the limits that gives way under the pressure of life's effervescence is very dear to you and me—our particular individuality, our embodied ego. Nature cares nothing for that

individuality and its desire to endure. Death is nature's gift to the fermentation of life. The corpse of one being feeds the life of another. Decomposing animal flesh promotes the growth of vegetation, which nourishes more animal life. Death annihilates life in order to make room for more life. Death consumes life's excess so that life can continue to reproduce itself, profusely squandering its resources. My particular existence is of no importance to the rampant fertility of life in general. From this perspective, the certainty of my death, rather than defining the meaning of my life as a conscious creation, shows rather that my life has no meaning apart from its biological function. My self has no distinctive identity: I am merely an instrument of nature's luxuriant productivity and impersonal violence.

Such thoughts are enough to give me nausea, like what I might feel in picking up a large stone and finding hundreds of wriggling, slimy, slithering creatures underneath. I am disgusted with the almost undifferentiated plethora of life. So many of them, and always more coming, and only one of me! Insofar as I am like these creatures, insofar as I am continuous with nature, I am not unique. I am like a worm under a rock, part of the endless, sickening process of generation. To cure my nausea, I need to insist on what differentiates me from the natural world. I can begin by invoking the prohibitions that found the order of human society, since they all work against nature: the taboo against incest, the restraint placed on sexual freedom, the law against murder, the rites of burial that veil the horror of a decomposing corpse. But these interdictions are too generally applicable to mankind to serve as a defense against my demeaning naturalization. I need more radical medicine. I fantasize removing myself entirely from the sexual function. I fantasize refusing the nutritional needs of my organism so that, at my death, I will offer ravenous nature a fleshless corpse that will feed no new life.

But these alternatives, castration and suicide, are not real solutions to my problem. They fail to give my individuality what I most desire, the experience of my death as a duration in life. I will explain. One way of understanding the nausea I am feeling is that it arises from my sense that I cannot die. My death is not my own; it belongs to the

general economy of life. I am, as it were, betrayed and abandoned by my own death. My end fails to give significant shape to my life; my life seems like a directionless expenditure of energy. So my task, if I wish to cure myself of nausea, is to gain control over my death, to wrench it away from nature. I have to be able to use death as a creative principle whereby I make my life my own. Rather than allowing nature's violence to absorb me into its incessantly productive cycle, I work to restrain that violence within limits of my own making. In this manner I frame my death. A dangerous proposition, for if I am caught inside that frame I may indeed die. The trick is to be at once inside and outside the experimental form containing my death.

This impressionistic scenario brings together elements inspired by Zola's novel of 1875, *La faute de l'abbé Mouret* (*The Sin of Father Mouret*), with fragments of the analysis of general and restricted economies made by Georges Bataille in *La part maudite* (*The Accursed Share*) and *L'érotisme* (*Eroticism and the Taboo*), and an interpretation of decadent methods and purposes inspired by Huysmans's novel *A rebours* (*Against Nature*). My goal in introducing this chapter in this manner is to suggest the intimate connection between certain fundamental premises of naturalism and certain strategies of decadent creativity. In French literary history, critics often present decadence as the antithesis of naturalism, subscribing to Huysmans's claim, in the preface he wrote twenty years after the book's 1884 publication, that *A rebours* made a complete rupture with its naturalist precedents. But the situation is considerably more complex than that.[1] Most naturalist texts include, or perhaps I should say produce, decadent moments, whereas the sense of natural process that subtends most decadent texts is entirely naturalistic in character. It is as if each attitude, style, approach—however one may wish to designate naturalism and decadence—acted like the unconscious of the other. To trace this mutual imbrication requires a close analysis of the imagery, psychology, and formal structures of particular works. I have chosen four novels for analysis, Zola's *La faute de l'abbé Mouret,* J.-K. Huysmans's *En rade,* Thomas Hardy's *Tess of the d'Urbervilles,* and Octave Mirbeau's *Le jardin des supplices.*

To think about naturalism in France is to evoke the name of Emile Zola, the founder of the school that called itself naturalist, the theoretician of the movement's goals and methods, and the man whose great work—the chronicle of the Rougon-Macquart family under the Second Empire—most brilliantly exemplifies its achievement. One could argue about this entire series of twenty novels that, if its method is naturalist, its subject is decadence, the corruption and degeneration of France under Louis Napoleon. Everything leads to the humiliating defeat of 1870 at the hands of the Prussians, described by Zola in *La débacle.* Zola's guiding trope of heredity signifies biological decay in the nation as in the family. Heredity is the unconscious acting through the blood, sometimes decomposing reason and causing hysterical or compulsive behaviors, sometimes driving passion to attain the heights of social and political power. That Zola's themes illustrate decadence understood in this sense, which emphasizes the medical basis of degenerative phenomena, has long been appreciated and requires no special attention here. What interests me rather are the aspects of Zola's novels that evoke less explicitly a thematic of decadence, those aspects in which decadence appears as a kind of subversive counterpoint to naturalism arising from within it.

Thus the book I have chosen for analysis is probably the single novel of the Rougon-Macquart cycle that has the least to do with the thematics of national decline or of inherited neurosis. Unlike earlier and subsequent volumes in the Rougon-Macquart series, *La faute de l'abbé Mouret* (*The Sin of Father Mouret,* 1875; henceforth *La faute*) does not dramatize current historical, social, or political concerns. The story adapts the popular nineteenth-century topos of the priest in love to the biblical narrative of Adam and Eve. But the real center of Zola's obsessive meditation throughout the book is the ambivalent role of nature as at once a beneficent model for human happiness and a force blindly driving man to his perdition. Man in particular, for it is the problematic function of male sexuality in the dynamic processes of nature that generates Zola's most creative anxiety.[2]

La faute is divided into three parts, each of which stages a kind of experimental psychodrama. In part 1, Serge Mouret, an ascetic young

priest who has recently arrived from the seminary in a small Provençal village called Les Artaud, is repulsed by the overflowing organic and animal life that surrounds him. A contrast is drawn between Serge, who contemptuously denies nature, sensual pleasure, and the sexual body, and his slow-witted, virginal sister Désirée, who celebrates the pullulating fertility of the barnyard animals she maternally tends. In the isolated village, promiscuous sexual activity characterizes the relation of the brutish peasants both to each other — they are all incestuously related through multiple *cousinages*—and to the land they till, with which they are described as "fornicating."[3] The alternatives Zola offers are singularly unappealing: on the one hand, a mindless embrace of nature as teeming animal generation; on the other, a violent repression of life in the flesh, so violent, indeed, that it leads to psychosomatic collapse. At the end of part I, Serge, in a masochistic delirium, calls on the Virgin Mary to castrate him so that he can unite with her without sin.

In the novel's second part, Serge wakes up from his long illness to find himself in the symbolically named Paradou, which used to be a country domain in the eighteenth century and is now a decaying manor surrounded by an immense, luxuriantly overgrown garden. There Serge, who has forgotten his past, is reborn and nursed back to life by the generous, spontaneously loving Albine. An exuberant child of nature, she teaches Serge to love the beauty of the garden's abundant flowers, plants, trees, and animals. The sensuous appreciation of organic life, his own included, this is Albine's cure for Serge, which enlists the indulgent cooperation of the erotically charged garden— roses reveal their delectable nakedness, fragrant perfumes fill the air, sap exudes from the fruit-laden trees. Soon the garden becomes an active force in encouraging Serge and Albine to consummate their love. Hesitant and anxious at first, when they finally "yield to the demands of the garden," Zola calls their act "a victory for the animals, plants, and things that had wanted the entry of these two children into the eternity of life" (F, 248).

Thus, the novel's message seems to reverse the Edenic myth, which equates eating the apple with shame about sexuality: instead of

being a fall, a sin, an act against man's better nature, sex here is a celebration of love and of the integration of man and woman into "l'éternité de la vie." Naturalism celebrates nature. But this revisionary message is revised in turn when, immediately after their carnal climax, Serge and Albine feel shame, and Serge's religious past returns to his consciousness. Overwhelmed by guilt, he flees from Albine and the Paradou to resume his priestly duties.

At the outset of the novel's third part, Serge has once again taken refuge in his church and dedicated himself to the negation of life. However, his worship of death is soon overtaken by a hallucinatory vision: the church is being split apart from within by the splendid growth of a colossal tree representing all the natural forces he has denied. This vision still does not convince him of the value of the body's sexual expression, however. He returns without enthusiasm to the Paradou, out of duty, hoping to be impotent. Unable to melt his coldness and revive his desire, Albine expulses him from her domain. She then gathers great quantities of flowers and herbs, carries them to her bedroom, seals off all cracks, and, imagining that she is conforming to the law of life's cycle, suffocates from the intense odor. In the final scene, Albine's coffin is being lowered into the ground when Désirée, standing on a manure pile, calls out jubilantly to her brother that the cow has given birth to a calf. It is a sign of the strangely uncomfortable feelings this novel generates about reproduction and fertility that this happy announcement of life's renewal has a quite chilling effect on the reader.

From the outset of *La faute,* the sun is presented as the great force promoting germination, renewal, and fertility. Its function is precisely that described by Bataille in *La part maudite:* the sun donates energy to the processes of growth and reproduction without requiring anything in return. The surplus it provides is the principle of exuberant life on earth. That life—whether vegetable, animal, or human—uses the free gift of solar energy to expand to the limits of whatever space is available and then to exercise pressure on those limits. Bataille's Zolaesque example is of a garden walkway that, once abandoned, "is soon covered over by grass and bushes, where animal

life pullulates."[4] Once the space becomes saturated, life moves toward what Bataille calls a boiling point, pushing for ever greater spatial extension and squandering itself in various forms of luxurious waste. Those forms are meat-eating (a luxury in relation to the consumption of vegetables and grains), death (a surplus in relation to the individual, who is supplanted), and sexual reproduction (also a surplus in relation to the individual, who renounces self-interest for the good of the species). The sun thus presides over a general economy that is fundamentally indifferent to the subsistence of any particular organism. Nature offers up the individual to the impersonal forces of sexuality and death, which happily accept the sacrifice in the name of life.

In Zola's novel this spirit of happy acceptance is embodied in the figure of Désirée. She celebrates and promotes the natural processes of fertility, generation, death, decomposition, and new birth wherever she finds them: "She found continuous satisfaction in feeling life pullulating around her. From manure heaps and coupling animals arose a wave of generation in the midst of which she tasted the joys of fecundity" (F, 94). Although she identifies with all the mothers in her teeming animal world, she is not troubled when some offspring have to be slaughtered for food. Indeed, she is an accomplished butcher herself. Her perspective is precisely that of the general economy: "It [the slaughter of barnyard animals] was necessary, she said; it made room for the little ones growing up. And she was very gay" (F, 367).

The meaning of Désirée's name, "she who is desired," becomes clear when Albine, after her "fall," comes across Désirée lying in sensual ecstasy in the hay: "She was all pink as she slept, caressed by the cow's strong breath, smothered under the weight of the big crouching rooster, who had inched down below her breast, beating his wings, his crest aroused, until his tawny belly burnt her through her skirts with a flaming caress" (F, 305). Zola's language could hardly be more explicit: Désirée satisfies her sexuality through an erotic communion with the animal world. She needs no man to obtain full gratification of her desire. This is what Albine finds so desirable: "[Albine] dreamed of being loved by the tawny rooster and of loving as the

trees grow, naturally, without shame, opening every one of her veins to spurts of sap. It was the earth that satisfied Désirée when she sprawled on her back" (F, 305–6). Note the slippage in this passage from the suggestion of bestiality to the mythic evocation of telluric union. Zola seems to be trying to sidestep the fundamental inconsistency of his portrayal of Désirée. He says that she shares the instincts of the animals she loves but he also insists that she is entirely devoid of the urge to mate.

This is Zola's problem: how can animal nature be a model for human innocence when in animals that innocence includes sexual activity? Rephrased in the Christian framework of *La faute,* this question could read: how can naturalism not view humankind as constitutionally fallen? Although Zola reduces Désirée to a minimally human consciousness, incapable of mature rational thought, still he cannot imagine her as sexual without introducing a condemnatory moral perspective. Albine's dream is Zola's fantasy: erotic *jouissance* without the need for sexual intercourse. Désirée is the desirable woman precisely because her desire requires no particular counterpart, whether animal or human. Mother Earth does the trick. Were Désirée to go into heat, as do the animals she supposedly resembles, Zola would not be able to preserve her from the charge of debauched promiscuity. She remains innocent because she is self-fertilized. She embodies the entire process of life—excrement—death—rebirth impersonally, without individualizing desire.

It is primarily because Désirée is "vide de pensées" ("empty headed"—F, 95) that she can so exuberantly celebrate the proliferation of life around her. Her thoughtful brother, imbued with Catholic morality, has quite a different response: anxiety and nausea. He experiences the force of natural generation as an asphyxiating odor given off by all procreative activity, whether it be in the vegetable, animal, or human realm. Thus, he finds that the Artaud village produces the same nauseating stench of pullulating animal life he had smelled in his sister's barnyard. Désirée herself "smelled too much of life" (F, 60), which causes her to resemble Albine, "the natural flower of this filth" (F, 143). Not even the Virgin Mary is im-

mune: her maternity "seemed to continue in the heavens the over-flowering outburst of generation in the midst of which he had been walking since morning. Like the vines on the rocky hillsides, like the Paradou trees, like the human flock of Artauds, Mary gave birth, engendered life" (F, 127). The comparisons proliferate, like a virus. Naturalism for Serge is an agent of metaphoric contamination that infects both the material and spiritual worlds with the stench of generation.

How to go *à rebours,* against nature? Huysmans's problem is already Zola's. No longer does naturalism appear to celebrate nature. Naturalist fantasies generate decadent dilemmas. Fantasies of nature's female fecundity generate dilemmas of male identity. Serge, a priest to whom sex is denied, is Zola's vehicle to express the anxiety of the *fin de siècle* male who feels irrelevant to the entire natural cycle. Serge wants to "close the door of his senses" (F, 60), "kill the man in him" (F, 61), and become "a castrated, deviant creature" (F, 61). Such masochistic wishes are not evoked by Zola only to question the Catholic abhorrence of fleshly desire. The evocation is far more personal and reflects a deep anxiety about the place of man in the general economy of nature. Serge's desire to "do violence to nature" (F, 60) not only expresses a traditional Catholic imperative but also suggests the decadent ambition to wrest death from nature and reconstruct masculinity in a space that would keep death alive.

This ambition becomes explicit in Huysmans, as we shall see. Zola finds death more difficult to extricate from life and feels more ambivalent about the effort to do so. He is perfectly clear, however, about the consequences for the male of giving up this effort entirely, and dramatizes them at the end of part 1 of *La faute.* Here Serge abandons death as a principle of resistance to the female power of nature and instead invokes it as a means of uniting with that power and being reborn. He explains to the Virgin: "I will love you in the death of my body, in the death of that which lives and propagates itself " (F, 147). His delirious fantasy is that male sexuality will be erased so that female virginity can become the sufficient condition for the propagation of life. The closeness of Zola to his protagonist at this moment

is striking, for Zola's creation of Désirée is the fulfillment of Serge's dream of the Immaculate Conception: "To multiply, to have children, without the abominable necessity of sex" (F, 145). When Serge, at the final point of his feverish delirium, calls on the Virgin to castrate him so that she can "fearlessly offer [him] the treasure of [her] virginity" (F, 148), this wish represents a complete abnegation of masculine difference. His fantasy is powerfully regressive: the son innocently possesses his mother with no objection by the father and thus unites with the very principle of life's generation. No penis, no transgression, no nausea . . . but also no masculine subject. The scenario is an extreme expression of the three forms of disavowal Gilles Deleuze finds characteristic of masochism: "The first magnifies the mother, by attributing to her the phallus instrumental to rebirth; the second excludes the father, since he has no part in this rebirth; and the third relates to sexual pleasure, which is interrupted, deprived of its genitality and transformed into the pleasure of being reborn."[5]

Part 2 of the novel seems to offer the cure for this nearly psychotic episode. The dream of union with Mother Nature will be fulfilled but without the prerequisite of castration. Naturalism will be purified by redeeming sexuality rather than destroying it. The sun, which presides over Serge's rebirth, will not cause a nauseating excess of natural growth but will serve to integrate human love and desire into the bounty of nature's fruitfulness. When Serge perceives Albine as a rose, the metaphor brings him a happy sense of integration, not a fear of collapsing distinctions. Later, when he declares his love for her, Serge makes a point of recognizing that she is neither his mother nor his sister (F, 219). So the incestuous longing so powerful in part 1 is no longer operative. Serge becomes a man by desiring Albine's sexual difference; their intercourse brings them "the peace of a goal logically discovered step by step" (F, 249); and the entire Paradou garden celebrates the logic of this newly discovered difference.

Or so it seems. At the garden's most intimate moment of complicity with the lovers, when its voices are urging them to consummate their union, Zola describes it as pullulating with fecund couplings and fertile fornications—"From the most distant places, from

patches of sun and of shade, rose the warm smell of animals universally in heat. All this pullulating life trembled with the labor of childbirth" (F, 247). This description is strikingly reminiscent both of Bataille's metaphor of nature's reaching a boiling point and of Zola's evocations of the rampant sexuality in the Artaud village and in Désirée's farmyard. Thus the text suggests that Serge's penetration of Albine is not the culminating expression of his virile identity but rather the collapse of that identity into "the fatality of generation" (F, 247). It is as if the garden had only been pretending to encourage the construction of a separate masculine subject while knowing all along that male sexual desire would ultimately serve nature's impersonal economy.

This is the naturalist version of the Fall, male difference dissolving into female indifference, the male attempt to assert individuality defeated by the fermentation of natural process. Zola describes this process as a kind of ominous undercurrent of morbidity running beneath the garden's exuberant celebration of growth and fertility. For instance, the vegetation aggressively attacks what remains of the Paradou's original layout: "[Nature] seemed bent on overturning what human efforts had created; she rebelled, released stampedes of flowers into the walkways, attacked the artistically arranged rocks with the rising tide of her moss" (F, 182). To make place for such rampant growth some plants must die, and the garden includes a quite unromantic cemetery, where flowers "exhale the plague of their decomposition," offer insects "the poison of suicide," and "stink of death" (F, 187). We are told, moreover, that the Paradou is capable of producing "monstrous, diseased growths, nameless beasts" (F, 227) made up of animal and vegetable parts intermixed. Thus the garden's binary logic of difference is shown to be infected by the general economy of natural excess. Death, the dire consequence of the Fall in the Bible, is part of "the eternity of life" embodied in the Paradou. Hence the paradox that the lovers' intercourse, even as it climaxes their discovery of sexual difference, also pulls them backward into an economy that erases that difference in the production and destruction of ever more "fatal generation."

This regression is communicated by the imagery of Zola's text. It is not explicitly stated. On the explicit narrative level, the couple's lovemaking is presented as the natural result of a healthy assertion of the body and the senses, which affords them "the absolute perfection of their being" (F, 249). It is as if Zola were portraying sexual love as at once progressive and regressive, as at once a cure for nausea and its cause. But this doubleness is not the only reason for interpretive bewilderment concerning the novel's climactic act. The shame and guilt that overwhelm the lovers moments afterward are not psychologically plausible. Insofar as we imagine Serge and Albine as realistic characters, their postcoital feelings make no sense. The sense is entirely intertextual: the lovers' feelings are those of Adam and Eve after eating the forbidden fruit. But why should Zola insist on this parallel when he has transformed the biblical garden from a place without sex to one in which good sex is everywhere? Why must Serge and Albine be punished for obeying the dictates of nature?

"It was the garden that had wanted the sin" (F, 246), writes Zola. By using the word "sin" (*faute*) here, Zola lends the authority of his narrative voice to a condemnation of the lovers' intercourse. He sides implicitly with the Catholic rejection of the body that the entire account of Serge's rebirth appears to be written against. There are, moreover, numerous allusions to the text of Genesis strewn all through the Paradou episode. For instance, Serge dreams that Albine was created out of his blood, muscles, and bones. These allusions put the reader in an interpretive quandary: the biblical Fall occurs because of disobedience to divine law, Serge and Albine's fall occurs because of obedience to natural law. How should one understand this crucial difference?

The allusions to Genesis implicitly invoke divine authority, yet it is unclear just what that authority prescribes and proscribes. The only prohibition that operates in the Paradou does so on very weak authority. Albine has been told by "gens du pays," local people (F, 192), that "it is forbidden" (F, 194) to lie under the great tree where, according to legend, the lovers in the eighteenth century found perfect bliss and the lady is buried. Who forbids? God does not seem to have

a representative in the garden. The interdiction against the tree is a vague rumor. It cannot withstand the powerful energy of Albine's desire for ecstatic dissolution in nature's general economy.

So the Genesis story does not stand behind Zola's text as final paternal archetype. But neither is it purely an object of attack and revision. Were the latter the case, the lovers would feel only ecstatic happiness after their carnal union. The reader finds the status of the canonical narrative of human decadence, of man's falling-away from his pristine state, uncertain and wavering, hard to keep clearly in view, puzzling. It is as if the Bible had itself fallen, become merely one text among others. Yet Zola continues to acknowledge its unique authority.

That authority, however, is implicitly put in question by the pervasive function of intertextual and cultural models in Zola's portrayal of the Paradou. Serge and Albine not only repeat Adam and Eve; their love affair also doubles that of the first lords of the Paradou, who previously discovered the tree of happiness. The Paradou is not a pristine wilderness but the luxuriant overgrowth of what was initially a sophisticated design: a cultural intention is at the origin of this natural efflorescence. Cultural also are the incitements to sex that Serge and Albine derive from the suggestive paintings of human and mythological couplings in the château's bedrooms. Thus their lesson in love is not taught only by animals and plants. Moreover, at the origin of Zola's evocation of the garden's many varieties of plants, flowers, and trees are not his promenades in nature but his extensive research in botanical dictionaries. His catalog-like paragraphs make us more aware of the richness of scientific nomenclatures than of the physical existence of vegetable growths in the Paradou.

The Bible has fallen into the library, nature has become a cultural construction, imitation has replaced origination—these are aspects of the modernist sensibility that begin as decadent perspectives. Zola does not foreground these perspectives, as Huysmans will just a few years later. But they are present in his text in subversive counterpoint to the general economy of naturalism. What is subversive is the dis-

placement of the sun as generative source of natural life by the library, the museum, and the field of cultural representations generally, as generative sources of unnatural death. Zola's text gives dramatic recognition to this decadent antinaturalism, but he rejects it as a positive force in his work, presumably because it does not fulfill his deep wish to redeem nature.

This recognition and this rejection are both manifest in part 3 of *La faute*. Back in his church, Serge sets out to transform it into a fortress that will close death off from nature. The project has something in common with des Esseintes's experiments at Fontenay-aux-roses. Serge fills holes in the walls, paints the entire church interior, and dedicates himself to contemplating fourteen horrifying pictures of Christ's Passion. His typically decadent refuge is an interior space in which death is saved from its natural role by its function in representation. Death in the church "saves one from putrefaction" (F, 317), Serge declares, because it gives nothing back to life. For the Paradou, bathed in sunlight, he now has only disgust. It is, he tells Albine, "a charnel house where the cadavers of things decompose" (F, 317). With "impregnable death" on his side, Serge defiantly challenges the naturalist world of rampant life: "Yes, let the bushes grow large, let them shake the walls with their thorny arms, let swarms of insects come out of the cracks in the floor to eat away at the walls—the church, however ruinous it may be, will never be carried away by this flood of life" (F, 318).

Not only does Serge enclose himself in the sanctuary of death, he also tries to recreate himself in death's image. Identifying with Christ, he dreams of taking his place on the cross, of being crowned with thorns, nailed, pierced, and cut open. The relationship he imagines is a sado-masochistic partnership between father and son, implicitly homosexual in the erotic need of the son to be beaten, wounded, and penetrated in the name of the beloved father, "the omnipotent master" (F, 324). Whereas at the end of part 1 Serge wished for an emasculating identification with the Virgin Mary as the immaculate principle of life's generation, now he wishes for emasculation in order to

symbolize femininity as a function of male masochism and to end generation. In this imaginary scenario, sexual difference is removed from the biological/natural sphere and becomes a symbolic structure of relations between men. The scenario short-circuits the general economy of natural production, which is Serge's goal, but the cost is his phallic masculinity.

Decadent sensibilities are often willing to pay this price and welcome the liberation from naturalized gender identities that it seems to afford. Zola, however, backs away. He makes Serge's denial of life and of Albine seem egotistic and cruel and creates as a positive antidote the priest's hallucinated vision of the fecund forces of nature besieging the church and of the tree of life finally bursting it apart. Since this passage is written with enormous rhetorical brio the reader tends to welcome its exuberant assertion of life's triumph over the powers of negation. But then he or she realizes that this exuberance derives its energy from precisely the naturalist excess whose pullulations had seemed nauseating in earlier evocations. Serge happily associates the "revolutionary" (F, 333) army of crawling vegetation, swarming insects, and multiplying animals that successfully destroys the church with a revival of his virility, whose analogue is the great tree that rises mightily within the crumbling edifice. But that tree also illustrates the dire consequences for the individual of being caught up in nature's general economy. The tree is made up of detached body parts, indifferently male and female: "Its forest of branches was a forest of human limbs, legs, arms, torsos, all sweating sap" (F, 334). The tree of life dismembers life. Nature is indifferent to the demands of any particular human existence.

Naturalist affirmation offers no solution to decadent denial. Nor is decadent denial a solution to naturalist affirmation. Neither perspective can cure the other because one implies the other. Decadence inhabits naturalism just as naturalism inhabits decadence. The relation, complex and conflicted, puts intense pressure on the masculine subject, threatening it on the one hand with dissolution in nature's general economy, on the other with isolation in a denatured space of representation and death.

Susceptibility to this dual threat is not just a peculiarity of Zola's creative fantasy. Huysmans's imaginative universe can be analyzed in very similar terms. Although Huysmans is the writer most commonly associated with French decadence, he began as a disciple of Zola. Having written a number of typically naturalistic novels about working-class life, in 1884 he published the classic work of French decadence, *A rebours* (*Against Nature*). According to his own mapping of his career in the preface to that novel, it represents a complete break from his previous work. This break was necessary, he explains, because naturalism had exhausted its vitality and become a formulaic and codified discourse that he was tired of repeating. The novel's protagonist, des Esseintes, polemicizes memorably against nature, which he says "has had its day,"[6] and praises artifice as "the distinctive mark of human genius" (AR, 107). His story constructs a kind of counter-discourse to naturalism, giving stamps of approval to literary and artistic works that exemplify a decadent sensibility and illustrating associated themes, motifs, behaviors, and attitudes. But the book's polemical thrust should not cause us to overlook the entirely naturalistic basis of des Esseintes's drive to reject nature. The book's prologue paints a picture of his heredity that rehearses all the standard themes of the naturalist diagnosis of degeneration: progressive effeminacy and anemia due to intermarriage, nervous exhaustion on the mother's side, obscure illness on the father's, "the languor and lethargy of chlorosis" (AR, 80), impotence, tedium vitae, hypersensitivity, and so forth. The diagnosis returns like a basso continuo all through the book, as des Esseintes's sickly constitution is increasingly depleted by his regimen of sensory stimulation. Finally, his doctor tells him that he faces "insanity speedily followed by tuberculosis" (AR, 349) if he does not leave his retreat and live a normal social life, advice that he reluctantly accepts at the novel's end.

Thus, one could argue, albeit crudely, that naturalism wins out over decadence in this work that Arthur Symons famously called "the breviary of the Decadence."[7] It is, moreover, not at all the case that des Esseintes, antinature as he claims to be, is equally antinaturalist. Indeed, Huysmans specifically names Zola along with Flaubert and

de Goncourt as one of the three modern masters "who had penetrated and molded des Esseintes's imagination more than any others" (AR, 312). And the book he singles out for praise is none other than *La faute de l'abbé Mouret,* which he calls "a prodigious Hindu poem . . . a hymn to the flesh, celebrating animate, living matter, whose procreative frenzy revealed to human beings the forbidden fruit of love, its suffocating spasms, its instinctive caresses, its natural postures" (AR, 312). We have seen how one-sided such a reading of Zola's novel is, but this is precisely the side the decadent aesthete des Esseintes admires: Zola's naturalist excess, his "fecundating showers of pollen falling into the palpitating genitals of flowers" (AR, 311). Des Esseintes even evokes an image of sap "boiling in the sun" (AR, 311), the same image that Bataille uses to illustrate the luxuriantly wasteful productivity of nature's general economy.

Much more could be said about the naturalist subtext and intertexts of *A rebours* (for instance, des Esseintes's famous collection of sickly looking exotic plants derives from Zola's Baudelairian description of hothouse plants in *La curée*), but I prefer to focus my analysis on a less-known novel by Huysmans that stages the interactions between naturalist and decadent representational modes in a particularly revealing manner. Critics have been unable to classify the novel Huysmans published two years after *A rebours, En rade* (1886), as either naturalist or decadent and have tended to see the novel as a confused juxtaposition of the two modes. This was the opinion of Zola, to whom Huysmans deferentially replied: "As for your opinion on the two legs of this pair of trousers, one down-to-earth [i.e., naturalistic] and the other up-in-the-air [i.e., the dream sequences with their decadent imagery], it is—alas—mine also."[8] But the awkward metaphor of the trousers need not be taken negatively. It is, after all, a tribute to the strength of the garment's seams that the legs can sustain the pull of opposing forces without ripping apart.

If *A rebours* is a book written against nature as the supposed source of aesthetic pleasure and ethical value, *En rade* is a book written against nature as the supposed source of inner peace, physical vitality, and spiritual renewal. The latter are what Jacques and Louise Marles

hope to find in escaping from financial disaster and nervous exhaustion in Paris to the deserted château of Lourps in the rural countryside. They are looking for "une rade" in the sense of a safe, calm harbor "where they could drop anchor and remake their plans."⁹ Instead they find themselves "laissés en rade" in the sense of being left in the lurch, stranded, forgotten. Huysmans's title has some of the doubleness Freud finds in the German word for uncanny, *unheimlich:* the *rade* can be thought of as a temporary home, a refuge, a protected haven, but it is also the opposite, a place where one is abandoned, left behind, left homeless, and exposed.

Instead of offering a refuge against the natural elements, the château of Lourps offers vivid evidence of their corrosive, dissolving force. The derelict château is characterized by its permeability: wind blows in through broken windows; rain pours in through leaky roofs; humidity seeps through porous walls; screech owls haunt empty corridors; the surrounding park has no protective wall, making it possible for anyone to enter. Everything within the château is in the process of dissolution: wood paneling is crumbling into powder, floorboards are loose and rotting, humidity has stained wallpaper that is becoming unglued, doors are warped and split, chunks of plaster are falling from ruinous ceilings, a deathly odor of mold and decomposition pervades all. No barrier, no division can hold its own against the invasive, erosive, contaminating force of natural decay. As Alain Buisine remarks about Huysmans's imaginative universe, "the inside is never sheltered from the outside. The membrane that should separate the internal from the external leaks all over. It is a repugnant magma: everything gets mixed together, mutually interpenetrates and contaminates in an atrocious confusion."¹⁰

This repugnant vision of universal erosion and collapse is naturalism as viewed from a decadent perspective. Zola occasionally looks from this perspective, but he balances that gaze against a positive view of the vital energy released through nature's general economy. Thus when Serge Mouret's church is first described, its permeability to nature's penetrations—sun shining through broken windows, sparrows flitting around among the pews, pungent barnyard odors com-

ing in through half-closed doors—all this suggests a welcome exuberance of organic life. Huysmans, in contrast, never imagines anything healthy and productive about nature's vital function. Nature for him is fundamentally morbid. Thus the garden surrounding Lourps resembles the cemetery in the Paradou: "All the cultivated flowers of the beds were dead; it was an inextricable tangle of roots and creepers, an invasion of couch grass, an assault by garden vegetables, whose seeds had planted themselves, and by inedible legumes with woolly pulp and with flesh deformed and soured by being left alone in fallow earth" (ER, 73). Nature outdoors is anything but peaceful and appeasing: it is in disorder, chaotic, crazy. It bursts, probes, climbs, creeps, smothers, wounds, and rots. Organic fertility and organic decay finally have the same degenerative, disintegrative effect. Thus, Jacques feels that the forest and garden, rather than offering him some relief from the castle's atmosphere of oppressive decay, are actually "an imaginatively analogous milieu" that repeats its "sickly and dull melancholy" (ER, 76).

Ironically, what Jacques and Louise have found in their rural retreat is the perfect external correlative of the debilitated, morbid, nervous state of mind that their move to the country was supposed to cure. Most specifically, the move repeats Jacques's experience with Louise's illness, for he had married her expecting her to provide "a happy retreat [une bienheureuse rade], a comfortably padded ark, protected from the wind" (ER, 121). Jacques had counted on Louise's dependence on him—she was a penniless orphan—to assure that she would remain silent, devoted, and undemanding. But Louise's disease, "this disconcerting folly of the nerves" (ER, 19), destroyed her husband's chauvinist dream of female subservience. He feels, it could be said, that she has left him "en rade," abandoned and defenseless. Indeed, Louise's whole organism is as porous, as subject to morbid infiltrations, as naturalistically decadent, as is the decaying château of Lourps. Initially affecting only her physical health, her disease has "infiltrated the moral sphere" (ER, 119) and finally become a "malaise of the entire organism, whose roots extended everywhere and were nowhere" (ER, 118). Sickly Louise is like sickly Lourps, where corri-

dors and rooms succeed each other in a labyrinth as bewildering as the present-absent roots of Louise's malaise, and where harvest bugs so torture the anguished couple that they scratch their skin until it bleeds.

That Louise's disease cannot be diagnosed by the medical specialists only serves to associate it all the more closely with the very essence of her sexual nature. The illness first appeared after marriage, as a result of "internal disorders" (ER, 119) that Louise shamefully tried to hide, implying a sexual or gynecological etiology. One of the symptoms is metritis, inflammation of the uterus, which makes intercourse painful—and the couple has practiced abstinence for what may now be years. Another symptom is convulsions in the legs, accompanied by hallucinations and fainting fits. In the late nineteenth century, manifestations such as these would typically have been considered symptomatic of hysteria and Louise's convulsed pose might have been identified as one of the "attitudes passionnelles" documented in the *Iconographie photographique* of the Salpêtrière hospital, domain of the acknowledged master of hysteria, Dr. Jean-Martin Charcot.[11] Surprisingly, however, the word hysteria is not used in reference to Louise. Instead a closely related disease, nervous chlorosis, is mentioned (ER, 219). Its etiology was often thought to involve a refusal of sexuality, thus making it practically indistinguishable, according to the *Dictionnaire encyclopédique des sciences medicales* of 1876, from "sensitive hysteria."[12] In any case, Louise's illness, and the consequent demise of physical desire, has laid bare what Jacques, like his creator, considers "the original defect of woman [la tare originelle de la femme]" (ER, 211).

Woman's nature in Huysmans's view is faulty, tainted, cracked, split, wounded. His unconscious fantasy is barely disguised: woman is castrated. This perception does not have the stabilizing function that Freud attributes to it as a revelation about sexual difference. Castration in the decadent imagination is the force of nature that threatens to dissolve differences, including that of sex. The decaying, degenerative natural world in which Jacques Marles finds himself unraveling is a morbid site of confusion between inside and outside. The fantasy of female castration generates the power that fuels this

confusion. In Huysmans's horrifying vision woman's "original defect" infects all of nature. Thereby nature itself appears hysterical, hysteria being the psychic consequence of castration. This natural analogy is brought out in the parallel Jacques imagines between hysterical Louise and the half-paralyzed cat she has adopted, which is dying horribly of convulsions, salivating, suffocating, miawling, painfully sensitive to touch.

Castration and its associated imagery of contamination and collapse is the agent of decadence in Huysmans's naturalism. The same agent operates in Zola's naturalist universe—one need only think of Nana. But Zola counteracts it with the fantasy that motherhood can suture woman's wound, that nature can be cured by means of nature. In contrast, Huysmans cannot imagine such a cure, and he turns for an antidote to the explicitly antinatural, which he dramatizes on the stage of naturalism's unconscious.

The three elaborate dream narratives that punctuate the text are explorations of decadence as a way of denying castration and living death.[13] Jacques identifies the primary figures of his first dream as the biblical Esther appearing in her virginal beauty before the aging but lascivious King Assuérus. What makes Esther desirable (to give her that name for simplicity's sake) is the degree to which her body is veiled, attenuated, and estheticized. She is so small, thin, and undeveloped that she appears "presque garçonnière," almost boyish (ER, 61). Her tiny, frail physique is encased in a fabulously decorated jeweled dress, her skin has been deliberately emptied of color, an undefinable perfume of complexly layered scents emanates from her white flesh. Standing immobile before the king, she is woman fetishized as art object, her animal odor eliminated, the evidence of blood in her veins denied by her "superhuman paleness" (ER, 61). Even naked, Esther remains a perfect object of misogynist scopic delectation, for her slender body with its aestheticizing circles of gold around breasts and navel and its golden pubic hair suggests nothing of the mature, desiring, self-assertive woman.

Read in this manner, the dream fulfills Jacques's desire for a wife who would be an obedient, quiet servant catering to his kingly com-

mands and hiding as much as possible "the intimate tribulations" (ER, 211) of her mature sexual body. Read in terms of Huysmans's own fantasy life, this picture of Esther is a decadent construction that functions to counter the naturalist vision of woman. Rather than a productive agent of organic life, Esther is so nearly a pure object that at one point her paleness is termed "inanimate" (ER, 62). It is as if the blood had been extracted from her veins and from her sexual organs. Looking down at herself nude, she sees her pubic region mirrored back by the floor's polished stone tiles as a "gold point" that echoes the gold crowns of her breasts and the gold star of her stomach. The dynamics of the gaze are in the service of male scopophilia: we see Esther seeing herself as seen by her lustful ruler. The gaze, however, is averted from the act of sexual intercourse by a metaphorical scenario, in which images of male potency—fireworks, rods, plowing, and sewing of jewels—both evoke and displace the violence of physical possession. In this fantasy, woman is dominated thrice over: first, she is reduced to an almost sexless aesthetic object, then she is raped by a king, but this rape is not seen as such and becomes an occasion for the display of verbal invention.

All this takes place in a palace that resembles Herod's as painted by Gustave Moreau and described by des Esseintes in *A rebours*—a similar mixture of architectural styles shapes an interior space in which cold, shiny surfaces of marble, basalt, and porphyry reflect the sparkling gleams of precious stones. In Jacques's dream, these stones are in the form of an immense spreading grapevine that twists its branches around columns and bursts forth in disorderly foliage and brilliant reflections, "the greenish glow of the emerald, prasine of the peridot, glaucous of the aquamarine, yellowish of the zircon, cerulean of the beryl" (ER, 59). Thus rampant vegetative growth is mineralized within the palace of stone. This vision is in many ways the antithesis of Serge Mouret's hallucination of the tree that bursts the church apart from inside, fueled in its exuberant growth by solar energy. No sun is needed to make Jacques's vine prosper: "This inconceivable vegetation lit itself up on its own; from all sides, obsidians and specular stones encrusted in the pilasters refracted and dispersed the

gleam of gems, which, reflected at the same time from the porphyry tiles, sowed the pavement with a wave of stars" (ER, 60). The energy fueling nature's organic growth has been replaced by the play of reflections between stones that imitate that growth and by the verbal play of exotic words that display their own brilliant opacity. The words are treated as if they were precious gems themselves. A phrase like "[les lueurs] prasines du péridot" sounds wonderful but evokes no referent for most readers, *péridot* being a stone known only to gemnologists and *prasine* an adjective long in disuse.

What we see here is that the imagery Huysmans attributes to Jacques's unconscious fulfills not only that character's wish for a subservient wife but also his creator's wish to overcome naturalism's degenerative female power. The dream constructs a scenario in which male dominance is associated with the enclosure and petrifaction of the natural world, the aesthetic objectification of woman, and the foregrounding of the verbal signifier. These strategies, characteristic of a decadent sensibility, use death as a creative principle.

Jacques's second dream explores the consequences of this attempt to live imaginatively within the domain of death. He finds himself with his wife on the moon, "where there is neither vapor, nor vegetation, nor earth, nor water, nothing but rocks and streams of lava" (ER, 108). Everything here is arid, hard, whitened, odorless, and silent. Gaston Bachelard, who gives a suggestive phenomenological analysis of this dream in *La terre et les rêveries de la volonté,* is right to say that it expresses a raging hostility against life.[14] But one needs to recognize furthermore that life in Huysmans is gendered female. At one point, the dreamer imagines that the landscape resembles enormous surgical instruments, such as medical saws and scalpels, as if the weapons of life's violent amputation had become frozen into the scene of death. Likewise, the natural agents of destructive rage are not annihilated in the dream but preserved in petrified form. Observing calcified cataracts, petrified avalanches, anesthetized tempests, and sedentary maelstroms, Jacques wonders "what tremendous compression of the ovaries had put a stop to the holy illness, the epilepsy of this world, the hysteria of this planet" (ER, 113). The reference is to

one of Charcot's techniques for the treatment of hysteria, pressure applied to the ovaries. Huysmans takes the old trope of moon-as-woman and replaces its romantic connotations with decadent ones: the moon here is woman as clamorous lunatic, as convulsive epileptic. The dream fulfills the wish—both Jacques's and Huysmans's—to see this sickly energy, originating in "incurable wounds" (ER, III), deactivated, immobilized, rendered impotent. To this end, the diseases associated with female castration must not just be summarily eradicated: the neutralization of their effects must be visually witnessed and described. Hence the evocation of mineral formations resembling chancres, tubercules, and cysts, all symptoms of venereal disease. Similarly, the Swamp of Putridity is identified only the better to evoke the smell of saponifying cadavers and decomposing blood that does *not* emanate from it. Thus, naturalist effects of biological and hysterical degeneration exist on the decadent moon, but only insofar as they have been eviscerated, frozen, petrified. They are simulacra, offering a purely externalized surface with no organic interiority. What is factitious and artificial exhibits the spectacle of life in all its putrescent decomposition but without the biological motor that generates its entropic energy.

The strategic problem of decadence, of course, is that simulacra are reassuring only when viewed from outside. They do not provide an existential model for how to be in the world. One can appreciate the brilliance of an embalmer's work, but one would not want to be its object.

Jacques's bizarre third dream expresses some of the anxiety associated with the failure of the decadent attempt to remove death from nature yet keep it alive. Many of the images evoke castration: the dreamer loses his cane, on which he imagines that his entire life depends; a young woman who seems at first to be attractively adolescent and virginal, so underdeveloped physically that, like Esther in the first dream, she could almost be male, turns out to be bleeding from wounds in her hips and to have eyes that, in horrifying fashion, repeatedly fall out of their blazing crimson sockets; this woman is transformed finally into a disgusting old hag, whose toothless mouth

is streaked with bands of blood. When Jacques identifies this "abominable whore" (ER, 196) with Truth, it is as if the Huysmanian imagination were defining the obsessive center of its naturalism, the fantasy that woman is a hideously wounded, bleeding creature, whose castrating power derives from the very horror of her castration and whose prostituted sexuality is a syphilitic virus infecting the entire organic world. This repellent vision finds its delirious culmination in the fantasy Huysmans attributes to the mass murderer, Gilles de Rais, in *Là-bas*: "On tree trunks Gilles now sees disturbing polyps, horrible gnarls. He becomes aware of exostoses and ulcers, of deeply-cut wounds, chancrous tubercles, atrocious blights; it is a leprosarium of the earth, a venereal clinic of trees, among which a red hedge suddenly comes into view . . . [whose] falling leaves tinged with crimson make him feel as if he were being soaked in a rain of blood."[15]

This hallucination expresses a naturalist nightmare, the biological process of pathogenic generation breaking down the barriers between animal and vegetable realms and infecting the world with venereal morbidity. On the moon of Jacques's second dream, these manifestations of woman's degenerative energy are safely frozen into the landscape. This mineralization fulfills the decadent fantasy of a world in which the solar principle of excess growth cannot operate and the general economy of nature is rendered ineffectual. But such a world cannot sustain life. So Huysmans vacillates, as Bachelard puts it, between "stone and wound, pus and cinders" (206). For instance, in *A rebours* he evokes a desolate, mineral landscape that prefigures the much-longer moon dream in *En rade*. This desiccated landscape appears briefly in des Esseintes's nightmare as a refuge from the terrifying figure of Syphilis, which is pursuing him. But the arid lunar atmosphere is not sufficiently life denying to prevent the emergence from its sterile soil of a female figure, who rapidly turns into a terrifying embodiment of Woman as Flower and Virus—bloody, castrated, pulsating with insatiable lust.

Now, one might object that the parallels we have noted between Zola and Huysmans reflect the closeness in sensibility of these two writers

and do not necessarily express something fundamental about the relation of decadence to naturalism in the *fin de siècle,* To answer this objection, I will now undertake a reading of a novel by the English writer most closely identified with naturalism, Thomas Hardy. Unlike Huysmans, who was associated in France with both naturalism and decadence, Hardy had nothing to do with the English decadent movement and evinced no interest in the work of its most celebrated representative, Oscar Wilde.[16] Yet I will show that Hardy shared certain fundamental beliefs about heredity and the dead with Wilde and that the opposition that Hardy dramatizes between natural process and aesthetic creation is a version of the conflict that motivates the decadent choice to privilege art over life.[17] Hardy's creative imagination, I will demonstrate, thrives on the tension between naturalist generation and decadent repetition that is also at the heart of Zola's and Huysmans's work. Moreover, just as this tension is often focused in the French authors on a woman's sexualized body, so is it in Hardy, nowhere more powerfully than in *Tess of the d'Urbervilles* (1891).

Let us plunge right into this novel. One of the most famous passages is the description of Tess walking through the overgrown garden at Talbothay's dairy as she listens to Angel Clare playing the harp. It precisely echoes Zola's evocation of natural process in the Paradou:

> The outskirt of the garden in which Tess found herself had been left uncultivated for some years, and was now damp and rank with juicy grass which sent up mists of pollen at a touch, and with tall blooming weeds emitting offensive smells—weeds whose red and yellow and purple hues formed a polychrome as dazzling as that of cultivated flowers. She went stealthily as a cat through this profusion of growth, gathering cuckoo-spittle on her skirts, cracking snails that were underfoot, staining her hands with thistle-milk and slug-slime, and rubbing off upon her naked arms sticky blights which, though snow-white on the apple tree-trunks, made madder stains on her skin; thus she drew quite near to Clare, still unobserved of him. (127)[18]

As David Lodge has noted, this passage is remarkable above all for the way it encompasses words with both repugnant and attractive

connotations, savoring both with "a kind of sensuous relish."[19] But I think Lodge is being too conservative when he insists that the entire paragraph be interpreted "as a metaphorical expression of Tess's character" (Lodge, 186). The passage seems to me, on the contrary, to explode the notions of character and difference, cracking them open like the snails under Tess's feet. Everything here is oozing, cracking, emitting, sticking, staining, in a production of excess that is at once life giving and death dealing. "Conscious of neither time nor space" (127), Tess is, like Albine in Zola's novel, the embodiment of the female principle, which fuses and confuses natural processes of growth and generation with natural processes of decomposition and death.

In this vision of an overly fecund nature, the sun, traditionally a symbol of male energy, becomes the agent of a surplus that Hardy associates with an essentially feminine sensuality and exuberance. At Talbothay's, during Tess and Angel's courtship, "the rays from the sunrise drew forth the buds and stretched them into long stalks, lifted up sap in noiseless streams, opened petals, and sucked out scents in invisible jets and breathings" (133). The highly eroticized language of this passage makes the sun appear like a female force that arouses the male shapes of nature. The male serves the female, is acted upon by the female. Expressing himself in more psychological terms, Hardy calls this female energy that opens and lifts up and brings forth "the invincible instinct towards self-delight" (104).[20] Just as Zola appears to be on the side of Serge and Albine's appetite for joy, so Hardy appears to be on the side of natural urges and invincible instincts. Both writers present a certain naturalism as a potential liberation from repression and create female characters who offer themselves as potential agents of the male's happy integration into nature's productive processes. Both writers attack the idea of sexual guilt and the religious paradigm of the Fall. Indeed, sex is at the center of their naturalist visions, which implicitly mock the notion of virginity and condemn moral prescriptions as "arbitrary law(s) of society" (271). Sex is a function of the "appetite for joy" that Hardy, in his philosophizing narrative voice, ascribes to "all creation" but that is usually associated with women in the unfolding of his stories. And this, precisely, is the

problem: sex, the motor of natural process, employs the male as a mere functionary. Angel Clare may be desired by all four milkmaids at Talbothay's dairy, but he is not thereby empowered. From Hardy's naturalist perspective, the girls' passion empowers them, for it dissolves the differences between them, making each "but part of one organism called sex" (149). Sex is not an attribute of an organism, it *is* an organism, and that organism is gendered female.

But there is less joy of sex in Hardy than initially meets the senses. "The Female shall not exist," writes D. H. Lawrence about Hardy's imaginative universe. "Where it appears, it is a criminal tendency to be stamped out."[21] This formulation is characteristically hyperbolic—and criminality does not seem to be the appropriate term here—but Lawrence is right to highlight the threat that what I call naturalism and what he calls "the great Law of the Womb, the primeval Female principle," represents for Hardy. He is also right, I think, to suggest that Hardy exercises a certain murderous violence against the "organism called sex." Hardy himself might call that violence spirituality, in the sense of the remark he made in reference to Zola (in whom, he told Edmund Gosse, he was "read very little"[22]): "The animal side of human nature should never be dwelt on except as a contrast or foil to its spiritual side."[23] My thesis is that the forms this violence takes in *Tess,* while not expressed in a literary style of high artifice, have much in common with those used in the decadent effort to go "against nature."

Perhaps the most brutally denaturalizing element in Hardy's novelistic writing is the narrator's articulation of Nature's laws. An instructive example comes just at the moment when Hardy is evoking the milkmaids' passionate response to Angel Clare, a response that infuses them with sexual energy. But Hardy's narrator tells the reader that the girls "writhed feverishly under the oppressiveness of an emotion thrust on them by cruel Nature's law" (149). Now, it is evidently the narrator's own cruelty that insists on robbing the girls of subjective agency and on viewing them as the oppressed victims of Nature's cruelty rather than the embodiments of nature's erotic exuberance. Nature's laws, one could say, are written against Nature's pulse, as em-

bodied, for instance, in Tess's attraction to Angel, about which Hardy writes: "every see-saw of her breath, every wave of her blood, every pulse singing in her ears, was a voice that joined with Nature in revolt against her scrupulousness" (179). Here Hardy seems to be lending his own narratorial voice to the celebration of pulsating female exuberance and to the attack against arbitrary moral scruples. He seems, in other words, to be "joining with Nature" as the emancipatory force that subverts any notion of law. But then he turns against this feminine energy, which threatens his identity, his patriarchal authority, perhaps even his verbal mastery. Thus he indulges the fantasy of loving Nature and advocating the Female but also revolts against this fantasy, most explicitly in sardonic attacks on the benevolence of the Romantic notion of "Nature's holy plan" (28), more covertly in the construction of a plot whose insistent repetitions enact the male cruelty of Nature's law.

The tendency that Hardy's plots try to "stamp out" (Lawrence's phrase) is the creation of excess. His plots are rigorously conservative, even miserly: whatever appears will reappear, what happens once will repeat itself, wherever one has been there one will be again. I need not spell out the numerous "returns of the native" that occur in Tess, every reader has noticed them. But this is just the point: one notices them because they are literary signs of the operation of Nature's implacable laws, posted by the novel's authorial lawgiver. To read these signs is to enter a library of ponderous male authority, with names such as Schopenhauer, Darwin, Huxley, Weismann, and Spencer. The meanings of these names, as Hardy interpreted them, is pessimism, hereditarian determinism, and scientific rigor. While Hardy's intellectual debt to these thinkers has been the subject of much discussion,[24] the way his implicit references to their ideas function in a politics of gender has often been overlooked. Embedded in the repetitive patterns of the plot, these references serve to stamp out the feminine "appetite for joy" that threatens to absorb masculine identity. Drawing attention to the laws of Nature that inform literary structure, repetition suggests that naturalism, gendered female, fails to conform to Nature, gendered male. And just as naturalism is associ-

ated with the life instincts and the life-death-life cycle, so Nature becomes associated with the death instincts and the effort to break that repeating cycle.

The association of this effort with a decadent sensibility is brought out in a statement by Oscar Wilde that links the scientific principle of heredity with a cultivation of the spirits of the dead. In "The Critic as Artist" (1891), Wilde evokes a vision of natural law every bit as bleak as Hardy's, then goes on to suggest that the individual may be compensated for his loss of freedom in everyday life by gaining access to the resources of the dead. The passage is worth quoting at some length, since the parallels with certain imagery in *Tess* are striking:

By revealing to us the absolute mechanism of all action, and so freeing us from the self-imposed and trammeling burden of moral responsibility, the scientific principle of heredity has become, as it were, the warrant for the contemplative life. It has shown us that we are never less free than when we try to act. It has hemmed us round with the nets of the hunter, and written upon the wall the prophecy of our doom. We may not watch it, for it is within us. We may not see it, save in a mirror that mirrors the soul. It is Nemesis without her mask. It is the last of the Fates, and the most terrible. It is the only one of the Gods whose real name we know.

And yet, while in the sphere of practical and external life it has robbed energy of its freedom and activity of its choice, in the subjective sphere, where the soul is at work, it comes to us, this terrible shadow, with many gifts in its hands, gifts of strange temperaments and subtle susceptibilities, gifts of wild ardours and chill moods of indifference, complex multiform gifts of thoughts that are at variance with each other, and passions that war against themselves. And so, it is not our own life that we live, but the lives of the dead, and the soul that dwells within us is no single spiritual entity, making us personal and individual, created for our service, and entering into us for our joy. It is something that has dwelt in fearful places, and in ancient sepulchers has made its abode. . . .

Do you think that it is the imagination that enables us to live these countless lives? Yes: it is the imagination; and the imagination is the result of heredity. It is simply concentrated race-experience.[25]

Now, Tess's story as Hardy recounts it begins precisely with the revelation that her life is inhabited by the dead and that her soul abides in ancient sepulchers: "rows and rows of you in your vaults, with your effigies" (15), says Parson Trinham. From the outset, Tess is defined in relation to the dead, and that relation returns repeatedly throughout the book, as if Tess were haunted by her concentrated race experience and the author were intent on being the agent of that haunting. To name a few signs of this intention: Tess's father's death is hastened by his obsession with his heritage; the ill-fated connection with Alec is established through the name his family has simply "annexed" (42); her son, the result of intercourse between members of a bogus family line and of the real one, dies; her unconsummated wedding night takes place in what was once a d'Urberville mansion, hung with intimidating portraits of her ancestors; Angel associates Tess's supposed moral failure with the decline of her family: "Decrepit families," he declares, "imply decrepit wills, decrepit conduct" (229); the legend of the d'Urberville coach foreshadows Tess's murder of Alec; Tess camps out in the d'Urberville aisle of a local church, sleeping just above the family vaults; an effigy over one of these vaults turns out to be Alec in the flesh, and so forth. All of this is arranged by the author, who seems to be using his narrative to make an imaginary abode for the "terrible shadow" cast by his dedication to death and to the lives of the dead.

It is not sufficient to explain the effects of this shadow by reference to critical ideas like fate or tragedy. These ideas are rooted in notions of literary tradition and philosophical belief. What I am getting at, in contrast, is a link between imagery and structure, on the one hand, and largely unconscious authorial impulses on the other. I see Hardy as staging a powerful internal conflict focused at once on his desire to release female energy within cultural forms and on his fear that this energy will dissolve masculine identity and patriarchal authority. This fear leads him in what I take to be a decadent direction: he invests authorial subjectivity in repetitive structures that signify death. Death thus is wrenched away from the biological cycle, where it contributes actively to organic process, and becomes instead a function of repre-

sentations, whether these be genealogies, effigies, stories, signs, or paintings (such as those of the d'Urberville dames whom Tess resembles—231).[26]

Hardy attributes to Tess an awareness of the violence that repetition, the death principle, does to the impulse to live her own life. In answer to Angel's question as to why she doesn't want to learn more history, Tess replies: "Because what's the use of learning that I am one of a long row only—finding out that there is set down in some old book somebody just like me, and to know that I shall only act her part; making me sad, that's all. The best is not to remember that your nature and your past doings have been just like thousands' and thousands', and that your coming life and doings'll be just like thousands' and thousands'" (130).

While he sympathizes with Tess's desire to have a unique and unreflective relation to life, Hardy produces his novel as precisely the kind of repetitive mechanism that Tess dreads. The old book in which somebody just like Tess is "set down" is inscribed in Hardy's text as a principle of remembering and forecasting. The novel's end provides a striking example of this principle: Tess's sister, whom the narrator calls "a spiritualized image of Tess" (383), takes her place with Angel Clare.

This substitution, it will be remembered, is Tess's own idea, and it is symptomatic of her gradual loss of the will to resist disembodiment. Whereas she rejects Angel's offer to instruct her, in her final moments at Stonehenge she explicitly requests him to train and teach her sister, Liza-Lu, saying "she has all the best of me without the bad of me; and if she were to become yours it would almost seem as if death had not divided us" (380). In terms of character psychology, this plea is understandable as an effort, in the face of death, to hold on by proxy to the man she loves. But the plan also functions, in what could be called the novel's psychic economy, as a moment when the female principle abandons its naturalist basis—now condemned, it would seem, as "the bad of me"—and embraces death as an agent of spiritual continuity, offering, in Wilde's terms, the gift of living "countless lives."

This gift of disincarnation is offered to the reader on the level of the plot's intersubjective relations through the operation of the male gaze. As Kaja Silverman has pointed out, the male gaze in this novel frequently imprints female identity (or "stamps it out" in another meaning of Lawrence's phrase), making the woman accessible as an image distinct from the naturalistic surrounding in which she tends to "lose her own margin" (142).[27] Not only are Alec and Angel dual agents of the mastering gaze, Hardy introduces other male observers —a traveler, a painter, an imaginary spectator—who typically pick Tess out from a generalized background and scrutinize her as spectacle. Thus she comes into view constructed and marked as an image. Given Tess's awareness of the force of the gazes bearing down upon her (at one point we are told that "she knew that Alec d'Urberville was still on the scene, observing her from some point or other, though she could not say where"—323), it is not surprising that she eventually dissociates her body from the picture she wants to preserve of herself. When Angel first sees Tess upon his return from South America, he reflects that "his original Tess had spiritually ceased to recognize the body before him as hers—allowing it to drift, like a corpse upon the current, in a direction dissociated from its living will" (366). Again, this dissociation can be read psychologically as a defensive strategy that Tess develops in response to Alec's brutality. But it also reflects a "drift" in the novel's imagery that entombs Tess's body in order to save her soul as an abode of representation.

Now, every reader will remember that, in one of the novel's most implausible episodes, Angel actually does entomb Tess. A few nights after their still-unconsummated wedding, Angel comes into Tess's bedroom sleepwalking, leans over her while murmuring "Dead, dead, dead!" (242), wraps her in the sheet as in a shroud, and picks her up whispering words of endearment. Still sleepwalking, he then carries her out of the house, across a flimsy bridge over a turbulent river, to the bare ruined choir of the abbey-church, where he lays her in the empty stone coffin of an abbot, kisses her, and, "as if a greatly desired end were attained" (244), falls asleep on the ground alongside. This

scene, as I read it, allegorizes Hardy's own decadent desire, decadent because it fulfills the dream of encrypting the life instincts and establishing an ideal masculinity in the abode of death. Hardy's narrator, of course, criticizes Angel for being "ethereal to a fault, imaginative to impracticability" (240). But this critique seems to be neutralized when Hardy rewards Angel's idealization of Tess as "a visionary essence of woman" (134) by granting him the postmortem companionship of her "spiritualized image."

Indeed, Hardy's novel repeatedly testifies to the appeal of the very "corporeal absence" (240) that it also condemns. As has often been noted, the most dramatic acts of physical violence in the novel are not described: Tess's violation, her murder of Alec, and her execution. In each of these cases, a sign stands in for the act: the narrator's metaphor of the "coarse pattern" traced on Tess's "beautiful feminine tissue" (77); the gigantic ace of hearts created on the ceiling below by Alec's dripping blood; the black flag raised on the distant tower that signifies that Tess has been hanged. Of these signs, as J. Hillis Miller remarks, the most significant is the narrator's metaphor, for it reveals that the sign-making is a writing on the body, a tracing that transforms the physical body into marks that can be reproduced.[28] It is, of course, of crucial importance that the body is female and that the marks are the residue of male inscription. These marks constitute the history of repetition into which Tess struggles not to be absorbed, not to become "one of a long row only." But the novel's structures of repetition and patterns of recurrence lead Tess inexorably to the altar at Stonehenge, on which sacrifices were made, Angel says, to the sun.

The sun—earlier we saw it as a feminized agent of surging fertility, allied with Tess's naturalist energies. But Hardy does not allow this alliance to hold. The sun ominously marks Tess's body. Its rays no longer nourish her at her source; rather, they stain her surface from without. Thus, on the afternoon of her wedding day: "The sun . . . formed a golden staff which stretched across to her skirt, where it made a spot like a paint-mark set upon her" (215). The image is still erotic, but now the suggestion is of a male sun singling Tess out for

possessive marking. The significance of that marking becomes clear at Stonehenge when Tess, lying on the sacrificial altar, is woken by "a ray [shining] upon her unconscious form" (381), and she learns that the police have come to arrest her. The sun serves death: it awakens in order to kill and encrypt. Stonehenge is described as a structure of phallic repetition: in the night, Tess and Angel encounter "another tower-like pillar, square and uncompromising as the first; beyond it another, and another" (379). Here male supremacy asserts itself through symbolic forms that articulate the solar cycle, telling time. It is as if the diurnal rhythm of nature had become subject to the "vast erection" (378) built by man's signifying will.

Hardy the naturalist decries this subjection, mocking the notion that Tess's execution represents an act of "justice" (in quotes in the text—384). But Hardy the decadent finds comfort in the opportunity to "stamp out" the Female at Stonehenge (or "blot" her out—the word appears twice on the last page). Given that Alec is not all bad—indeed, he is more devoted in his physical desire for Tess than Angel is in his spiritual love—and that the plot could easily have accommodated Tess's running away without her first killing Alec, the ending points strongly to the author's (largely unconscious) desire: he leads Tess into the stone circle of Stonehenge much as Angel earlier laid her in a stone coffin.[29] "Older than the centuries, older than the d'Urbervilles" (379), Stonehenge represents the death drive as the principle of repetition operating from time immemorial. When Hardy has Tess murmur at the moment of her arrest, "It is as it should be!" (381), he is fulfilling his decadent fantasy that woman's true desire is to offer her death not to the (female) natural cycle but to the (male) principle of eternal recurrence. Tess's gift of her sister pays homage to this principle, tacitly acknowledging that, after all, she herself has been "one of a long row only." In his poem "Heredity," Hardy defines this row as the projection of a trace through time:

> I am the family face;
> Flesh perishes, I live on,
> Projecting trait and trace

Through time to times anon,
And leaping from place to place
Over oblivion.

The years-heired feature that can
In curve and voice and eye
Despise the human span
Of durance—that is I;
The eternal thing in man,
That heeds no call to die.

My analysis of *Tess* would lead one to suppose that the "I" speaking
in this poem is gendered male and that the family face it projects is
gendered female.[30] The poem suggests that biological death is over-
come by the eternity of the death wish, and that the perishable flesh
is overcome by the masculine force of repetition.

But this overcoming is never complete. Decadent projection,
which "heeds no call to die" because it is driven by the death instinct,
is countered by naturalist productivity, which absorbs any individual
death into the feminine biological cycle. Hardy celebrates the power
of that generative cycle, but he also reacts forcefully against it, ulti-
mately choosing the lives of the dead over the deaths of the living.

We may be surprised at first to find that Thomas Hardy, deeply
rooted in the customs of the English countryside, greatly influenced
by the great moral tradition of English literature, should share fun-
damental imaginative paradigms with authors as different in cultural
background as Zola and Huysmans. But my point is that naturalism
and decadence form a nexus that transcends individual writers in the
fin de siècle. I would surmise that some version of the conflicts I have
highlighted in the three novels we have analyzed is operative in most
of the works associated by critics with one or the other of these move-
ments. As a final demonstration of this thesis, I will turn now to a
novel by Octave Mirbeau, *Le jardin des supplices* (1899, *The Torture
Garden*). In this work the tensions typical of the decadent/naturalist
nexus of obsessional themes attain such grotesque excess that readers

find themselves wondering whether or not to consider the excess as parodic.

Written by a militant Dreyfusard activist, published early in the summer during which Dreyfus was subjected to a second trial, and dedicated ironically "To Priests, Soldiers, Judges—to Men who educate, lead, and govern men," *Le jardin* has usually been interpreted as a virulent attack against both the decadence of contemporary French society and the received forms of literary decadence. Thus Jennifer Birkett, in her recent book on decadence in France, says that in this novel "Mirbeau draws together all the emblems of decadent style—flowers, peacocks, the green eyes and blond hair of the mother-mistress, blood, pain and death—in a quintessence no less heady than *A rebours,* whose purpose is to settle accounts with the decadent poison."[31] But in my opinion what is most interesting about Mirbeau's book is precisely how it fails to settle those accounts and how the poison spreads throughout the text despite the author's efforts to control it.

Mirbeau wants to castigate the rabid injustice of the anti-Dreyfus prosecution in the mirror of Chinese cruelty and decadence, but the novel is driven by a vision of decadence that is more liberating than it is repulsive. Or rather, the liberation is a masochistic function of the repulsion. Mirbeau's hallucinatory imagination, dominated by the fantasy of the femme fatale, produces a thematic coherence to the novel that its political agenda fails to achieve. In the political allegory, a garden in which innocent victims are subjected to horrendous tortures sanctioned by the state is a repellent transposition of the torturous regime at home. On the fantasy level, these tortures are exquisite inventions of a psychological regime perfectly at home with the repellent and decadent.

The novel's opening section, called a frontispiece, in which we listen to a discussion among male friends about the universal desire to kill, immediately puts the author's stance in question. The idea that man is naturally murderous is a fundamental precept of the founders of decadent thinking (unnamed here but implicitly alluded to), Sade and Baudelaire ("Nature can only counsel crime," writes Baude-

laire.[32] "Murder is a normal and not an exceptional function of nature and of every living being," echoes one of Mirbeau's discussants[33]). Many examples are cited, from the joy of the populace in shooting down humanoid targets at fairs to the Dreyfus affair, in which "the passion for blood and the joy of the chase were completely and cynically displayed" (JS, 51).

Does Mirbeau himself endorse this view of humanity? Emily Apter argues that Mirbeau's claim that man is universally murderous is intended to critique current psychiatric methods for determining criminal deviance by isolating specific anomalous traits.[34] She suggests that the premise of man's inherent desire to kill is espoused in Mirbeau's frontispiece as a satirical strategy aimed against the positivist criminology of Cesare Lombroso and the psychophysiological techniques of Alphonse Bertillon, both of which were used to stigmatize Dreyfus.[35] Mirbeau would be claiming satirically that no specific traits can be used to distinguish Dreyfus from any other man since all humans have the traits of a murderer by the very fact of their humanity. Thus Mirbeau would be espousing a decadent thesis as a tactic to expose the absurdity of antidecadent positivism. But it is not clear that he is ready to repudiate his weapon of attack along with its satirical object.

Indeed, as the discussion progresses the decadent fantasy comes increasingly to the fore as a speaker argues that the natural law of murder is embodied in woman. In her, we are told, the instinct to kill and the sexual instinct are one and the same. So argues the unnamed man who narrates the subsequent story of his failed political schemes in France; of his trip to Ceylon by ship, on which he meets the beautiful Clara; of his following her to China and accompanying her there to the Canton prison and its torture garden—all this in order to illustrate his thesis. "Woman," he declares, "has a cosmic elemental force within her, an invincible force of destruction, like nature. In herself alone she is all of nature. Being the matrix of life, she is, by that very fact, the matrix of death, since life is perpetually reborn from death and to eliminate death would be to kill life at its unique source of fecundity" (JS, 61).

This thesis expresses the core vision of decadent naturalism.[36] Since woman embodies the double matrix of life and death and thus constitutes all of nature in herself alone, man is reduced to a mere functionary, a sexual slave needed only to assure nature's continuing production of herself. This, says Mirbeau's narrator, is in the essence of things, and he offers his own ravaged face, bent back, and trembling hands as testimony to the devastating effects of his having known a woman "in her truth, in her original nudity" (JS, 61).

But should we take this virulent misogyny seriously? Is Mirbeau satirizing a decadent topos? Is he asking us to join him in making fun of the decadent construction of the femme fatale? Is he asking us to appreciate his perfect parody of decadent naturalism? Any knowledge of Mirbeau's politics makes it understandable that we should ask such questions. His hatred of decadence was a staple of his vituperative political invective and remained equally virulent whether he was supporting right-wing causes (as he did at the outset of his career as journalist and reviewer), anarchist terrorism (in the early 1890s), or Dreyfusard liberal values (in the later 1890s). Moreover, he wrote fiercely satirical articles attacking pre-Raphaelite painting for its sterile aestheticism, and he delighted in describing art nouveau forms as grotesquely twisted expressions of hysterical nervousness. So a reader acquainted with Mirbeau's polemical stances might feel justified in assuming that the decadent arguments presented in the frontispiece should be read as satirical exaggerations.

But such an assumption underestimates the force of the essentialist fantasies that drive Mirbeau's passionate creative imagination. Subtending his changing political positions was a conviction that mankind is indeed fundamentally murderous and that governments are simply the organized outlets for arbitrary violence against individuals. And coloring his entire world view was a misogyny so extreme that its frankest expression, published under a pseudonym for fear of his wife's wrath, could easily be taken as a deliberate parody. "Woman is not a brain," Mirbeau writes in 1892, "she is only a sexual organ, nothing more. She has only one role in the universe, to make love, that is, to perpetuate the species. . . . Woman possesses man. She

possesses him and dominates him: that is how nature wanted it to be, according to her impenetrable ways."[37] And underlying his repeated fictive renditions of female domination is a profound masochism that is stimulated by fantasies of male debasement.

The ambiguity of Mirbeau's novel arises from the interplay of his antidecadent satirical intentions; his philosophical outlook, with its implicit decadent sympathies; and his unconscious drives, which readily espouse decadent themes and imagery as their vehicle. This ambiguity is focused in the complex figure of Clara. Her philosophy aligns her with the views elaborated by the speakers in the frontispiece. Like them, she condemns contemporary French society for its hypocrisy, mediocrity, and deceit, a condemnation that the narrator's account of his experience, as well as his own servile, pusillanimous character, amply justify. As against the negative, constricting qualities of European culture, its bad decadence if you like, she places the freedom of transgressive desire encouraged by Chinese culture, what one might call China's good decadence in the Sadian/Baudelairian sense. "In China," she explains, "life is free, happy, total, without conventions, without prejudices, without laws . . . for us at least. No other limits to freedom than oneself, no other limits to love than the triumphant variety of one's desire. Europe and its hypocritical, barbarous civilization is a lie" (JS, 133). Here Clara sounds like a positive voice, advocating individual liberty, boundless desire, and natural vitality. Linked to this advocacy is her strongly worded, anticolonial position, which repeats Mirbeau's own criticism of the religious and scientific pretexts used by colonizing powers to mask their imperial ambitions.[38]

In linking her affirmation of life to an equally strong affirmation of death, Clara agrees with the learned gentleman in the frontispiece who makes a point of declaring that the urge to murder "is not a pathological form of degeneration [but] a vital instinct within us . . . like the sexual instinct," with which it merges so completely that "the two instincts are, in a sense, one and the same" (JS, 44). This idea is part of Mirbeau's rationally conceived decadent philosophy. But by making a woman the embodiment of this philosophy, he deliberately

stimulates misogynist fantasies that contradict its premise. In those fantasies, the conjunction of the instinct to kill and the instinct to love is typically female and is indeed pathological and degenerate.

To illustrate this pathology, Mirbeau pushes his portrait of Clara's death lust to an extreme. She is shown to be erotically stimulated by the spectacle of dying, by dead bodies, and by decomposing organic matter. Mirbeau dwells on the orgasmic pleasure she gets from the odor of rotting meat, on the joy she feels about the way the blood and corpses of victims fertilize the luxuriant flowers of the torture garden, and, most insistently, on the ecstatic delight she derives from watching scenes of torture or even just from hearing about exquisitely inventive tortures—such as that of the caress, in which the victim is bound to a table, gagged, and masturbated without stop until he dies in a massive spurt of blood; or that of the rat, in which a starved rodent is introduced into the rectum of the victim (a torture remembered with delicious horror by Freud's patient the Rat Man).

It is hard to know just how to respond to Clara's morbid libidinal excesses. They seem so outrageous that they should be laughable. Emily Apter suggests (158–65) that Clara is the agent of Mirbeau's critique of the scopophilia and voyeurism satisfied by such popular *fin de siècle* spectacles as the Dreyfus trials, the exhibition of hysterics at the Salpêtrière hospital, and the patriotic display of the exotic spoils of empire. Perhaps Mirbeau did have such critical intentions. But it is difficult to gain enough detachment from the horrors Clara witnesses, and from her intense involvement with them, either to be amused or to decode a political allegory. The driving force of the fantasy of decadent naturalism has too powerful an impact, and the suggestion that there can be any alternative definition of nature is too weak. One of the narrator's few attempts to make such a suggestion is pathetically ineffectual. "Can it be natural," he timidly objects to Clara, "that you search for pleasure in putrescence and that you stimulate your desires to greater heights at horrible spectacles of suffering and death? Isn't that, on the contrary, a perversion of that Nature whose cult you invoke, in order perhaps to excuse the criminal and monstrous character of your sensuality?" (JS, 162).

Nature is not transgressive, nature is not perverse, nature does not love death, the narrator wants to argue. But nothing in Mirbeau's book sustains his objection. On the contrary, the text's vision of natural transgression is so comprehensive that Clara's erotic frenzies do not seem to exceed that vision's fantasy domain. That domain coincides in many ways with the experience of eroticism as described by Georges Bataille. Bataille's analysis of the erotic is closely related to his view of nature's general economy. Just as that economy, originating with the sun's prodigal gift of energy, is based on an exuberant wasting of life, so eroticism is an experience that dissolves the boundaries of the individual's separate, discontinuous existence. That dissolution—which entails behavior society calls *dissolute*—is both obscene, in the opening out of bodies and organs, and violent, in the attack on the individual's established limits and the flirtation with death. Rituals of religious sacrifice, animal or human, had a comparable function, Bataille argues. Participants in the ceremony experienced the sacred as a spectacular revelation of the continuity of being to which death returned the sacrificial victim. In both erotic and sacred experience, we transgress the boundaries of our constituted selves and sometimes of the laws established to protect those selves. We wish to spend ourselves, to lose ourselves, and thereby to participate in the violence of nature's life.

"It takes a lot of strength," writes Bataille, "to perceive the connection between the promise of life, which is the meaning of eroticism, and the sensuous aspect of death. Mankind conspires to ignore the fact that death is also the youth of the world."[39] Mirbeau's Clara has this strength. "Love and Death are the same thing!" she exclaims, "since putrefaction is the eternal resurrection of Life" (JS, 163). The tortures she witnesses have the function for her of sacrificial rituals, whose beauty is the revelation of what Bataille calls "the lie of discontinuity" (E, 107). "It is generally the function of sacrifice," he comments, "to harmonize life and death, to give death the upsurge of life and life the weight, the vertigo, and opening of death" (E, 101). Clara's affirmation of nature's general economy suggests that she has more in common with Zola's Désirée than is immediately apparent.

Désirée celebrates the impersonal process whereby life's decay feeds new life; she is as much at home with death and decomposition as she is with birth and generation. But she is asexual herself. Clara dramatizes what happens to woman in the fantasy world of decadent naturalism when Désirée is transformed from desired object to desiring subject. The entire economy of nature is eroticized in function of female desire.

Mirbeau illustrates this eroticization primarily through the theme of flowers. Like his description of Clara's delight in torture, his treatment of the Baudelairean flowers-of-evil topos seems so outrageous that it could only be satirical. Take, for instance, Clara's violent sexual stimulation by the semenlike odor of the thalictrum, whose pollen-covered flowers at the end of a phalliform sheath she masticates in an erotic frenzy. This imagery appears to parody the anthropomorphic sexualization of floral morphology that was Zola's pseudoscientific contribution to Baudelaire's heritage, and that was further elaborated—with fascinated repulsion—by Huysmans. We are being asked, it would seem, to remember these earlier versions of the demonically erotic flower and to read Clara's botanical ecstasy as a caricature of such decadent iconography.

But here too the parodic effort is counteracted by the function of the parody's object within a fantasized general economy that is not itself subject to parody. "Why would there be so many flowers resembling sexual organs," Clara exclaims—and both Désirée and Albine would agree—"if it were not that nature ceaselessly cries out to living beings through all her forms and all her scents: Love each other! Love each other! Be like the flowers! There is nothing but love!" (JS, 199). Clara's behavior may be grotesque, but Mirbeau offers no perspective from which to critique its claim to be based in nature. It is as if he were trying to kill the decadent poison by intensifying it to the point of auto-destruction, only to find that this lethal concoction actually fertilized what it was supposed to destroy. Thus when the narrator dwells on the Venus flytrap, with its rotten violet color on the inside, its decomposing greenish-yellow tint on the outside—making it "resemble the gaping thorax of dead animals"—and with its "long bleed-

ing spadices in the form of monstrous phalluses" (JS, 224), the reader is tempted to distance himself from the repellent imagery by finding it both derivative and hyperbolic. But Clara is quick to recuperate this excess for her triumphant view of decadent nature. This plant is not a monster, she explains; there are no monsters in nature, only some superior beings, among which she numbers herself, who live "above social lies, in the splendid and divine immorality of things" (JS, 225).

The narrator can find no outside to his vision of decadent female desire encompassing all of nature. When, toward the end of his day in the torture garden, he attributes symbolic value to his experience there, all of existence appears to him as a general economy in which "the Doors of life never open except upon death" (JS, 248). Although he has attempted on a few occasions to distance himself from Clara by seeing her as depraved and perverted, when he sums up the meaning of life he sounds just like her—and, moreover, echoes his friends in the novel's frontispiece: "The individual man and the crowd man, the beast, the plant, the element—all of nature in sum—urged on by the cosmic forces of love, rushes to murder, hoping thus to find outside of life the satisfaction of those furious desires for life that devour nature and that burst forth from it in jets of dirty foam" (JS, 250). Eros is nature is woman is desire is death is life, this is the series of equations that constitutes the narrator's world view, which is sustained by the novel as a whole. The role of the male is suggested by the repellent image of jets of *sale écume*. The narrator concludes his meditation with the exclamation, "Clara is life, she is the real presence of life, of all of life" (JS, 250).

The narrator's self-exclusion from nature is the masochistic fantasy motivating his philosophy of decadent naturalism. He finds it hard to condemn Clara and separate himself from her because she enforces his pleasurably eroticized self-condemnation. "It is the victim who speaks through the mouth of his torturer, without sparing himself," writes Gilles Deleuze of the masochist (M, 22). Mirbeau's own libido seems to be so heavily invested in fantasies of male debasement that even the most outlandish visions of female cruelty and lust are more

gratifying to him than they are absurd. Or perhaps it would be more accurate to say that these visions are gratifying to the extent that they are absurd, the masochist being, according to Deleuze, "insolent in his obsequiousness, rebellious in his submission; in short, a humorist, a logician of consequences" (M, 89).

The reader senses Mirbeau's enjoyment of a language of decadent naturalism that, rather than submit to parodic control, luxuriantly parades its excess. This is why I cannot agree with Emily Apter that the author wishes to punish his reader for collaborating with Clara's scopophilic pleasure in scenes of torture. Mirbeau gets too much masochistic satisfaction from Clara's voyeurism for her scopic violence to be a convincing vehicle of moral and political critique. What he enjoys in her looking, I would argue, is the spectacle of his own castration. Like the narrator, the more he looks—and creates what he sees—the less of a man he becomes. "Of us two, I am the man," Clara declares disdainfully (JS, 217). Whereas Zola rejects castration as a masochistic solution to the problem of male irrelevance in nature, and Huysmans attempts to deny it by elaborating a poetic of antinature, Mirbeau flamboyantly exhibits the loss of masculinity as a desirable means of returning man to nature's general economy, thereby enabling his rebirth.

The novel's final scene, however, seems implicitly to critique this fantasy. Here Clara undergoes the successive stages of a hysterical attack as analyzed by Charcot and illustrated in his Tuesday lecture-demonstrations at the Salpêtrière hospital. Mirbeau does not label these stages, which include the famous rainbow posture, nor does he mention Charcot by name. He is implicitly appealing to the widespread knowledge of the diagnostic iconography of hysteria in order to elicit his reader's recognition of Clara's pathology. But just what is the function of this appeal? Does it distance us conclusively from the narrator's identification of Clara with life itself? Are we being invited to stand with paternal scientific reason against the castrating threat of hysterical femininity? No other aspect of Mirbeau's fantasy-driven novel buttresses this hypothesis. Mirbeau sees reason as a convenient mask for passionate desires to dominate and kill. Perhaps, then, the

implied diagnosis is a kind of ironic citation from the received topoi of decadence, not so much an authoritative scientific analysis as the construction of such an analysis from within the established discourse. A typically perverse femme fatale is hysterical, and the typical description of her hysteria is Charcot's—perhaps that is what we are meant to recognize, with sophisticated detachment.

But the novel ends with Clara's return to mythic status. Although in her sleep she murmurs—like Poe's raven—"nevermore," her servant maintains that she will wake up and avidly repeat her visits to the torture garden. The certainty of her return to desire is symbolized for the narrator by a bronze monkey he perceives in a dark corner of the room holding out a monstrous phallus in Clara's direction. The point is that Clara's hysteria in no way diminishes her primal force in the masochistic male psyche. Indeed, one could well view the monkey's phallus as an illustration of the first of the three forms of disavowal that Deleuze associates with masochism and that I cited earlier in regard to Serge Mouret, the magnification of the mother "by attributing to her the phallus instrumental to rebirth" (M, 100). Rebirth is very much the issue in these final pages of Mirbeau's novel, Clara's rebirth after her hysterical collapse and, in function of it, that of the narrator whose masochism she signifies. The fantasy behind this pairing is actually not unlike that driving Serge Mouret's desire for union with the Virgin Mary: exclusion of the father and male castration welcomed as the means of merger with the mother and of rebirth from her. Mirbeau indulges this fantasy, allowing it to overcome his resistance to its decadent naturalism. Zola is ambivalent, wishing to attribute a more progressive role to nature, which would sustain the claims of sexual difference. Huysmans dreams of short-circuiting nature's general economy and creating decadence in its own realm of living death.

Despite their explicit goal of restoring Mirbeau's reputation, the authors of the huge recent biography, Pierre Michel and Jean-François Nivet, find little to praise about *Le jardin des supplices*. It is, they say, "a literary monstrosity" put together with pieces of previously written texts, lacking unity of tone and consistency in charac-

ter portrayal, and stretching the reader's credulity to the breaking point. "The reader is distraught," they say, "he never really knows how to read the text" (Michel and Nivet, 610). The interpretive difficulty is real, as my disagreements with Emily Apter's strong reading demonstrate. But the novel has survived, despite its evident weaknesses, because of the intensity and coherence of the fantasy material it organizes. Were the novel primarily a political protest appropriating the scandalous Orient in order to make a point about the scandalous Occident, then it would probably have lost interest for us today.

What makes the novel compelling is its visionary extremity. It takes certain received topoi of decadent literature—the insatiable desire of the sadistic woman, the rampant sexuality of flowers, the vital energy generated from organic decomposition—and pushes them to a point of grotesque exaggeration at which they seem almost laughable. At this point the reader may feel that the book is a kind of satiric pastiche of *fin de siècle* themes, such as misogyny, orientalism, or perversion. But the connection between this satire and the political allegory remains puzzling. What relation is there between decadence as a corrupt literary mode and decadence as a corrupt mode of exercising political power? Mirbeau leaves the question unresolved. The political dimension of the book, the theme of the dominating oppression and arbitrary cruelty of the state apparatus, has little resonance as social critique. The public context of social analysis collapses under the pressure of private fantasy. To defend Dreyfus is far less compelling to Mirbeau than to submit to Clara.

This is why the reader's impulse to laugh at the novel's excesses does not persist. In the last analysis, the excesses are not funny because, derivative as they may be, they express a desiring fantasy that is their willing prisoner. Mirbeau needs his torture-loving femme fatale too much for him to expose her as a cliché. She thrills him, and the complicit reader shares the thrill of a terrifying ride through the landscape of decadence. Just as a good amusement park ride is no less stimulating for its familiarity, so Mirbeau's journey into the tunnel of decadence does not lose intensity because we recognize many of the

set pieces. Like other works of late decadence, his book appears at first to cite a received repertory of images and themes in order to make sophisticated fun of their lifelessness but then invests that worn repertory with vital fantasy. It is as if the artist had intended to bury a corpse and had instead revived it and found its life to be his own.

Visions of Salome

Salome is the favorite femme fatale of the *fin de siècle.* In poems, stories, plays, paintings, posters, sculptures, decorative objects, dance, and opera, well over a thousand versions of the Judean princess were made in Europe between 1870 and 1920—and that reckoning does not include all the sketches by Gustave Moreau, whose personal Salome output totals in the hundreds. What accounts for the immense popularity of this theme? The usual answer is that given by Bram Dijkstra in his comprehensive account of representations of feminine evil around 1900. "Salome's hunger for the Baptist's head," he writes, "proved to be a mere pretext for men's needs to find the source of all the wrongs they thought were being done to them. Salome, the evil woman, became their favorite scapegoat, became the creature whose doings might explain why the millennium, that glorious world of the mind's transcendence over matter, did not loom as near as their impatient souls desired."[1] Dijkstra's thesis is that Salome embodies a male fantasy of woman's inherent perversity. She is a predator whose lust unmans man, a castrating sadist whose victims can best survive her violence either by finding masochistic pleasure in submission or, better, by ridding the world of this purveyor of vice and degeneracy.

Misogynist hatred for the Jewish Salome helps prepare the ground, so argues Dijkstra, for the genocidal violence of the twentieth century.

From the broad cultural perspective that Dijkstra adopts, there is no doubt much truth to his thesis, which echoes the views of many other writers on the subject, from Mario Praz to Mireille Dottin-Orsini. No account of possible historical causes for a cultural obsession of this kind can possibly be adequate to the complex overdetermination of the phenomenon. Nevertheless, it is worth mentioning some of the factors that contributed to the climate that nourished the Salome craze. In France, where Salomania begins, the fear of female violence had an historical anchor in the widely disseminated stories of the *pétroleuses* who, during the popular uprising of the *commune* in 1871, supposedly danced in the blood of their victims. The defeat of France at the hands of the Prussians the year before left the country feeling emasculated, and the massive loss of young men made women seem at once more powerful—some were beginning to organize in feminist groups—and more needy sexually. The perception that increasing numbers of young women were sexually frustrated was reinforced by the fact that bourgeois men, wishing to establish themselves financially before starting a family, were beginning to marry later than before. These men could find a sexual outlet with working girls and prostitutes, whereas young bourgeois women were expected to remain virgin until marriage. The increasingly prolonged period of sexual inactivity required of women was widely thought to explain why so many of them were being diagnosed as hysterics.[2] Indeed, medical science often tended to generalize the phenomenon of hysteria and to treat women's sexuality as inherently pathological, the vehicle not only of hysteria but also of other hereditary diseases, such as syphilis and insanity. The fact that syphilis was extremely widespread (there were 85,000 infected people in Paris alone, according to one estimate made in 1890[3]) strengthened the imagined link between active female sexuality—embodied in the prostitute, thought to be the primary source of contamination—and male destruction. The writings of Schopenhauer, enormously popular from the 1880s on, gave

philosophical legitimacy to the idea that women are unconscious instruments of brute natural processes.

The awkward positivism of this quick listing of historical causalities suggests the inadequacy of such explanations to account for a cultural craze such as Salomania. Although there can be little doubt that many of the fears generated by the *fin de siècle* crisis of masculine identity were projected onto the figure of Salome, there can be just as little doubt that this projection rapidly became a popular style of representation rather than the felt expression of a cultural malaise. For artists and writers at a loss for a subject, the decollating princess was always at hand to offer a familiar frisson. Salome fostered imitation and revision, much of it bad. But the Salome theme also produced some of the high points of decadent art, and a close reading of these treatments makes clear that male insecurity and antifeminism are not sufficient to explain the full range of the princess's meanings. Salome's associations with death can be far more complex than those displayed by the vulgar femme fatale theme. These associations operate primarily in two related contexts, that of subjectivity and that of language. As I will show, Salome in these contexts often has a positive function. She creates overtures to new modes of insight concerning the role of negativity in the psyche and in writing. In what sense these modes can be understood as decadent will, once again, be a subject of our inquiry.

Early in his career, when he decided to undertake a poem that would illustrate his new poetics—"To paint not the thing but the effect it produces"[4]—Stéphane Mallarmé chose the Salome story as perfectly suited to his enterprise. What suited him in particular was that he would write *against* this story, evoking it in order to erase it. He began by changing Salomé's name to Hérodiade, explaining in typically convoluted syntax: "I kept the name of Hérodiade in order to differentiate her from the Salomé whom I will call modern or exhumed, with her archaic anecdote—the dance, etc., to isolate her, as have solitary pictures, in the fact itself, terrible, mysterious—and to make shimmer what probably haunted, in her appearance with her attribute—the head of the saint—even if the young lady were to con-

stitute a monster in the eyes of the vulgar lovers of life."[5] In Mallarmé's interpretation, Salome is a prisoner of history, of archaic anecdotes, whereas Hérodiade is "a purely ideal being, absolutely independent of history."[6] To write *Hérodiade* is to enact this negating transfiguration, to cancel the desire of the femme fatale and produce in its stead a mysteriously haunting effect. That production, as I read it, annihilates the world of decadent desire in order to create a world of symbolist decadence. Salome's murderous impulse is replaced by the gaze that annihilates Hérodiade.

Begun in 1864, *Hérodiade* remained incomplete at the time of Mallarmé's death. The section entitled "Scène" retains a dialogic form from the author's early plan to write the poem as a tragic drama. In the exchanges between Hérodiade and her nurse, no mention is made of the biblical narrative. Not a single word is uttered that could connect Hérodiade to Salome and her "archaic anecdote." The nurse's questions and exhortations are merely pretexts for Hérodiade's verbal self-definition, or rather, for her explanation of why and how her self is absent. The vehicle of that absence is a mirror. In it, Hérodiade does not find her image reassuringly composed as a whole; rather, she finds a surface constituted of metallic gleams, radiating from her golden hair, and of effulgent flashes, blazing from her jewel-like eyes. No wonder that she exclaims in horror at this mortifying effect of her specular contemplation. Yet she also wants to maintain the barren, isolated, immaculate existence that the mirror holds in its "frozen frame."[7]

"Will you die, then, Madam?" (OCM, 48) asks the nurse, making explicit what is at issue in Hérodiade's "idolatry of a mirror" (OCM, 48). Psychoanalytically inclined readers might be tempted to interpret Hérodiade's specular self-perception in terms of the Lacanian mirror phase, in which the subject celebrates its unity by identifying with an image that is alien to it. But this interpretation would be mistaken. Mallarmé does indeed illustrate something fundamental about subjectivity, but this something concerns the subject's erasure rather than its constitution. The image perceived in Lacan's mirror, however deluded the viewer may be about its being the same as himself, is

nevertheless human and familiar. This cannot be said of what Héro-
diade sees in her mirror, which erases her humanity, through "the
shimmering of a surface, . . . a play of light and opacity."[8] These are
phrases Lacan uses to describe what he calls "the gaze." The gaze orig-
inates in the world. It is terrifying, yet fascinating, for, like the evil
eye, it "has the effect of arresting movement and, literally, of killing
life" (FF, 118). Such is the "knowledge" that Hérodiade attributes to
the gems and metals that cover her "useless flesh" (OCM, 47):

> Vous le savez, jardins d'améthyste, enfouis
> Sans fin dans de savants abîmes éblouis,
> Ors ignorés, gardant votre antique lumière
> Sous le sombre sommeil d'une terre première,
> Vous, pierres où mes yeux comme de purs bijoux
> Empruntent leur clarté mélodieuse, et vous
> Métaux qui donnez à ma jeune chevelure
> Une splendeur fatale et sa massive allure! (OCM, 47)

> You know this, gardens of amethyst, deep
> In the dazzling, unfathomable caves where you sleep;
> Hidden gold hoarding your antique light
> Beneath the dark slumbers of primordial night;
> You stones, like the purest gems, whence my eyes
> Borrow melodious charities;
> And metals that give to my youthful hair
> Its fatal splendor and massive allure.[9]

As an expression of narcissistic love of oneself, these lines make little
sense, for Hérodiade is fascinated not by the presence of her image in
the mirror but by its absence. She does not perceive herself as the
subject of a look but as the object of a gaze. It is as if the source of
light resided in objects outside herself—the "antique lumière" ema-
nating from "Ors ignorés," the luminosity that stones give to her
eyes, the "splendeur fatale" that metals convey to her hair. In a side
remark with particular relevance to Mallarmé, Lacan comments that
"the point of the gaze always participates in the ambiguity of the
jewel" (FF, 96). That ambiguity, as I understand it, resides in the way
the jewel's beauty, rather than reinforcing narcissism as one might ex-

pect of an ornament, actually reflects the subject's dissolution in the field of the other.

This analysis illuminates a crucial function of jewels and gems in decadent literature: they are not merely decorative objects but, more significantly, emblems of the subject's attraction to death. Think of the description of Salammbô quoted on page 51 (which may have influenced Mallarmé, who began writing *Hérodiade* in the year Flaubert's novel appeared). What fascinates Mathô in looking at the Carthaginian princess is the way her organic being is continuous with her sparkling, bejeweled surface. Flaubert's apposition, "Ses yeux, ses diamants étincelaient," expresses something similar to Mallarmé's line, "Hérodiade au clair regard de diamant" (OCM, 48) (Hérodias whose gaze is diamond keen). Light is reflected from eyes as it is from diamonds, and the meaning of that reflected gaze is death—hence its appeal and its terror.

What is most radical about Mallarmé's poetic project is that he wants words themselves to be like jewels and give off the gaze. "The pure work," he writes in "Crise de vers" (1895), "implies the disappearance of the speaking poet, who yields his initiative to words, mobilized by the shock of their differences; they light up with reciprocal reflections like a virtual trail of sparks over jewels, replacing the breath perceptible in the old lyric impulse or the enthusiastic personal shaping of the sentence" (OCM, 366).[10] Pure poetic language, Mallarmé suggests, gives words the density of objects that reflect light. Language becomes alien to subjective intention: it does not express a speaker but rather his disappearance. Words "light up" as if with a gaze that silences the poet's voice and blinds his vision.[11]

That the trope of castration is at the core of this transcending move "against nature" is brought out in the short poem "Cantique de Saint Jean" (OCM, 49; CP, 36), which Mallarmé planned as a section of Hérodiade but did not publish in his lifetime. Notoriously difficult, this gem of a poem is spoken by John's head at the precise moment of its "rupture franche" (clean rupture) with its body. The head surges upward, triumphantly free from "les anciens désaccords avec le corps" (the ancient disharmony with the body), into a realm where

its "pur regard" (gaze profound) contemplates a frozen eternity. Here the gaze is explicitly linked to beheading/castration: what the head "sees" is what is severed from sight, what is unnatural and alien. The unseen seen is, in Mallarmé's reflexive aesthetics, the poem itself as object, "illuminée au même principe qui m'élut" [illuminated by the principle that chose my consecration] (OC, 49; CP 36–37).[12] Castration functions, thus, as the symbol of release from the mimetic imperative. It is a release similar to the one Mallarmé associates with dance. Writing about ballet, he praised the way dance erases woman as such and makes her into a metaphor for "our form," into "a corporeal writing, . . . a poem detached from the instrument of any scribe." Not surprisingly, the first two examples he gives of this form are props of the Salomé story, a sword and a platter: "The dancer *is not a woman who dances,*" he claims paradoxically, using italics to emphasize the obliterative point, "for the juxtaposed reasons that *she is not a woman,* but a metaphor of our form, sword, platter, flower, etc., and that *she does not dance*" (OCM, 304).[13]

Dance is like poetry in that it reflects the subject as pure aesthetic form. The gender dynamics of the transaction have much in common with the Nietzschean move I analyzed in chapter 1, whereby woman's magical "actio in distans" transfigures her "repulsive natural functions" into the "soul and form" of male aesthetics (see above, p. 22). Mallarmé makes this move when he "transposes" (his favorite word for the purifying work of poetry) the "modern or exhumed" Salome into the "haunted . . . ideal" Hérodiade. Mallarmé wants language to be the agent whereby the subject experiences its own erasure. Or I should say *his* erasure, for the creation of death is for Mallarmé, as for many other decadent writers, the defining accomplishment of masculinity. Hérodiade is Mallarmé's name for this creation, a name whose meaning is the erasure of its referent's history.[14]

The decadence of Mallarmé's symbolist enterprise was explicitly recognized by Joris-Karl Huysmans, who associated the poet's achievement with an ability to express the work of death in language. But Huysmans thought about death in a markedly different way from Mallarmé, and that difference necessarily affects the meaning of

decadence as it is applied to the two writers. Death in Mallarmé occurs by means of a certain linguistic operation: the subject is dissolved—or, from another conceptual viewpoint, is castrated—through the negating performance of words. Such an idea is abstract and cerebral. Huysmans's sensibility, in contrast, is much more naturalistic. *A rebours* may be the work that awarded other works the stamp of decadent authenticity, but the terms of that award often refer insistently to the organic world. Thus, what des Esseintes appreciates about the death principle, and what he finds at work in Mallarmé's language, is not the erasure of subjectivity but rather the pathologization of the verbal body itself. Citing lines from *Hérodiade,* he praises their highly condensed, suggestive style for its exquisite morbidity: "The truth of the matter was that the decadence of French literature, irreparably affected in its organism, weakened by intellectual senility, exhausted by syntactical excesses, sensitive only to the curious whims that excite the sick, and yet eager to express itself completely in its last hours, determined to make up for all the pleasures it had missed, wishing on its death bed to leave behind the subtlest memories of suffering, had been embodied in Mallarmé in the most consummate and exquisite fashion."[15] The link between symbolism and pathology that des Esseintes appreciates in Mallarmé is also the origin of his attraction to the paintings by Gustave Moreau that he owns, *Salome Dancing before Herod,* in oil (fig. 1) and *The Apparition,* in watercolor (fig. 2). First exhibited at the salon of 1876, then again at the Exposition Universelle of 1878, these paintings were bought shortly thereafter and became unavailable for viewing by the general public. So Huysmans's ekphrases took the place of the artworks themselves for many readers and became arguably the most famous representations of Salome in the *fin de siècle.*[16] His description of des Esseintes's desiderata in the acquisition of these pictures combines a symbolist program ("he had wanted . . . some evocative works that would propel him into an unknown world") with a naturalist description of the desired psychosomatic consequences ("shattering the nervous system through erudite hysterias, complicated nightmares, nonchalant and ghastly visions"—AR, 145; AN, 63). Morbid

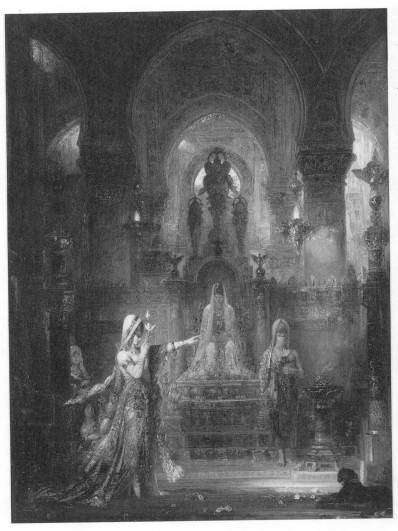

Fig. 1. Gustave Moreau, *Salome Dancing before Herod*, 1876. Oil on canvas, 143.5 × 104.3 cm. The Armand Hammer Collection, UCLA at the Armand Hammer Museum of Art and Cultural Center, Los Angeles.

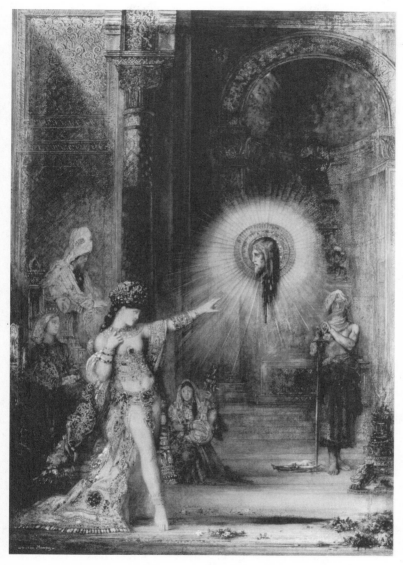

Fig. 2. Gustave Moreau, *The Apparition,* watercolor. Réunion des Musées Nationaux/Art Resource, NY.

symbolist suggestion appeals to des Esseintes, it would seem, because it stimulates a certain masochistic enjoyment, a shattering of the self through hysterias, nightmares, visions. Indeed, he says a little later that Salome's "maddening charm and potent depravity," entirely absent from the biblical account, had been accessible through the ages "only to brains shattered, sharpened, and rendered almost visionary by neurosis" (AR, 148; AN, 65). What is attractive about decadence for des Esseintes is the access it gives through visionary neurosis to a new experience of subjectivity. And Salome is his preferred agent of this stimulating castration.

According to des Esseintes's ekphrasis, the Salome in oil appears to be a site of subjective obliteration of the kind Mallarmé associates with "a trail of sparks over jewels": "Her bracelets, her belts, her rings all spit out fiery sparks; and across her triumphal robe, sewn with pearls, patterned with silver, spangled with gold, the jeweled cuirass, of which every chain is a precious stone, seems to be ablaze with little snakes of fire" (AR, 147; AN, 64). But this evocation of lapidary reflections is actually quite different from Mallarmé's, for here the fiery stones are imagined as hostile weapons. Des Esseintes does not wish to be frozen in the mirror, as does Hérodiade; on the contrary, he wants to exacerbate his neurosis. Toward this end, he completely misrepresents the pose of Moreau's dancer, who is immobilized in suspension just above the floor, her impossibly pointed feet sustaining no discernible weight. According to des Esseintes, however, she is engaged in a "lascivious dance" in which "her breasts rise and fall, the nipples hardening at the touch of her whirling necklaces" (AR, 147; AN, 64). The "little snakes of fire" given off by Salome's jewels feed des Esseintes's desire to feel subjected to this "strange and superhuman Salome of his dreams" (AR, 148; AN, 65). But she is superhuman in an entirely naturalistic manner. Her symbolic attributes are those of the archetypal femme fatale, the dreaded Other of man, whose pleasure is his undoing. Salome becomes, says des Esseintes, "the symbolic incarnation of undying Lust, the goddess of immortal Hysteria, the accursed Beauty, exalted above all others by the catalepsy that hardens her flesh and steels her muscles; the monstrous

Beast, indifferent, irresponsible, insensible, poisoning, like the Helen of ancient myth, everything that approaches her, everything that sees her, everything that she touches" (AR, 149; AN, 66). In this famous passage, the decadent topos of the masochistic male exalting the poisonous agent of his own destruction achieves a kind of rhetorical paroxysm. There is no psychological complexity here, only a kind of theatricalized citation of misogynist tropes, whose excess flirts with over-the-top absurdity.

But Huysmans's evocation of Moreau's painting does not end with this purple passage. It provides, one might say, a kind of essentialist reassurance on the basis of which Huysmans/des Esseintes undertakes a more speculative exploration of psychological structures. That speculation is as much a part of the decadent construction of Salome as is the misogynist topos. Questioning the meaning of the lotus Salome is carrying, des Esseintes's thinking revolves around the relation of the phallus and castration to the symbolic construction of woman in male fantasy. First, he speculates that the flower may have "a phallic significance," as if the femme fatale gained her power by symbolizing masculinity; then he switches to what seems like a contrary interpretation: it may represent, he suggests, "an impure wound," the sign of mutilation and lack, "an exchange of blood . . . offered to the old Herod on the express condition of a murder." Next he proposes that it could be "an allegory of fertility" and crazed male desire, the emblem, in other words, of man's sense of his own neediness in contrast to woman's generative power. Then he returns to the misogynist archetype and wonders if Moreau might not have been thinking of "the dancer, the mortal woman, the soiled Vessel, cause of all sins and all crimes" (AR, 150; AN, 66). Finally, he proposes an interpretation that is clearly a fetishistic defense against the previous evocations of woman's shifting significance. The lotus now becomes a tool of male control over female sexuality. The ancient Egyptians, he remembers, had an embalming ritual whereby male experts, chemists and priests, empty a woman's corpse of its internal organs, insert a lotus flower to purify the sexual parts, and ornament the body's surface by gilding the nails and teeth.

My point is that des Esseintes finds Moreau's painting "irresistibly fascinating" not just because it embodies his dream of female evil but because it stimulates his thinking about the symbolic construction of gender. His contemplation of Moreau's watercolor, *The Apparition,* offers yet more intense stimulation for this thinking, creating "still more anxiety in him" (AR, 150; AN, 67). Interestingly, he has nothing to say about what most viewers would consider the painting's psychological narrative, the guilty conscience that causes Salome's hallucination of the Baptist's head suspended in the air before her. Des Esseintes does not read the painting in terms of traditional humanism or religious morality. The confrontation, as he sees it, is not between good and evil, saint and sinner. There is nothing in such a banal interpretation to stimulate his neurosis. Nor is there much to provoke welcome anxiety about his claim that in this picture, as in the oil painting, Salome embodies essential female nature. The difference that he claims to perceive between the two paintings—that she is a goddess of evil in the oil and "a true whore, obedient to her passionate and cruel female temperament" (AR, 153; AN, 68) in the watercolor—has no iconographic basis and seems to function as a misogynist basso continuo (she lusts after what she lacks), sustaining a more complex meditation on the function of lack in the formation of subjectivity.

Both Mallarmé and Huysmans give reflexivity a major role to play in visualizing this lack. For Mallarmé, the mirror/head represents an otherness that has no subjective meaning. The goal of Hérodiade's narcissism is to erase psychology, narrative, and the notion of narcissism itself. She needs the other only insofar as it enables her to appropriate it as the principle of her own negation. Thus Salome becomes Hérodiade, who is nothing more than the poem itself as aesthetic object.[17] In Huysmans's text, in contrast, reflexivity is the very principle of subjective formation. The beheaded saint and the agent of his death are equally horrified by each other and equally in thrall to the other's look. Whereas the severed head in Mallarmé conveys the "pure gaze" of the other, in Huysmans it is caught in an exchange of looks that undermines the self-other distinction, and with

it the distinction of the sexes (Moreau's entire oeuvre, peopled with androgynous figures, is exemplary in this respect).

These destabilizing implications of Salome's portrayal are what attracts des Esseintes to her, to the point of identification. He feels "crushed, subjugated, stunned before the dancer" (AR, 152; AN, 68), precisely as he imagines that she feels "petrified, hypnotized by terror" (AR, 152; AN, 68) before the hallucinated head. But des Esseintes also identifies with the head, imagining it as an agent of revenge against the naturalist Salome, which transforms that "great venereal flower" (AR, 153; AN, 68) into a decorative surface as artificial as Mallarmé's version of the princess. The rays emanating from John's aureole, des Esseintes claims, "draw the woman's body in incandescent strokes, prick her on the neck, legs, and arms with points of fire, vermilion like coal, violet like jets of gas, blue like alcohol flames, white like astral rays" (AR, 152; AN, 68). Salome is thus immobilized and transformed into a kind of ornamental mummy. Subjected to the apparition, Salome, like Mallarmé's dancer who does not dance, is "nailed to the spot, . . . clad only in wrought metals and translucent gems" (AR, 151; AN, 67).

Des Esseintes identifies both with the head's sadistic look and with its masochistic object. These identifications, as I read them, illustrate the construction of male subjectivity and suggest that this construction is decadent insofar as it is a function of castration. Castration offers both an essentialist interpretation of woman's lack, which justifies the misogyny so characteristic of decadent sensibilities, and a constructivist interpretation of the male subject as a mobile play of identifications and reflections. Hence the crucial role of castration as the foremost trope of decadence: it is at once naturalizing and denaturalizing; it insists on the most retrograde misogynist ideology, yet it opens a radically new view of the operations of negativity in the psyche.

Salome continues to narrativize this trope throughout the *fin de siècle.* By the time we get to 1901, the date of Jean Lorrain's *Monsieur de Phocas,* much of the imagery related to her story has become familiar and worn. Yet Lorrain's novel, derivative as it may be, is inter-

esting nevertheless for the way it foregrounds the role of death in the construction of decadent subjectivity. I will therefore turn now to a brief discussion of this late work by Lorrain, indefatigable chronicler of the 1880s and 1890s; author of countless journal articles in which he pilloried friend and foe alike; prolific writer of stories, poems, and novels; notorious homosexual, anti-Semite, drug user, and connoisseur of perversions; enemy of Robert de Montesquiou, Paul Bourget, and Marcel Proust (with whom he fought a duel); friend of Huysmans, d'Annunzio, Rachilde, and Sarah Bernhardt. Phocas tells his own story through a series of journal entries, dated from April 1891 to July 1899, the majority being from 1898 and 1899. The last of an aristocratic line, like des Esseintes, Phocas's real name is Duke de Fréneuse. Twenty-eight years old, he has spent his time thus far collecting gems and jewelry and indulging his perverse tastes. His journal has nothing to say about political events, such as the Dreyfus affair. Some historical figures do appear, and there are some accounts of debauched social gatherings, but the external world is important only insofar as it serves Phocas's visionary neurosis, which is fixated on the gleam of "a gem or look."[18] Thus is introduced a conjunction of jewel and look, familiar to us from Mallarmé and Huysmans—and identified here as there with Salome—that Lorrain will elaborate obsessively throughout this book.

Just what is this look that haunts Phocas, this "blue and green thing that was revealed to [him] in the dead water of certain gems and the even deader water of certain painted looks" (29–30)? Although the novel poses this question over and over again, it keeps any possibility of a clear answer in suspension.

What does it mean to look for a look? Reflexivity is fundamental to the narrative of such a quest, or rather such a "possession" (18). The look is apparently in the external world, since one can go looking for it. Yet Phocas says that "no human eyes" possess the particular gleam in question and that, when he finds it "in the empty socket of a statue's eye or under a portrait's painted eyelids," this is only a deception [*leurre*], a luminosity that quickly disappears (19). So the look in question belongs neither to other human subjects nor to artistic

representations, though it may provisionally glimmer in their eyes. It is like the Lacanian gaze; it refers to subjectivity by suggesting its erasure. Its function, it would seem, is to make the subject aware, through the *leurre* of difference, that the other is only a mask in which the self perceives that it has no substance.

Masks, indeed, are a major theme in the novel. Phocas at one point becomes fascinated by masks, imagining that behind them are the liquid green eyes he loves. But soon everyone he sees appears to be masked. The association of masks with castration, beheading, and death is brought out by both of Phocas's mentors, the Irish lord Sir Thomas Welcome and the English painter Claudius Ethal. Although the former appears to be working to save Phocas and the latter to damn him, the difference between them tends to dissolve in a play of interchangeable masks.

This dissolution occurs most dramatically when the two men, independently of each other, recommend that Phocas visit the Gustave Moreau museum. Cultivated aesthete that he is, Phocas is already well acquainted with Moreau, whom he thinks of as "the painter and thinker who has always troubled [him] the most" (212). The purely literary derivation of that psychic trouble is evident from the fact that Phocas's response to Moreau's visionary depictions of women in ecstasy repeats part of Huysmans's ekphrasis nearly word for word ("they subjugate the will all the more surely with their charms of great passive and venereal flowers, grown in a bed of sacrilege"— 212–13). Phocas had already evoked this misogynist image of Salome as femme fatale earlier in his journal when he watched the performance of a music hall dancer named Izé Kranile. Although there is no indication that her dance had anything to do with the Salome theme, Phocas identifies Izé in Huysmanian terms as "the creature of perdition execrated by the prophets, the eternal impure beast" and immediately evokes "the immemorial image": "Salome! Salome! the Salome of Gustave Moreau and of Gustave Flaubert" (42). It is the way Izé embodies essential female difference that Phocas finds attractive here. For a moment he imagines she could "cure" him through the unassimalable vulgarity of her otherness. But this is a fleeting

delusion. Izé/Salome represents the essentialist basis on which decadent subjectivity constructs itself reflexively. Such a fleshly female is fundamentally repellent to Phocas, who periodically feels the urge to strangle women ("The palpitation of life has always filled me with a strange rage to destroy," he remarks—27).

Yet Salome can also be the vehicle of the mysterious look, as Phocas recognizes when he thinks of the Moreau pictures he will see in the museum with their "long nudities, terror-stricken eyes, and dead sensuality" (212). When he gets to the museum, however, it is not the Salomes, familiar already, that attract him the most. His attention is drawn to the gaze of two young men, whose gestures indicate that they are welcoming the death about to befall them from the arrows of Odysseus, killer of his mother's suitors in Moreau's epic canvas *Les prétendants* (fig. 3). This painting is a celebration of masochistic passivity, a glorification of feminized men. Adolescent male bodies, sprawled in supine languor, are displayed for the viewer's sensuous appreciation. The heroic agent of the massacre is almost indistinguishable, a tiny figure in the background. His power is symbolized by the goddess Athena, whose body, floating in midair, is surrounded, like the Baptist's head in *The Apparition,* by an aureole of luminous rays. This displacement of attention away from the male killer onto the goddess suggests a reluctance on Moreau's part to underline the explicitly male-to-male sadomasochistic eroticism his scene nevertheless evokes. It is to this eroticism that Phocas responds. Here, finally, are the eyes of his dream, the "inexpressible eyes" (217) of men about to die, of men looking death in the face. They echo those of a handsome farmhand run over by a haycart on the family estate, into which Phocas had gazed as a boy of eleven. Those "watery pupils," he reflects, "had in them everything I desired and that I have searched for since. They were the first revelation of an impossible happiness" (193).

Here the novel's disguised homosexual subtext becomes clear. Phocas's search for the look is premised on a turn away from real women.[19] The mythical female figures that are carriers of the look, Salome and Astarte in particular, have the role of Athena in Moreau's

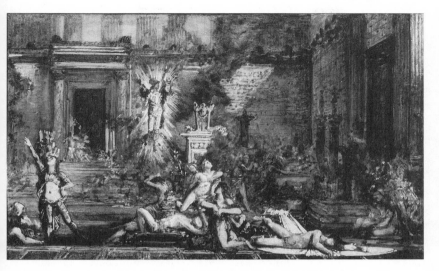

Fig. 3. Gustave Moreau, *Les prétendants,* oil. Réunion des Musées Nationaux/Art Resource, NY.

painting: they are stand-ins for the male sadist from whom the masochist desires self-shattering pleasures. The other exists in the world only insofar as it represents the subject's castration. Hence the proliferation of masks, doubles, severed heads—and of the look itself, which, despite his never being satisfied that he has found it, Phocas does actually locate in many places (a statue of Antinoüs in the Louvre, a girl dying of ovarian cancer in a Venetian hospital, an androgynous statue of Astarte in black onyx with a death's head in the place of her sexual organs, and so forth—somehow he makes nothing of the fact that Welcôme's eyes are themselves "at once green and violet like the water of a dead pond"—118). To see an image of his own constitution as castrated, this is what excites Phocas, despite his claim that he wishes for a cure.[20]

This is decadent subjectivity at its most regressive: what is appealing about the other is the way it has the same at its core.[21] The look contains water in its greenish pupils. Phocas associates that water with the ocean, suggesting a desire for dissolution in an archaic fluid-

ity (he talks of the "terrible atavisms" that the look stimulates in him—47). This atavistic desire gets caught up in the perverse interplay of Phocas's sadomasochism when he murders Ethal by forcing him to swallow the liquid poison contained in an emerald modeled after one that once served as an artificial eye. Here the look literally kills, the sadistic counterpart to Phocas's masochistic pleasure in drinking "the liquid poison frozen in the pupils" of certain portraits in museums (36). Thus Lorrain illustrates the claim Freud will make some twenty years later that sadomasochism serves the death drive. The water held inside the jewel suggests the enclosure of the maternal fluid by the inorganic matter to which Freud postulated that all living beings wish to return.

Sensationalist and melodramatic though it may be, Lorrain's text dramatizes a vision of Salome that includes but goes well beyond a banal image of the femme fatale. Salome is internalized as an attractive figure of self-destruction and death. She represents within the subject the subject's desire to see his own castration. Of just what such a sight might be is the obscure question Lorrain's novel never answers. It is by no means an idiosyncratic preoccupation in the decadent period: the look has played a crucial role in each of the works I have examined so far. And its role is absolutely central, indeed obsessively so, in the work to which I want to turn now, Oscar Wilde's play, written in French in the fall of 1891 with the friendly counsel of, among others, Jean Lorrain.[22]

The theme of looking is introduced in the play's second speech, when the page of Herodias tries to persuade the young Syrian, whom he loves, to look away from Salome: "Look at the moon. How strange the moon seems. She is like a woman rising from a tomb. She is like a dead woman. One might fancy she was looking for dead things" (WS, 195). This speech is characteristic of many others in *Salome*. The sentences are short. There are no connectives between them to indicate logical relation. Each paratactic sentence has a kind of declarative autonomy, as if it were a talking head without a body. The effect is typical of a decadent style as defined by Paul Bourget

(see above, p. 10). Individual words are foregrounded through their recurrence from sentence to sentence, which produces a rhythmic, incantatory effect. In the above passage, "moon" occurs in sentences 1 and 2, "woman" and "like" in sentences 3 and 4, "dead" in sentences 4 and 5, "look" in sentence 1, and "looking" in sentence 5. The semantic counterpart to this rhythmic suspension of linear syntax and atomistic decomposition of textual wholeness concerns the meaning of the look. The page suggests that to look at the moon is not to see what is but what seems. The look discovers the strangeness of things, how they are like other things, how, one might say, they are constitutive of a rhythm. The vehicle of the look's apprehension of strangeness is metaphor, which functions through verbal displacements and substitutions. The passage associates this process with a dead woman and the reanimation of her corpse. Male fancy recreates woman's strangeness and attributes to it a necrophiliac drive. Originating in a metaphor, this drive is energized by rhetorical rather than psychic force.

Admittedly, this reading pushes interpretation to what may seem like an exaggerated extreme. This extremity is, however, the necessary point of analytic departure if one takes seriously Wilde's claim that "the primary aesthetic impression of a work of art borrows nothing from recognition or resemblance."[23] The verbal repetitions in Wilde's sentences create a sense of ritualized artifice, as if talking were a mode of reciting. Likewise, looking becomes a veil over the seen, a vehicle of productive non-recognition rather than of mimetic apprehension. To pull a veil of metaphor over the object of sight is, so to speak, to suspend its life, but also to prolong that life in the shimmering folds of the veil's unfurling.[24]

The value of such a veil is the lesson Herod learns from his experience of desire. "One should not look at anything," he says. "Neither at things, nor at people should one look. Only in mirrors is it well to look, for mirrors do but show us masks" (WS, 229). This sounds like advice Lorrain's Claudius Ethal might give to Monsieur de Phocas. But the mirror in Lorrain has a more psychological function than it does in Wilde. Lorrain's masks represent modes of subjectivity imag-

ined in masochistic subjection; Wilde's masks are vehicles of subjective loss, of ventriloquization and transvestism. They displace the immediacy of sensation through the play-giarizing imagination. Salome is an expert at this kind of displacement. Seeing Jokanaan for the first time, she finds his eyes "terrible," a direct emotional response, then she proceeds to create masks that aestheticize her feeling: "They are like black holes burned by torches in a tapestry of Tyre. They are like the black caverns of Egypt in which the dragons make their lairs. They are like black lakes troubled by fantastic moons" (WS, 206). These metaphors have no epistemological value; rather than helping us "see" Jokanaan's eyes more clearly, they offer verbal masks that mirror Salome's literary constitution. This mirroring function is particularly striking when Salome evokes Jokanaan's physical attractions in terms borrowed from the Song of Songs: his white body is "like the lilies of a field," is "like the snows that lie on the mountains of Judaea" (WS, 208), and so forth. The "likes" proliferate as Salome plunders the language of erotic psalmody to describe Jokanaan's incomparable body, hair, and mouth, each symbolically linked to a color (white, black, red). When Jokanaan rejects her advances, Salome simply switches metaphoric masks, from beautiful to hideous. Having first compared Jokanaan's hair both to clusters of grapes and to cedars of Lebanon, an incongruous pairing that suggests how dissociated rhetorical display is from its object, she sees his hair after his rebuff as "a knot of serpents coiled around [his] neck" (WS, 208). Salome has exchanged the mirror of Narcissus (which is like that of Mallarmé's Hérodiade, cold and virginal: "like an image of silver . . . chaste as the moon"—WS, 206) for that of Medusa, but her gaze has remained reflexive.

Not so her desire, and this conflict is the crux of the play. None of the characters manages to follow Herod's advice and look only in mirrors and be satisfied with masks. This is the achievement of the Baptist's speaking head in Mallarmé's poem. Wilde's characters, in contrast, are unable to disconnect their gaze from the concupiscence of desire. The vehicle of that concupiscence is a mimetic language that offers an illusion of presence, both of a psychological subject and

of a natural object. Speeches by Salome such as "I desire to speak with him" (WS, 202), "I will kiss thy mouth, Jokanaan" (WS, 209), or "I demand the head of Jokanaan" (WS, 229) are antireflexive: they express a desire for the referent itself rather than for its metaphoric displacement. In this mode, displacement is perceived psychologically as the frustration of desire: the page wants Narraboth, Narraboth and Herod both want Salome, Salome wants Jokanaan, Jokanaan wants God. Desire never coincides with its object: this is the tragic psychological truth conveyed by the play's naturalistic mimesis. Salome is the embodiment of that desire, shocking in what Kate Millett calls her "insatiable clitoral demand"[25] and, when rejected, in the violence of her vengefulness. Many discussions of the play focus on this naturalistic dimension. Katharine Worth, for instance, explains Salome's psychology as that of "a girl fiercely defensive of her virginal integrity who, by the end of the play, "has learnt to the full what passion is and has learnt through her suffering the value of love."[26]

Such a reading neglects the destabilizing effects of the intersection of symbolist and naturalist modes in Wilde's play, effects that define its peculiarly decadent irresolution. The mimetic and metaphoric orientations are not as distinct as my discussion so far has suggested. For instance, Salome expresses her desire to touch and kiss Jokanaan in nearly identical short phrases that are like refrains in a poetic structure rather than lustful outcries: "Suffer me to touch thy body. . . . Suffer me to touch thy hair. . . . Suffer me to kiss thy mouth" (WS, 201–9). Desire here is a mask carefully made up in a verbal mirror. Its very orientation, indeed, may be affected by metaphoric masking. Salome's part-by-part praise of her beloved's physical attributes derives from the Renaissance *blason* tradition, in which a male poet gazes admiringly on a woman and searches for adequate images to evoke her qualities.[27] As the subject of the gaze and the creator of metaphors, Salome takes over this male position. Thus gender identities are detached from essentialist definitions, and Salome, the archetypal femme fatale, becomes "like" a man, a homosexual in love with a man who rejects his passion. Once this slippage is noted, and gender takes on the qualities of a mask, then the desiring vectors in the play

begin to vacillate. Jokanaan's refusal to be touched is reminiscent of Hérodiade's similar refusal in Mallarmé's poem; Herod appears to be as susceptible to Narraboth's languorous charms as is the page. Salome's carnal lust can be read as a parodic collage of decadent fantasies about the castrating femme fatale. She wants to kill men, specifically, to dismember them: "Well, I tell thee, there are not dead men enough" (WS, 234). She gets erotic pleasure from cannibalizing male corpses: "I will bite [thy mouth] with my teeth as one bites a ripe fruit" (WS, 234), she says to Jokanaan's taciturn head. She loves revenge and delights in perverse cruelty: "Well, I still live, but thou art dead, and thy head belongs to me. I can do with it what I will. I can throw it to the dogs and the birds of the air" (WS, 234). Her lust knows no bounds: "Neither the floods nor the great waters can quench my passion" (WS, 236).

Just how seriously should one take these declarations? Many critics have taken them dead seriously. Elliott Gilbert, for instance, speaks of "Wilde's vision of patriarchal culture under attack by a destructive female nature."[28] The horror for Wilde, Gilbert speculates citing Freud, was that he imagined Salome's desire as deriving from her castration. But this is to neglect the crucial point I have stressed throughout this chapter: Salome's function in decadence is not only to exemplify the castrated/castrating female but also, often simultaneously, to put that image in doubt, to give it a mask, and to make it dance.

That dance is often parodic and intertextual.[29] Composed in a feverish state of Salomania, Wilde's play often seems like a collage of earlier versions of the princess's story.[30] Echoes of Flaubert's "Hérodias" and *Temptation of Saint Anthony* can be heard throughout, especially in the debates among representatives of the different religious sects. Herod's description of the jewels he is willing to offer Salome is lifted from Hamilcar's inventory of his treasure in *Salammbô*. Salome's early association with coldness, chastity, the moon, and the mirror derive from Mallarmé's *Hérodiade*. Noticing these and other borrowings (from Maurice Maeterlinck, for instance, whose *La princess Maleine* [1899] has plot elements in common with Wilde's

play and whose repetitious, incantatory style Wilde clearly imitated), early reviewers accused Wilde of a lack of originality.[31] "The reader of *Salome* seems to stand in the Island of Voices," complained an anonymous reviewer in the *Pall Mall Gazette* in 1893. "[*Salome*] is the daughter of too many fathers. She is a victim of heredity."[32] But Wilde deliberately subverts the biological metaphor of literary paternity. As far as he is concerned, the imagination is creatively murderous. It castrates the fathers in order to wear their authority as masks.[33] "Of course I plagiarize," he told Max Beerbohm. "It is the privilege of the appreciative man. I never read Flaubert's *Tentation de saint Antoine* without signing my name at the end of it. *Que voulez-vous?* All the best hundred books bear my signature in this manner" (OW, 376).[34]

The drama's final moment demonstrates the potentially violent consequences of a mimetic denial of reflexivity. As Herod is about to retreat into his palace, he turns around, sees Salome embracing Jokanaan's severed head, and orders her to be killed. His gaze is in direct violation of his own taboo against looking at anything other than mirrors. Indeed, his assertion of power and moral outrage (he calls Salome "monstrous") is actually a gesture of weakness in his own terms, since it confirms his inability to be satisfied by specular imagery and rhetoric. Identifying Salome with the defeat of his phallic desire, Herod's "turn" symbolically reinstates castration as a threat directed specifically against patriarchal privilege. Earlier, he had warned against making such naturalizing symbolic equations: "How red those petals are! They are like stains of blood on the cloth. That does not matter. It is not wise to find symbols in everything that one sees. It makes life too full of terrors. It were better to say that stains of blood are as lovely as rose petals" (WS, 225). This is another version of Mallarmé's point about "our form": if metaphors have no epistemological value but are simply reversible tropes, then they can be vehicles to free the poet from the natural world. It is precisely this wisdom that fails the tetrarch at the end: he finds symbolic "matter" in Salome's dismissal of the "matter" of whether or not she has tasted blood on Jokanaan's lips ("But what matter? what matter? I have kissed thy mouth"—WS, 233). For Herod, this blood represents the

mutilation of his official authority, Salome having exploited the symbolic value of his kingly word to fulfill her desire against his. His order of execution sets to right the patriarchal order of nature: women are not as lovely as petals; the fact of the matter is that they stain cloths with blood.

Herod's perspective, obviously, is not Wilde's. Or rather, Herod's perspective is only one of Wilde's. It is tempting to think that Wilde did not describe Salome's dance precisely in order to maintain ambiguity about just how the author "looks on" his heroine. Performances have ranged from an orientalizing lubricious striptease, defined by a traditional masculinist mastery of the gaze, to highly stylized and ironic unveilings of gender inversions (Lindsay Kemp, for instance, in his 1977 all-male free adaptation of the play, removed the props of his drag in the course of the dance, revealing a middle-aged man in a sequined body stocking). From a theoretical perspective, one could say that in the first style of performance castration defines woman's sexual nature, whereas in the second it denaturalizes her sexuality and displays sexual difference as artifice. Salome's expertise in decadence makes us imagine both possibilities without allowing us to decide that either applies.

A similar undecidability saturates Aubrey Beardsley's illustrations for Wilde's play. The drawing he made for the inaugural issue of *The Studio* in April 1893 was an implicit invitation to be asked to illustrate the English translation.[35] *J'ai baisé ta bouche, Iokanaan* (fig. 4) displays beheading/castration as a bloody horror while stylizing the natural world so elaborately that the values of graphic design seem alone to matter. Beardsley goes still farther than Moreau, whose exotic fantasies he found "perfectly ravishing,"[36] in shattering mimesis on the stage of gender. Space itself has lost its gravitational and contextual imperatives: Salome appears to be suspended in midair; the blood dripping down from Jokanaan's severed head forms a stalk that rises up from a pool, on the surface of which a lily takes root; bubbly, circular forms to the upper left have no objective correlative; hairline filaments traverse the image, occasionally forming decorative patterns; little hairs appear on the surface of both human and nonhu-

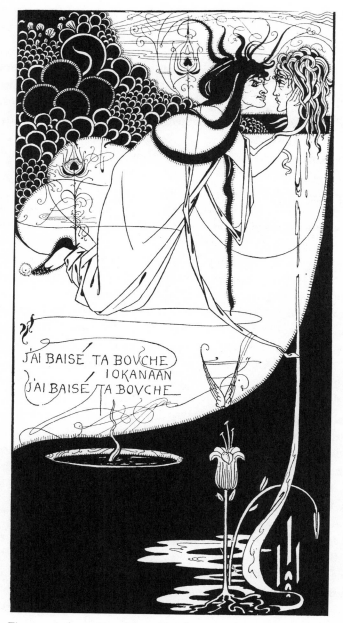

Fig. 4. Aubrey Beardsley, *J'ai baisé ta bouche, Iokanaan*.
Reprinted from *Best Works of Aubrey Beardsley* (New York:
Dover, 1990), 18.

man forms, making them seem equally atavistic. The human, the organic, and the decorative seem to feed off each other in a world where both life and death are in aesthetic suspension. As is gender, for the heads of Salome and Jokanaan resemble each other more closely than they do in *The Apparition,* clearly Beardsley's inspiration here: both are coifed—albeit in contrasting styles—with snakelike hair, as if to suggest the freezing of desire in an equivocation between sameness and difference, Narcissus and Medusa.

In this image, reflexivity overtakes the thematics of castration and deessentializes them. What is seen in the mirror is a question about the seeable, castration being the figure for that question as it concerns gender. Thus, if Jokanaan is feminized in the image of Salome, his emasculation is also compensated by the phallic lily that his blood nourishes and by the aggressively thrusting column formed by that blood. Salome, conversely, is masculinized both by her tentacular hair, one strand of which visually imitates the lance of Jokanaan's blood, and by her traditionally male mastery of the gaze. The elegance of these counterbalanced uncertainties is brought out in Beardsley's revision of this picture to illustrate the English translation of *Salome.* Entitled *The Climax* (fig. 5), the drawing eliminates the profusion of flourishes that makes the earlier image seem to be suffused with morbid growth and concentrates instead on purity of line and balance of compositional masses. If the title refers to the sexual climax of an erotically satisfied femme fatale, this meaning is ironized by the castrator's angelic levitation and by her association with the lily, ambivalent symbol of both purity and of the phallus, and intertextual reference to Huysmans's questioning of the significance of the lotus carried by Moreau's Salome.

Beardsley's illustrations are most faithful to Wilde insofar as they repeatedly stage the drama of the look as a vehicle of desire that destabilizes gender. *The Woman in the Moon* (fig. 6) is exemplary in this respect. Wilde is caricatured as a female moon (or homosexual "queen") looking askance at a naked man with a draped companion. Much has been written about the uncertain identities of these figures, whether they be Jokanaan (naked) with Salome, Narraboth (naked)

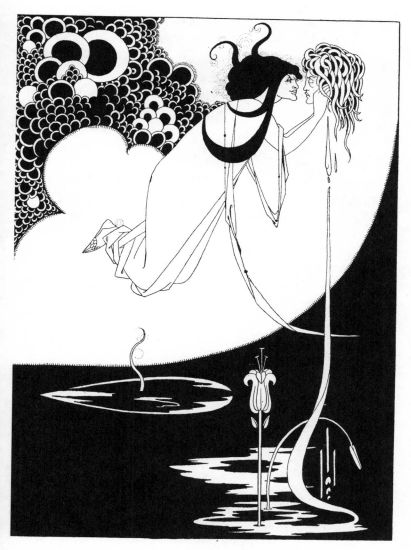

Fig. 5. Aubrey Beardsley, *The Climax*. Reprinted from *Best Works of Aubrey Beardsley* (New York: Dover, 1990), 37.

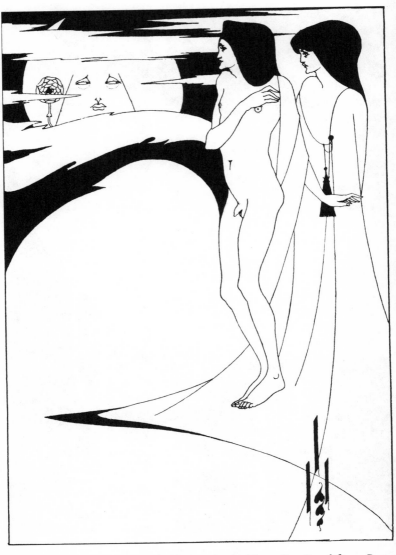

Fig. 6. Aubrey Beardsley, *The Woman in the Moon*. Reprinted from *Best Works of Aubrey Beardsley* (New York: Dover, 1990), 26.

with Salome, the page of Herodias (naked) and Narraboth, or Narraboth (naked) and the page.[37] What is peculiar about this effort at identification is that it attempts to bind Beardsley's picture to the play mimetically, whereas the image severs this conventional relation of text and illustration. Obviously, *no* male figure appears naked in Wilde's play, and this picture cannot be said to "illustrate" any scene in the play. Rather, it illustrates something about the way Wilde sees, the way he "looks on" his characters. The point about that look is that it denaturalizes identity, transforming it into a representational style. Indeed, Beardsley's display of frontal nudity in the Salome pictures never serves to anchor gender in the body; on the contrary, it demonstrates how peculiarly independent gender ascriptions are from sexual organs. For instance, in *Enter Herodias* (fig. 7) Herodias's breasts appear as phallic weapons, while the naked boy's penis hardly suffices to undo our impression of his effeminacy. Similarly, the naked figure in *The Woman in the Moon* has obvious male genital equipment, but his long, stylized hair, hesitant stance, and self-protective gesture all suggest a certain femininity. The draped figure has even more typically feminine hair, wears a flowing robe, and stands passively behind her companion, but she has no apparent breasts, and the triangular tassel hanging on her robe could be interpreted as either masculine or feminine. The hand crossing the tassel could conceivably belong to either of the figures, just as the robe of one is defined by the same line that creates the cape of the other. This shifting landscape, Beardsley suggests, is what Wilde, that lunar gender bender, visualizes, askance, when he writes *Salome*.

To look askance is to uncover what is hidden when we see straight: discrete parts, marginal happenings, obscure designs, ornamental details, minute flourishes. This is the kind of look Beardsley's drawings require, a look that does not fixate or fetishize but that stays in motion, registering the play of equivocal forms and oscillating identities. It is a look that defers fulfillment and espouses temporality, obeying Herod's injunction to look only at masks seen in mirrors. But Wilde is not only the god of this decadent landscape, whose gaze—whether pictured or implied—pervades its equivocal figurations; he is also the

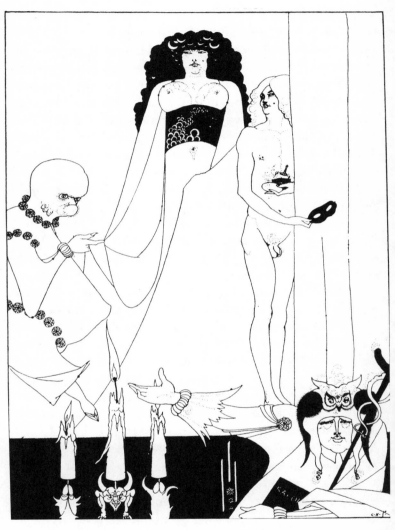

Fig. 7. Aubrey Beardsley, *Enter Herodias*. Reprinted from *Best Works of Aubrey Beardsley* (New York: Dover, 1990), 31.

object of Beardsley's parodic critique. The illustrations are at once a tribute to the subversive obliquity of Wilde's vision and a claim to be still more radically iconoclastic. The icon in question is the doctrine of mimesis. Wilde had attacked it brilliantly in "The Decay of Lying," in which he argued that "art finds her own perfection within, and not outside of herself. She is not to be judged by any external standard of resemblance. She is a veil rather than a mirror" (DL, 306). The "external standard" that Wilde has in mind is, of course, nature, but Beardsley extends the idea into the realm of the arts. The art of the illustrator, he claims implicitly, need not be subservient to the art of the writer; if the writer veils instead of mirroring nature, so the illustrator veils any resemblance his pictures may have to the external verbal world.[38]

In the case of at least one of his illustrations for *Salome, The Black Cape* (fig. 8), the veil is completely opaque: this drawing makes no reference to any character or event in Wilde's play. Although it was included to replace one declared indecent by the publisher (*John and Salome* [fig. 9]), and is hence a wry commentary on Victorian moral and sartorial fashions, the piece also has special relevance to Wilde's decadent aesthetics.[39] In the sense Wilde develops in his witty essay, the picture "lies," that is, it "break[s] from the prison-house of realism" and aims only "to charm, to delight, to give pleasure" (DL, 305). No conceivable body sustains this extravagant garment, which is a pure abstract fantasy of exquisite design, just the kind of "orientalist" decorative artifact that Wilde praises for "its frank rejection of imitation, its love of artistic conventions, its dislike to the actual representation of any object in Nature" (DL, 303). By including this picture as an "illustration" for *Salome*, Beardsley points to the degree to which Wilde's play, despite his aesthetics of lying, still has a naturalistic dimension. This picture takes the parodic distance that Beardsley puts between himself and Wilde to its furthest point. He attacks Wilde for not being wild enough, he makes fun of decadence for not going far enough in its own direction of artifice and reflexivity. *The Black Cape* may be a joke thrown in the face of Victorian prudery,

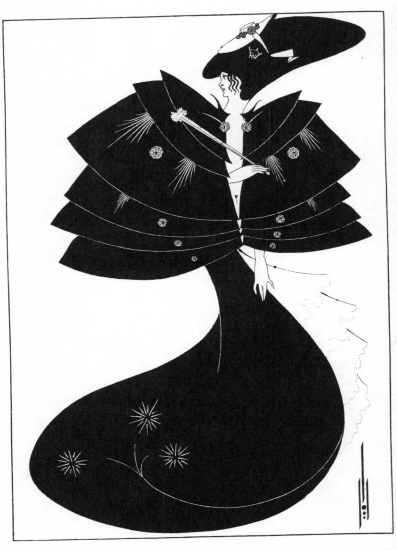

Fig. 8. Aubrey Beardsley, *The Black Cape*. Reprinted from *Best Works of Aubrey Beardsley* (New York: Dover, 1990), 28.

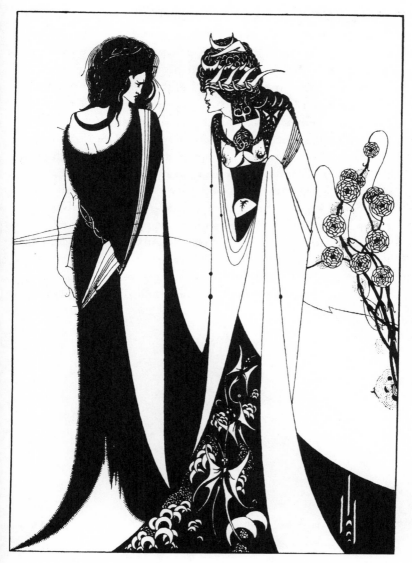

Fig. 9. Aubrey Beardsley, *John and Salome.* Reprinted from *Best Works of Aubrey Beardsley* (New York: Dover, 1990), 30.

but it is more importantly a radical document of parodic Salomania. Parody produces Salome as pure style, so pure that the fatal princess is nowhere to be found. Her story is erased, as Mallarmé wished it to be. Nothing herself, she "makes a statement" as a fashion fantasy.

This image is at the opposite end of the Salome spectrum from Huysmans's and Lorrain's psychological extravaganzas. Yet the two ends have something in common: both are explorations in negativity, the first in the subject's constitution through lack (as castrated), the second in the evacuation of subjectivity through aesthetic form. For the decadent male creator, Salome is the muse of negation, the siren of death. When she inhabits the psyche, she drives it to sado-masochistic splitting; when she inhabits language, she drives it to compulsive reflexivity. Covered with jewels, she reflects the mortifying gaze of the other. Medusa and Narcissus in one, she gives men the thrill of collapsing differences. And, yes, she is also the archetypal femme fatale, whose castration motivates her insatiable desire for a male organ. She is indifferent as to whether the organ be a head or a penis.

Decadent Diagnostics

One of the primary goals of positivist science in the *fin de siècle* in such fields as psychiatry, anthropology, sexology, and criminology was the diagnosis of decadence. Because of the overwhelming dominance of the biomedical model in this period, decadence in these professional discourses was conceived in sociobiological terms such as degeneration, and degeneration was felt to be a powerful and pervasive force threatening the very fabric of European civilization. It was, as Daniel Pick observes in his illuminating study of the idea, "the ultimate signifier of pathology, . . . a shifting term produced, inflected, refined and re-constituted in the movement between human sciences, fictional narratives, and socio-political commentaries."[1]

The recent work of Pick and others has documented just how far-reaching the discourse of degeneration was in the late nineteenth century, in terms of nations—it spread into every European country, the United States, and Russia; in terms of the number of professional disciplines where its influence was felt; and in terms of the number of signifiers through which it could be recognized: Cesare Lombroso's by no means exhaustive list for the diagnosis of individuals, based—a footnote tells us—on the psychiatric work of Drs. Magnan, Déjérine, and Ireland, includes:

On the moral side, apathy, loss of moral sense, frequent tendencies to impulsiveness or doubt, psychical inequalities owing to the excess of some faculty (memory, aesthetic taste, etc.) or defect of other qualities (calculation, for example), exaggerated mutism or verbosity, morbid vanity, excessive originality, and excessive preoccupation with self, the tendency to put mystical interpretations on the simplest facts, the abuse of symbolism and of special words which are used in an almost exclusive mode of expression. On the physical side are prominent ears, deficiency of beard, irregularity of teeth, excessive asymmetry of face and head, which may be very large or very small, sexual precocity, smallness or disproportion of the body, left-handedness, stammering, rickets, phthisis, excessive fecundity, neutralized afterwards by abortions or complete sterility, with constant aggravation of abnormalities in the children.[2]

The double-sidedness of this picture, moral on the one side, physical on the other, is characteristic of the discourse of degeneration, which reads physical stigmata as signs of moral corruption and interprets moral infirmities as symptoms of bodily disease. The medical model of deviance, combining varying doses of psychiatric hereditarianism, Darwinian evolutionism, and Lamarckian environmentalism, was *moralisé* by bourgeois scientists articulating fears—common to their class in the *fin de siècle*—of a rising tide of crime, alcoholism, sexual perversion, and nervous exhaustion. Typical is the perspective of the Austrian psychiatrist Richard von Krafft-Ebing, who warns his readers at the outset of his massive study of the psychopathology of sexual life that the current age is the historical equivalent of the great periods of decadence in the past:

The episodes of moral decay always coincide with the progression of effeminacy, lewdness and luxuriance of nations. These phenomena can only be ascribed to the higher and more stringent demands which circumstances make upon the nervous system. Exaggerated tension of the nervous system stimulates sensuality, leads the individual as well as the masses to excesses, and undermines the very foundations of society, and the morality and purity of family life. The material and moral ruin of the community is read-

ily brought about by debauchery, adultery and luxury. Greece, the Roman Empire and France under Louis XIV and XV are striking examples of this assertion. In such periods of civic and moral decline the most monstrous excesses of sexual life may be observed, which, however, can always be traced to psycho-pathological and neuro-pathological conditions of the nations involved.

Large cities are hotbeds in which neuroses and low morality are bred, as is evident in the history of Babylon, Nineveh, Rome and the mysteries of modern metropolitan life.[3]

Here the vocabulary of degeneration—rather than that, say, of religion or philosophy—is used to explain the decadence of nations, which are treated like biomoral subjects with "psycho-pathological and neuro-pathological conditions." Krafft-Ebing's assumption, which he shares with his liberal-minded degenerationist colleagues, is that, by viewing the decadence of civilizations from this scientific perspective, identifying the signs of decline and acting to rectify the backward trend, the continued progress of European civilization will be assured.

The problem with this project is the slipperiness of the concepts involved. We should remember that the period from 1880 to 1914—arguably the apogee of degeneration's reign in the social sciences, literature, and the popular imagination—was also, in France, the lighthearted, fun-loving belle epoque, when man's unprecedented and spectacular technological triumphs seemed to many to herald a carefree future. Indeed, there was no consensus as to just what degeneration referred to. As Pick notes, the numerous terms deployed by medical authorities to diagnose it "were always slipping out of focus, leading into one another, crossing borderlines, signifying another signifier" (8). This instability brought out in the degenerationists an urge to master the social and political anxieties it generated through objective scientific classification and preventive methods of social hygiene.

This goal of mastery required first of all that the diagnosticians of decadence themselves stand outside the sweeping reach of its pathology. To this end, they adopt the position of distant, dispassionate ob-

servers, unaffected by the morbid contamination of their degenerate subjects. In an effort to totalize the manifestations of the diseased other and confine its symptoms within precisely defined bodies, they multiply nosological classifications and categories and offer ever more exemplary cases. This inclusionary ambition often causes each successive edition of major works to increase substantially in size. For example, Cesare Lombroso's *Criminal Man,* first published in 1876 at a length of 252 pages, had reached three volumes and 1903 pages by its fifth edition in 1896–97; Krafft-Ebing's *Psychopathia Sexualis* grew from 45 case histories and 110 pages in 1886 to 238 histories and 437 pages by the twelfth edition of 1903. As the other swells in number and increases in complexity, the fascinated scientists find themselves hard-pressed to keep their proliferating categories separate from each other. Moreover, the project of cataloging ever more degenerates in order to manage their exclusion from a healthy body politic risks overwhelming a shrinking center of normalcy by an expanding margin of deviance. This risk threatens the supposedly immune position of the scientist, whose otherness to the other may seem questionable, given his absorption in a shifting morass of degenerative morbidity. The diagnostician of decadence may thus become a decadent positivist. This is the evolution I propose to examine in this chapter, using as my example the Italian founder of criminal anthropology, Cesare Lombroso. I will then turn my attention to *Degeneration* (1892), the best-selling attack on *fin de siècle* culture by Lombroso's admiring disciple, the medical doctor and journalist Max Nordau, and examine whether it manages to remain apart from the decadence it so extensively chronicles.

The year is 1870. Cesare Lombroso, a thirty-five-year-old professor of psychiatry at the University of Pavia, is doing research on one aspect of his lifelong preoccupation, differentiating the normal from the abnormal, the good citizen from the dangerous deviant. On this occasion the differences at issue are between lunatics and criminals. One cold gray November morning, death offers him a wonderful gift, the opportunity to do a post-mortem on the body of the famous brigand

Villela. Cutting open the late Villela's skull, Lombroso discovers a series of what he considers atavistic anomalies, most strikingly a distinct depression, characteristically found in rodents, in the place where the spine is located in normal humans. "This was not merely an idea, but a revelation," writes the founder of criminal anthropology, reflecting on this auspicious moment some thirty-five years later.

> At the sight of that skull, I seemed to see all of a sudden, lighted up like a vast plain under a flaming sky, the problem of the nature of the criminal—an atavistic being who reproduces in his person the ferocious instincts of primitive humanity and the inferior animals. Thus were explained anatomically the enormous jaws, high cheek-bones, prominent superciliary arches, solitary lines in the palms, extreme size of the orbits, handle-shaped or sessile ears found in criminals, savages, and apes, insensibility to pain, extremely acute sight, tattooing, excessive idleness, love of orgies, and the irresistible craving for evil for its own sake, the desire not only to extinguish life in the victim, but to mutilate the corpse, tear its flesh, and drink its blood.[4]

You will agree that this is a lot to deduce from a cranial depression! Anatomy reveals itself to Lombroso as destiny, a retrograde destiny in the case of the criminal, who reproduces in the present a primitive stage of human evolution that is now anomalous, even monstrous. The founding premise of the theory of atavism is normative and progressive: one has to know positively what normal, sane man essentially is, the result of a long meliorist evolution, in order to identify atavistic traits belonging to his savage ancestry. The vast plain lighted up by Lombroso's discovery is the field of difference on which, implicitly, his own normalcy shines brightly in contrast to the cannibalistic ferocity of the criminal degenerate. One notes, however, that the experimental scientist resembles no one more than the savage he decries, as he excitedly mutilates Villela's corpse and heatedly dissects the brigand's flesh.

My point is that in this passage, the founding Eureka! of positivist criminology, as in all of Lombroso's voluminous writings on crime, prostitution, insanity, degeneration, genius, and so forth, there is an

unconscious, fantasmatic crossing of the bright field of difference, which collapses its constitutive polarities. In the resulting twilight of the idols, "normalcy" is contaminated by its "primitive" other and the enlightened present of good bourgeois science slips backward into an age of dream, superstition, obsession, even delirium. This crossing, this contamination, this slippage makes of Lombroso a symptomatic figure of precisely the decadent *fin de siècle* that he fought so tenaciously to purge of its atavistic pathology.

Although Lombroso remains a controversial figure in the history of criminology, he is credited by most modern scholars with a fundamental reorientation of the discipline. He turned attention away from the classical conception of justice, which sought to establish an exact scale of punishments for similar transgressions, irrespective of a criminal's particular heredity and of mitigating circumstances, to a more behavioristically oriented conception, focused on the individual criminal's personality, biology, and life history.[5] Thus the reforms Lombroso and his colleagues advocated would be considered liberal today: indeterminate sentences, parole as a reward for good behavior, the establishment of juvenile courts, the creation of institutions other than prisons to offer merciful treatment to the less-than-hardened criminal, the facilitation of divorce so as to decrease domestic violence, laws to control alcohol abuse, indemnification of the victim at the expense of the aggressor. At the basis for these reforms, however, was an unjustifiable faith in the criminologist's ability to distinguish between so-called "born" criminals, with identifiable "stigmata"; occasional criminals; and otherwise normal individuals driven by some overwhelming passion, such as jealous rage. Anthropological factors, declared Lombroso's disciple Enrico Ferri, offer judges "scientific guidance" in detecting the guilty through "tattooing, anthropometry, physiognomy, physical and mental conditions, records of sensibility, reflex activity, vaso-motor reactions, the range of sight, the data of criminal statistics."[6] Today we recognize that much of this so-called "positive" evidence was based more on prejudice and fantasy than on facts and, given the history of the century, we are of course appalled at the thought of the exclusionist uses to which such theories of

atavistic anomaly can be put. Lombroso's intent, however, was more patriotic than protofascist: in the context of the fragile coherence of postunification Italy, he hoped to serve the progressive goals of nationhood by identifying backward elements so that they could be brought under control. In Pick's formulation, he wanted "to link the body, the nation, and history."[7]

But this grand edifice was constructed on shifting sands. Modern specialists consider completely unreliable the statistical procedures of which Lombroso was so proud. They complain especially about his neglect of control groups of "normals" against which to measure his many varieties of deviants. This neglect, however, is not just a sign of Lombroso's inadequacies as a social scientist. It is symptomatic of his extremely tenuous hold on any notion of normalcy as a criterion of difference. Reviewing Lombroso's writings for a standard survey called *Pioneers in Criminology,* the sociologist Marvin Wolfgang comments, without grasping the full implications of his insight, that "one is impressed with the lack of definition regarding the criminal."[8] *Lack* of definition, despite the 1,903 pages of Lombroso's *L'uomo delinquente (Criminal Man).* This mammoth enterprise, aimed at articulating the criminal's difference, and differences between categories of criminals, produces so many signs of otherness that no room is left for the norm, which becomes, one might say, the only true anomaly. In an uncharacteristic moment of self-doubt, Lombroso himself admits that "differences in measurements between the abnormal and the normal are so small that they do not even appear except in the most delicate research."[9]

Normal man is anomalous in nature because he is an artificial, and tenuous, construct of advanced civilization. His difference does not exist at the origin. "In conclusion," writes Lombroso in the fourth edition of *L'uomo delinquente,* "crime appears as a natural phenomenon, both according to statistical and to anthropological analysis; and, to adopt the language of philosophers, it appears as a necessary phenomenon, like birth, death, conception, or mental illness, of which it is often a sad variation. Thus we see that the instinctively cruel acts of animals, and even of plants, no longer seem separated by

an abyss from those of criminal man; every difference diminishes constantly and tends to disappear."[10] Natural necessity is here defined as the devolutionary breakdown of differences, even of the difference between human, animal, and vegetable. All natural beginnings are characterized by instinctive cruelty. Carnivorous plants devour insects that they attract by their odor; cannibalism and infanticide are practiced by ants; animals devise traps for their enemies and plot revenge schemes. Primitive peoples display all these violent propensities,[11] and children today repeat this phase of man's history. "There is a natural predisposition to crime in childhood,"[12] Lombroso maintains, and he argues further that: "Nature can only counsel crime. Crime, to which the human animal took a fancy in his mother's womb, is by origin natural. Virtue, on the other hand, is *artificial,* supernatural, since in every age and nation gods and prophets have been necessary to teach it to bestialized humanity, and since man would have been powerless to discover it by himself."[13]

You may have caught my little deception: the last quotation is from Baudelaire, not Lombroso. From Baudelaire, whom Lombroso describes in his *Man of Genius* as "the true type of the lunatic possessed by *la manie des grandeurs*"[14] and castigates as a sexual pervert who, in his final madness, became a verbal pervert, "affected by an inversion of words" (HG, 95). But, in his view of natural necessity, Lombroso has more in common with Baudelaire than he would care to admit. His positivism is a science of the artificial, the mathematical, the statistical, which purports to teach man the virtue of normalcy, and to reveal the material bases of difference. But, as he admits himself, "virtue is a big anomaly in this world" (AC, 9). His true fascination is with natural processes that erode difference, making crime and insanity biological imperatives as necessary as life and death. Perversion is natural; the straight path of virtue is, as Baudelaire declares, an artifice justified by recourse to metaphysics.

In a gesture whose duplicity is fundamental to misogynist ideology, Lombroso has recourse to precisely this artifice to define woman's unnatural immunity to perversion. The originary agent of instinctive, perverse cruelty is male sexual desire. Killing is sexually

stimulating—"I know a distinguished poet," declares Lombroso, "who is overcome by lubricious desires as soon as he sees a calf being skinned or its bloody flesh hung up in a butcher's stall" (HG, 665). Sex is accompanied by a desire to kill, the male's desire to kill the female: "The first and most famous painter of nature, Lucretius, observed that, even in the ordinary instances when the sexes unite, one can detect a germ of ferocity in regard to the woman, a germ that leads us to strike even if she does not resist" (HG, 665). This is Lombroso's version of the Fall: woman provokes the primitive link between desire and violence, between eros and blood. She provokes her own victimization by activating the "germ of ferocity" against her that is man's natural heritage. But she herself remains unnatural in that she cannot be the subject of desire, only its object. She has no instinctive cruelty; she is not perverse. Although he would obviously deny this, the materialist Lombroso constructs woman's nature in ideal terms, which are, for him, the terms of an essentially masochistic, and safely bourgeois, normality: "Woman being naturally and organically monogamous and frigid" (FC, 53), love is for her "a voluntary slavery to which she aspires by nature" (FC, 118—this is supposedly a quote from George Sand; Lombroso cites numerous literary and philosophical writers, male and female, to support his scientific claims).[15]

I will not rehearse here the unfortunately all-too-familiar dogmas of the misogynist ideology that Lombroso offers as scientifically determined anthropological and biological facts. Essential to his documentation of woman's intellectual, physical, sensual, erotic, creative, and moral inferiority is the notion that she is better adapted to her natural functions in social life than is man. Her job as mother and caretaker is passively to maintain the species. Atavism is an aspect of her normality. Her true crime of passion takes the form of suicide rather than violence against the beloved (FC, 517). Men, in contrast, have to fight for dominance, thereby developing their intelligence, strength, and originality, and becoming more differentiated and various among themselves than are women. Woman's conservative typicality in her normalcy is the sameness that assures her difference from

the perversities of male nature. "In woman," writes Lombroso in his book of 1893 *La donna deliquente: La prostituta e la donna normale,* whose thesis is that prostitution is the characteristic, because atavistic, female form of criminality, "[in woman] we look above all for femininity, and when we find the contrary we infer the maximum of anomaly" (FC, 346). In other words, if woman does not correspond to the ideological construction of her complementary otherness to man, then she is no longer the creature of artifice that illuminates the positivist field of difference. She then can be as anomalous as man himself, as perverse, perhaps even more so, maximally anomalous because, as a woman, she is abrogating the perverse qualities of male nature.

Nothing is more characteristic of the phantasms driving Lombroso's thought than the way in which he undermines his own construction of an essential, normal femininity. Hilde Olrik has traced this process in an excellent article that rightly foregrounds passages in which Lombroso speaks of the "depth of perversity" (FC, 508) that remains latent in the normal "honest woman" but is eagerly waiting to emerge as soon as civilized restraints weaken.[16] The panicked scientist obsessively documents the innumerable manifestations of this emergence until, as Olrik observes, the supposed exceptions to normalcy crowd out the norm. If "there are no real exceptions in nature," as Lombroso claims in the introduction to *The Man of Genius* (HG, xxv), then the world of the unnatural must be awfully vast, for Lombroso is constantly finding himself faced with exceptions. He tells us, for instance, that the female "born criminal" is "doubly an exception, as a criminal and as a woman, for criminals are an exception in civilization and female criminals an exception among criminals, given that the natural regression of women is to prostitution and not to criminality. Therefore," he adds, "as a double exception, she must be more monstrous" (FC, 429).

It is on the field of gender difference that Lombroso's positivist project, like that of his contemporaries Zola and Charcot, collapses most spectacularly. The "depth of perversity" that defines the female criminal as an individual rather than a type is her virility. Woman's capacity to be male, that is, to be the subject of desire and the agent

of cruelty, is the fantasy driving Lombroso's theses about female re-
gression to prostitution and criminality. The prostitute, he claims, is
sexually frigid precisely *because* she desires, viciously and precociously.
Indeed, her frigidity is a kind of "Darwinian adaptation, since a
woman too easily stimulated would be exhausted by the life of a pros-
titute" (FC, 542). In contrast, female criminals are driven by an "ex-
aggerated eroticism" that makes them into "antisocial beings who
seek only to satisfy their violent desires, like those lascivious barbar-
ians in whom civilization and necessity have not yet disciplined their
sexuality" (FC, 430). Always offering anthropometric proof for even
his most delirious fantasies, Lombroso demonstrates that the skulls of
female criminals have abnormal characteristics that are "almost nor-
mal in men; these are virile characteristics, like frontal sinuses or pro-
truding zygomes" (FC, 275). Most extraordinary, perhaps, of the fe-
male physiological traits that Lombroso associates with essentially
virile desire is menstruation. Interpreting menstruation, as did many
of the medical experts of the time, as the equivalent of heat in ani-
mals, Lombroso calls the menstruating woman "still more woman
than usual" (FC, 140). But then he shows her to be most liable pre-
cisely at this time to allow her perverse *maleness* to manifest itself in
acts of cruelty, criminality, and unbridled eroticism. Rather than ex-
citing the male's desire for blood, the menstruating woman excites
herself by exercising "male" desire to her own ends. Which may well
take the form of a "germ of ferocity" *against* men. Witness the ex-
ample, cited by Lombroso from Dr. Icard's science fiction, *La femme
pendant la période menstruelle* (1890), of a young girl who "at every
menstrual period . . . castrated the first animal who fell under her hand,
although in the intervals she had no delirious episodes" (FC, 602).

It is entirely logical within the fantasy development of Lombroso's
book on criminal women that the last section should concern the
hysteric and that Lombroso should define hysteria as an essentially fe-
male illness characterized by what he calls a "paradoxical" eroticism
(FC, 626). Female hysterics may not always have the physical
strength to commit crimes, but when they do, "they know too often
how to surpass their sex, and then they become more terrible than

men—those who multiply crimes are not rare. One may wound, steal, poison, burn and perjure herself; another may prostitute herself, rape children, tell slander, steal" (FC, 633). Although Lombroso does not say this explicitly, the essence of the hysterical paradox is the man within the woman. He does not confront the fact that the power he attributes to this paradox undermines the bases of patriarchal hegemony, whose naturalism he has posited as a metaphysical given. No longer the guarantor of difference, woman is now the irresistible agent of its subversion. She is the primary agent of degeneration, which, as Barbara Spackman observes in her insightful book *Decadent Genealogies,* "is also degenderation."[17] "The influence of degeneration," writes Lombroso, "tends to bring the two sexes together and to confuse them, through an atavistic return to the period of hermaphroditism" (FC, 409).

In each of his books, Lombroso traces the analogous manifestations of this subversive influence, which is the agency of decadence itself. His awareness of the analogies between his descriptions of, say, the hysteric, the epileptic, the alcoholic, the prostitute, the morally insane, the inspired genius, the born criminal (whether male or female), repeatedly defeats his attempts to establish satisfactory taxonomies of deviant types and behaviors. Typically, he finds a fluid continuity where he had endeavored to establish clear differences. Thus, the preface to *The Man of Genius* offers the following self-contradictory admission: "I must confess here that very often in this book I have had to confound genius with talent; not because they are not quite distinct, but because the line that separates them, like that which separates vice from crime, is very difficult to define" (MG, viii). The same book ends by pointing to another crucial area of definitional slippage: "Between the physiology of the man of genius, therefore, and the pathology of the insane, there are many points of coincidence; there is even actual continuity" (MG, 359). So talent, genius, and insanity are strung out on a continuum that permits no firm distinctions between them, although the determination of just such distinctions is the fundamental goal of Lombroso's positivist enterprise. (Indeed, he notes that even Auguste Comte, the founder of

positivist philosophy, was under the care for ten years of the famous alienist Esquirol and, when he recovered, "repudiated without any cause the wife who had saved him"!—MG, 73.)

The epileptic fit is, for Lombroso, the exemplary physiological display of deviance, for it offers the spectacle of a body convulsed and decomposed by its otherness to itself. But these fits are not necessarily recognizable as pathology, for their manifestation is often disguised and their energy displaced. Here again analogy defeats positive diagnosis by visual signs. There is, for instance, "the analogy of the epileptic seizure with the moment of inspiration" (MG, 338). The epileptic body is all potentiality—it may produce a great artistic work, a criminal act, or a wild erotic display. Such a body clearly fascinates Lombroso, as does the language of degenerates, which, be it in the mouths of criminals, prostitutes, or madmen, is characterized, he observes, by excessive indulgence in analogical forms: "an abundance of tropes, bold metaphors, innumerable homophonies, plays on words, puns, and a lyricism of ideas confusing to a cold observer" (HC, 479).

Lombroso, the "cold observer," is indeed "confused" by his visions of the other's powerfully poetic rhetorical heat. Although he claims to write a purely objective, neutral language himself, he often appears to be more attracted by crossings, duplicities, games—whether these be metaphorical, sexual, ethical, or legal—than he is by the creation of rigid taxonomies of difference. At the end of one of his last books, he writes of the social *usefulness* of criminals, whose "energy of action, love of the new, . . . lack of scruples, and blindness to obstacles"[18] serve as a great and necessary impulse to progress. If "the destiny of nations has often been in the hands of the insane," this is not necessarily something to be bemoaned, for such men frequently "overcome obstacles which would have dismayed any cool and deliberate mind" (MG, 361). Even epileptic insanity can be turned to society's profit when it "impels born criminals to excessive altruism and even saintliness, which, in its turn, draws along not only individuals but whole masses in an epidemic of virtue" (CCR, 449). More and more one has the sense that Lombroso fantasizes himself as the decadent other, the hysteric, the degenerate, even the woman. After all, would he not

rate himself as a man of true genius, true genius being distinguishable from imbecilic insanity in that its products are "all the more sublime as the body [is] sicker, in fact, precisely because the body [is] sick"?[19] As Barbara Spackman remarks, this attribution of generation to degeneration, of sublimity to sickness, is a typically decadent perspective. And is not this man of genius much like the priests of ancient Greece who, he tells us, envious of the powers of magic and prophecy that many women exercised by virtue of their susceptibility to hypnosis and hysteria, decided to dress in female robes and jewelry, some even going so far as to castrate themselves (FC, 659)? Indeed, isn't Lombroso's last book, *Ricerche sui fenomeni ipnotici e spiritici* (1908), translated as *After Death—What?,* a book about his extensive personal experience (beginning in 1882) with turning tables, mediums, spirits, and apparitions, is this not equivalent, for a scientific materialist, to a kind of self-castration? And what is one to make of his conviction that his dead mother appeared to him at numerous séances, whispering tenderly "Cesar, fio mio!"[20] Was Cesar losing his positivist wits?

Not at all, says the aging man of science. "There exists an immense series of psychical phenomena," he declares, "that completely elude the laws of psycho-physiology, and that have solely this feature in common and this certainty—that they take place more readily in individuals subject to hysteria, or who are neuropathic, or who are in the hypnotic or dreaming condition, just at the moment, in fact, when the normal ideation is more or less completely inactive, and in its stead the action of the unconscious dominates, which is more difficult to subject to scientific examination of any kind" (ADW, 38). Here Lombroso sounds like Freud, another intrepid explorer of the unconscious domain. And just as Freud's access to this domain was facilitated by his female hysterical patients, so Lombroso's access was enabled by a woman whom he diagnosed as an atavistic epileptoid hysteric. Yet this working-class woman, a medium by the name of Eusapia Paladino, whose culture was that "of a villager of the lower order" (ADW, 111), made visible to the brilliant practitioner of positive science "a continent incompletely submerged by the ocean" (ADW, vi).

Mapping this obscure continent—which is of the same gender as Freud's "dark continent"—was Lombroso's last great challenge, "my predestined end and way" (ADW, v), he says. He witnesses the medium's fluidic emanations; he examines bas-reliefs created by Eusapia by simply placing her hand on a box filled with clay; he documents the transposition of sense experience between different body parts (the back of the foot, for instance, becomes the locus of the sense of smell); he tells of the appearance of phantasmal doubles "with all the living faculties of the material body" (ADW, 257); he speaks of haunted houses as providing "the least contestable records of the autonomous, volitional, and persistent activity of the departed" (ADW, 297). Although he is aware that Eusapia plays "crafty tricks" (ADW, 102) (after all, she is not only a woman but also a hysteric, hence doubly a liar!), this awareness does not interfere with his astonishing credulity in the numerous manifestations of the spirit world. He does not hesitate to cite as reliable evidence anecdotes such as that of "a servant, drowned near the villa of his master, who reappears by night and rinses the bottles and water-jugs of his employer as if he were still in his service" (ADW, 341).

The distance Lombroso has traveled is particularly striking when one compares the illustrations of his major criminological studies with those in his book on spiritism. The former are full of photographs of bodies, whose physiological aberrations stigmatize as dangerous deviations from the norm; the latter offer photographic proof that levitating tables, phantomal apparitions, mediumistic sculptures, and the like are not deviations from nature but proof that nature includes what is usually thought to be its contrary, that is, the world of spirits. The body of positivism, already undermined—as we have seen—through the subversive work of analogy, has now lost all firm outline. Indeed, Lombroso goes to the point of claiming that, through the medium's influence, "the conditions of matter are modified," as if in this fourth dimension, "the laws that rule time and space would suddenly cease" (ADW, 126). Giving himself over entirely to the hypnotic power of a woman, he introjects her hysteria and proudly declares himself a prophetic seer, for whom even the difference be-

tween the here and the beyond has no ground. The body in this groundless environment is decomposed, doubled, transposed, spectral. It exists in the space of death's life, a space we have seen to be a fundamental focus of decadent fantasy. Here the biological cycle loses its hold, and the man of genius, having annexed the power of the hysterical woman, can conjure up his own mother, as if he were giving birth to himself.

Lombroso was not unique in his effort to combine positivism and spiritism. The widespread interest in Charcot's work on hypnosis and Bernheim's on suggestion provided the stimulus in both England and France for the foundation of learned societies for the study of paranormal phenomena. Indeed, the services of Eusapia Paladino were much in demand throughout Europe—in 1895, she was the medium used for a series of experiments conducted by Lieutenant Colonel de Rochas, with the editor of the *Annales de sciences psychiques* present, along with a physicist and a zoologist.[21] No less an authority than the physiologist Charles Richet, who wrote an elogious preface to the French translation of Lombroso's *The Man of Genius,* declared that he had scientifically confirmed the claims of occultists and spiritists. But, of course, the majority of the scientific community remained skeptical. This was also the attitude of Max Nordau, who would have been dismayed to learn of the involvement with spiritism of the man he called his "dear and honored master."[22] In his *Degeneration* of 1892, the year Lombroso had his first séances with Eusapia, Nordau remarked that "no completely sound mind has been led by the experiments of the new hypnotic science into a belief in the marvelous" (D, 217). But the major focus of the disciple's disagreement with the master to whom he dedicates his comprehensive attack on *fin de siècle* literary and aesthetic culture—and whose method he claims to be using—concerns "Lombroso's opinion that highly-gifted degenerates are an active force in the progress of mankind" (D, 24). Not so, declares Nordau, "they corrupt and delude" (D, 24), and it is the duty of enlightened men of science to expose their evil influence.

That exposé took Nordau 560 pages in the 1895 English transla-

tion of the second German edition. A prolific journalist, novelist, playwright, essayist, cultural commentator, and practicing physician to boot, Nordau by 1892 had already written two books of popular social philosophy castigating the modern age, *The Conventional Lies of Our Civilization* (1883), which went through seventy-one editions, and *Paradoxes* (1885). *Degeneration* is distinguished from these earlier works not only by the detailed specificity of Nordau's attacks on particular figures, but also by the inclusion of an elaborate footnote apparatus citing psychiatric and anthropological authorities on degeneration as offering unimpeachable evidence for his analyses. He intends to do in regard to authors and artists, he says in his dedicatory letter to Lombroso, what the master has done in regard to "criminals, prostitutes, anarchists, and pronounced lunatics." All of these degenerates, he maintains, whether they wield a knife or a pen, "manifest the same mental characteristics, and for the most part the same somatic features" (D, vii). They form, thus, one nearly homogeneous mass of deviance. Astonishingly, Nordau can at once claim that his book is "an attempt at a really scientific criticism" and argue that all modern fashions in art and literature (he has chapters on the Pre-Raphaelites, the symbolists, the decadents, the Parnassians, Wagner, Ibsen, Nietzsche, and Zola, and dozens of others are mentioned along the way) are "manifestations of more or less pronounced moral insanity, imbecility, and dementia" (D, viii)! No wonder George Bernard Shaw responded (in 1895) "in the name of common sense" by asking what the value of a theory could possibly be that identifies the main creative minds of the age with "the refuse of our prisons and lunatic asylums": "Is there not something deliciously ironical," queried Shaw, "in the ease with which a splenetic pamphleteer, with nothing to shew for himself except a bookful of blunders tacked on to a mock scientific theory picked up at second hand from a few lunacy doctors with a literary turn, should be able to create a European scandal by declaring that the greatest creative artists of the century are barren and hysterical madmen?"[23]

It is not my purpose to try to explain how a book so obviously cranky, obsessive, and overheated could be received by so many as a

valuable analysis of contemporary artistic culture. It did have the appeal of a comprehensive overview, and in the case of writers such as Nietzsche actually served to introduce their thought to a broad public, in however skewed a manner. The historian George Mosse points out that the bases of Nordau's ideas were common to liberal opinion of his day—the Darwinist association of moral good and aesthetic pleasure with what benefits the progress of the species (rather than with metaphysical truth); the organicist belief in the unity of mankind and nature, subject to the law of survival of the fittest; the conservative conviction that slow evolution in politics is better than convulsive revolution; the moral imperatives of will-power, self-restraint, hard work, and physical health.[24] Insofar as Nordau appealed to all these standards to condemn their transgression by the degenerates, his book necessarily appealed to the class whose values it extolled. And he catered to the widespread fears of the moment in regard to destabilizing forces in politics and culture—such as anarchism, crime, population decline, and sexual deviance. Such factors no doubt helped generate the immense popularity of *Degeneration,* but they are of little relevance in determining whether the book is of any value to us now as a diagnosis of decadence. This is the question I propose to address: can a reading of *Degeneration* today teach us anything of theoretical value about the phenomenon of decadence?

Nordau restricts his usage of the term "decadent" to French writers in the school of Baudelaire (English writers such as Wilde are called "aesthetes"). To describe their style, he quotes key passages from Théophile Gautier, Paul Bourget, and Joris-Karl Huysmans, twisting their positive valuations of such ideas as artifice, depravity, and decomposition to suit his condemnatory perspective. By reversing this twist, one can gain an approximate notion of what the decadent movement was about, as one does by reevaluating the following summary—unintentionally parodic—of Baudelaire's literary character: "He has the 'cult of the self'; he abhors nature, movement and life; he dreams of an ideal of immobility, of eternal silence, of symmetry and artificiality; he loves disease, ugliness, and crime; all his inclinations, in profound aberration, are opposed to those of sane be-

ings; what charms his sense of smell is the odor of corruption; his eye, the sight of carrion, suppurating wounds and the pain of others; he feels happy in muddy, cloudy, autumn weather; his senses are excited by unnatural pleasures only" (D, 294). Such a passage is typical of much of Nordau's writing—he is not necessarily wrong in what he observes, but he fails totally to empathize with the creative sensibilities of those engaged in shaping the various modes of modern aesthetic expression. One can be amused by his distortions and vituperations concerning decadent "ego-mania," but they offer few insights worth retaining.

More interesting than any of the chapters on individual personalities or artistic movements is the first section of the book, entitled "Fin-de-siècle." It is divided into four chapters, "The Dusk of Nations," "The Symptoms," "Diagnosis," and "Etiology." Here Nordau attempts an overview of the characteristics of his age, which he defines in a phrase characteristic of historical definitions of decadent periods: "One epoch of history is unmistakably in its decline, and another is announcing its approach" (D, 5). His analysis of the cultural fashions of this period as characterized by fragmentation, disjunction, and disharmony is not devoid of insight. One notices, moreover, that these supposedly pernicious qualities seem to stimulate Nordau himself much as they do those he labels degenerate. He appears to enjoy transgressing the "law of organic harmony" (D, 8) when he evokes "bewildering" *fin de siècle* practices in dress, interior design, literature, and the arts. Thus he claims to be dismayed that women are dressing themselves in such a way that "all the outlines of the human figure are lost" (D, 8), yet he indulges in an exuberant paragraph visualizing in precise detail the discordant incongruities of female attire, "which cause female bodies to resemble now a beast of the Apocalypse, now an armchair, now a triptych, or some other ornament" (D, 8). Similarly, he vividly fantasizes guests at a high-society event in terms of mobile body parts: "one seems to be moving amongst dummies patched together at haphazard, in a mythical mortuary, from fragments of bodies, heads, trunks, limbs, just as they came to hand, and which the designer, in heedless pell-mell, clothed at random in the

garments of all epochs and countries" (D, 9). There follows a long paragraph offering an almost surreal list of the "discrepant, indiscriminate jumble" (D, 11) that is his imaginative recreation of a typical *fin de siècle* interior. Denizens of this decadent age like all this fragmentation, he says, because it creates "a strong nervous excitement" (D, 9), which is also the goal of musical polyphony that pulls in many directions at once and of spectacles that attempt to play on all the senses simultaneously.

In his lively anatomization of *fin de siècle* aesthetic productions, Nordau resembles Lombroso dissecting the pathologically marked skull of the brigand Villela. While claiming scientific detachment, both men mirror aspects of the decadent material they are analyzing. That pathological material, Nordau explains in his chapter on etiology, is the result of "excessive organic wear and tear" (D, 43) due to the increased pace and overstimulation of modern life, especially in cities. Only the strongest, among whom he evidently counts himself, can successfully adapt to the debilitating shocks of contemporary urban existence, whether these come from train travel, international news reports, narcotic stimulants, or political upheavals (all factors he mentions). The majority (of the upper classes—the peasantry and the working class are "sound," he tells us in a footnote, D, 2) are stimulated by the disintegration of their organic integrity. They search out shocks (one thinks of Benjamin's analysis of Baudelaire's urban poetics); they enjoy the fleeting, disjunctive way reality is seen from speeding trains; they deliberately choose enervating colors (des Esseintes likes orange because it is "morbid and irritating"[25]); their mobile ideation is associative and evasive, close to unconscious impulses; their sense of self is precarious: they desperately desire to be original but, governed by hysteria, they are actually impressionable and imitative. In Nordau's picture of decadent subjectivity the work of death is everywhere. Degenerates, he says, actively seek an "enormous increase in organic expenditure" (D, 39), which is the reason that the current generation is aging more rapidly than the previous one. In the psychodynamic terms that would soon displace Nordau's biopsychic model, one could say that his degenerates are dominated by the

death instinct. What excites them is the unraveling of the self. Their hysteria is manifest in their "surrender to the perpetual obfuscation of a boundless, aimless, and shoreless system of fugitive ideas" (D, 21). Their celebration of an aesthetic of decomposition can thus be seen as expressing their desire to witness their own death impulse displayed in art.

Read in this way, Nordau's diagnosis of decadence no longer seems quite as misguided as it initially appeared. He uses every positivist tool in his library to describe an agency that those tools cannot grasp. But he is at least partially right about the effects of that agency. Where he is wrong—and the book's self-righteous tone is largely due to this error—is in his denial that he is himself in any way contaminated by these morbid effects. Claiming that "all degenerates, of whatever nature they may be, are molded from the same clay" (D, 241), he declares that "we have nothing in common with them" (D, 560). As I noted earlier, this claim of immunity distinguishes Nordau from Lombroso, for whom physiological decay is a necessary source of cultural renovation and physical sickness the generative force behind creations of genius.[26] Nordau cannot accept creativity born of disease. Health for him is monolithic and includes the good bourgeois qualities of reason, domination of the instincts, and careful attention to reality. There are the healthy on the one hand, who will lead the race progressively forward, and the diseased on the other, of whom he writes, in a chilling sentence at the end of *Degeneration*: "Whoever believes with me that society is the natural organic form of humanity must mercilessly crush the anti-social vermin" (D, 557). As an example of such vermin, he cites Nietzsche, Nietzsche who, we remember, himself declared that, in the interest of the organism as a whole, degenerate parts should be "excised" (see p. 14, and WP, 389).

What does it mean that Nordau makes Nietzsche the preferred victim of a eugenicist policy precisely like the one the philosopher himself advocated? At this point Nordau could just as well have enlisted Nietzsche as an ally in his campaign for a sanitizing exclusion of the diseased other, citing in corroboration any number of passages in which Nietzsche promotes healthy organisms, both individual and

political.[27] Among these passages could have been Nietzsche's unacknowledged borrowing of Bourget's analysis of decadent style—Nordau's interpretation of the same passage actually sounds just like Nietzsche's in its warning against the disintegration of the body politic. But Nordau can no more acknowledge his affinities with certain aspects of Nietzsche's thought (both attack the project of a *Gesamtkunstwerk,* for instance[28]) than he can acknowledge his stimulation by an aesthetics of fragmentation. Thus, when he refers to Nietzsche's critique of Wagner's cult of redemption, with which he is in entire agreement, he is careful to distance himself from the philosopher by claiming that Nietzsche's analysis, which he cites at length, is full of "repulsively superficial witticisms" (D, 184). It is crucial to the rhetorical construction of his self-image that he remain untouched by the pathological infection that he sees spreading everywhere. He wants death to serve exclusively the forward-moving thrust of vital evolution and consciousness to dominate entirely the impulses of the unconscious. But the conceptual motor for his project of containing the other, degeneration theory, is itself infected by the virus of decadence. The most evident sign of this infection is Nordau's inability to maintain a position outside of degeneration's reach.

Among the many symptoms of degeneration that Nordau's text both diagnoses and displays, one stands out as subversive of his enterprise from the outset. Just to use language, he claims, is a sign of epistemological degeneration! He considers words nebulous and mystical because they have lost the "proper meaning" they had at the origin when they derived from "immediate perceptions" (D, 68). Now they feed on themselves, producing ideas divorced from any "real connection" (D, 69) to phenomena. In this sense, "mysticism is the habitual condition of the human race" (D, 67), a view with which Nietzsche, for one, would agree. But Nordau—in a move that suggests the designation of certain men, not Nietzschean philosophers but pragmatic scientists, as superior to the race as a whole—also stigmatizes mysticism as "a principal characteristic of degeneration" (D, 45) and argues that a truly healthy man will distrust all symbolism and work "to obtain sharply defined presentations from his own im-

mediate perceptions" (D, 69). Such a criterion for health clearly disqualifies Nordau himself. After all, he is constantly scribbling words about the words of others, in a scriptive activity so compulsive that it could well be subject to his own diagnosis of "graphomania." His ideas are evidently suggested more by words than by things, by reading more than by experience. His frequent citations of medical authorities are no doubt meant to compensate for his distance from the "immediate perceptions" of scientific observers. Yet his medium remains language, which is, he says, "a social function, but not a source of knowledge. Words," he continues, "are in reality much more a source of error" (D, 68).

So Nordau, according to his own analysis, exhibits mystical degeneracy the moment he relies on the linguistic agent of error to set mankind straight. And many more of the traits he applies to degenerates could be used to describe qualities of his own writing—hysterical, egotistic, unbalanced, emotional, pessimistic, imitative. That these traits were also frequently applied to Jews in the *fin de siècle* suggests to what degree Nordau, a Jew like Lombroso, was blind to his own stigmatization by the discourse he wields against the other.[29] As Sander Gilman's work has shown, Jews were characterized in this period as archetypal city dwellers, whose infection by the nervous diseases of modern life reinforced a hereditary disposition to mysticism, hysteria, and the perversions of inbred sexuality.[30] These characterizations were not the stuff of rabid anti-Semitism. They were widespread cultural stereotypes. No less a psychomedical authority than Charcot, one of Nordau's favorite references, maintained that "nervous illnesses of all types are innumerably more frequent among Jews than among other groups,"[31] a point that Edouard Drumont used to support his anti-Semitic diatribe in *La France juive* (1886).[32] Krafft-Ebing attributed the high incidence of insanity among Jews to their inbreeding and "abnormally intensified sexuality."[33] Nordau, however, does not recognize, at least in print, that his own rhetoric mirrors that of current anti-Semitism.[34] In his only mention of anti-Semitism in all of *Degeneration,* he identifies it as a symptom of German hysteria exemplified by Wagner (D, 209).

Here again Nordau seems to be oblivious to his inclusion as the other in his own discourse that excludes that other. Such is the work of decadence within the theory of degeneration: the binary opposition of (healthy) self and (diseased) other collapses. At the very moment when difference is most emphatically asserted, through an appeal to a positive norm, the norm falls into the world of multiple abnormalities. Just when Nordau most brutally advocates the extermination of degenerate vermin, he exactly mirrors the vermin he is most anxious to eliminate. Whereas the goal of degeneration theory is to diagnose the psycho-physiological symptoms of decadence and organize these diagnoses into a coherent system of knowledge, decadence subverts this project by allowing it no standpoint outside the temporal world of endless decay, permanent pathology. Positivism may seem like the antithesis of decadence, but when positivism operates with the tools of degeneration theory, antitheses themselves degenerate.

Freud's Decadence

Although Freud's biographer Ernest Jones tells us that Freud found Nordau "vain and stupid" when the two men met in Paris in 1886, Freud's diagnosis of *fin de siècle* decadence is not all that different from Nordau's.[1] In an essay of 1908 entitled "'Civilized' Sexual Morality and Modern Nervous Illness," Freud starts out by citing just the sort of medico-psychiatric authorities that Nordau repeatedly invokes to give his cultural analysis the stamp of scientific validity. Besides Ludwig Binswanger and Richard von Krafft-Ebing, Freud quotes a passage from Wilhelm Erb's *Uber die wachsende Nervosität unserer Zeit* (*On the Growing Nervousness of Our Times*—1893) that sounds like a summary of Nordau's etiology of contemporary disease. Erb attributes the widespread increase of nervous illness to factors such as the speeded-up pace of city life, which causes a depraved desire for ever more stimulation and a craving for pleasure that ignores all ethical considerations; to modern literature that "brings before the reader's mind pathological figures and problems concerned with psychopathic sexuality" (SE 9, 184),[2] and so forth. Freud finds nothing wrong with this analysis but considers that it leaves the most important etiological factor out of account, sexuality, specifically "the

harmful suppression of the sexualized life of civilized peoples" by their own morality (SE 9, 185).

On the face of it, this seems like a startlingly original claim: contemporary decadence is due to people having too little sex rather than too much. Freud's perspective is physiologically based like Nietzsche's: after its sexual awakening at puberty, the human organism, male or female, needs a healthy outlet for its powerful sexual drive. But civilization requires that its youth abstain until marriage. As a consequence, young men go to prostitutes, thereby creating the mother-whore syndrome (they can love only where they do not desire); young women become frigid and hysterical. Marriage, when it comes, cannot help but be a major disappointment: since contraceptive devices "impair enjoyment" (SE 9, 194) and can even cause neurosis, most couples abandon their sexual relation after the first few years, when the goal of sex is procreation. Freud's outlook is bleak: "The spiritual disillusionment and bodily deprivation to which most marriages are thus doomed," he remarks, "puts both partners back in the state they were in before their marriage, except for being the poorer by the loss of an illusion" (SE 9, 194–95). Since mastering the sexual impulse through sublimation "can be achieved by a minority and then only intermittently, [m]ost of the rest become neurotic or are harmed in one way or another" (SE 9, 193).

What Freud sees around him, then, is a society made up of frustrated, neurotic individuals, with the group of "normals" reduced to an only intermittently perceptible minority. Moreover, since he believes that a person's sexual behavior "*lays down the pattern*" (Freud's italics, SE 9, 198) for his other modes of reacting to life, he sees pervasive repression as having widespread consequences, such as intellectual weakness in women and a loss of virile energy and a spread of homosexuality among men. The culprit for transmitting perversion from generation to generation is not inherited degeneracy (Freud turned increasingly against this idea from 1895 on) but the unsatisfied, neurotic mother, who transfers her need for love onto her children, awakening them to sexual precocity and causing lifelong

patterns of emotional ambivalence. At the end of the essay, Freud declares that "it is not a physician's business to come forward with proposals for reform" (SE 9, 204), and it is indeed hard to imagine just what remedies could possibly be proposed for such a comprehensive diagnosis of illness (more research in the field of contraception? relaxation of the double standard so as to offer women the same relative toleration of extramarital affairs that men have long enjoyed?). The conclusion seems inescapable that civilization and sexual health are mutually exclusive.

Yet Freud refers in this essay to "normal sexuality—that is, sexuality which is serviceable to civilization" (SE 9, 189). One wonders: hasn't he just been showing in devastating detail how civilization distorts sexuality? Sexuality that serves civilization would have to be sexuality willing to conform to its unhealthy demands, willing, in other words, to be abnormal. Freud glosses over this difficulty, intent as he is on describing "two kinds of harmful deviation" (SE 9, 189) from the normal development of the sexual instinct, the so-called positive perversions, and their negative, the neuroses, which contain the same tendencies as the perversions but in a state of repression (SE 9, 191). What perverts and neurotics have in common is their inability to complete the full trajectory to maturation, "from auto-eroticism to object-love" (SE 9, 189), which Freud analyzes in the *Three Essays on the Theory of Sexuality* (1905). "Object-love" refers to mature heterosexual genital satisfaction. But this is just what Freud's view of civilization makes it seem next to impossible to attain. Indeed, he comments himself that "what is known as normal sexual life" is brought about only "in the most favorable cases, which lie between the two extremes [of perversion and neurosis], by means of effective restriction and other kinds of modification" (SE 7, 172). If normality is obtained through the restraining force of what Freud would later call "the cultural super-ego" (SE 21, 142), then it must be viewed as a construct of civilization and of civilization's social, institutional, and ideological pressures. But this is just the contemporary problem: today's sexual morality, in Freud's view, is more restrictive than the average person can tolerate, with the consequence that normalcy is being

constructed as "modern nervous illness." Deviation from the norm is the norm.

Hence arises a major dilemma in Freud's thought: if he historicizes the norm, then it becomes abnormal, if he maintains the norm as an ideal, then he undermines the pragmatic goals of his therapy, to cure the psychically ill of their deviance from the norm. Freud confronts this problem by preserving the ideal norm while simultaneously recognizing its artificial status. That is, Freud solves his dilemma by turning away from his own analysis of the social and historical determinants of normalcy and considering the problem as internal to psychoanalysis. Thus, in the late essay "Analysis Terminable and Interminable" (1937), he observes that "a normal ego . . . is, like normality in general, an ideal fiction. . . . Every normal person, in fact, is only normal on the average. His ego approximates to that of the psychotic in some part or other and to a greater or lesser extent" (SE 23, 235). The consequence for therapy is that a successful analysis is also an "ideal fiction"—"as though it were possible by means of analysis to attain to a level of absolute psychical normality" (SE 23, 219–20), which would mean that all repressions were resolved and all gaps in memory filled. Yet, Freud adds—in order, it appears, to make the goal of psychoanalysis not seem too remote and chimerical—every analyst has had a few experiences when this ideal was realized—cases, his skepticism forces him to admit, to the success of which "a kind fate" (SE 23, 220) may not have been irrelevant. The issue here is not so much the permanent illness of civilization, which makes normalcy impossible, but the permanent illness of the psyche, which makes psychoanalysis interminable.

The notions of normalcy and of cure exist in Freud as postulates whose primary function is to be brought into question. It is only by rhetorical fiat that Freud manages to position the norm against which he measures perversion, positive and negative, outside the domain of that perversion. Teresa de Lauretis speaks in this regard of a "structural, constitutive ambiguity,"[3] which is precisely right. I want to go further and associate this ambiguity with a pattern that I have found to be typical of decadent thought: a norm is projected from the per-

spective of which the decadent world is judged as such; simultaneously this norm is shown to have no justification for its authority, yet it is not abandoned. We have seen numbers of variations on this fundamental pattern. For example, Flaubert insists that *Salammbô* is true to history, while his novel systematically decomposes any possibility of historical knowledge; Zola appeals to the biblical model of the Fall, even as he shows its irrelevance to natural processes; closest to Freud, Nietzsche claims that physiological health is necessary for vital cultural production, while he also shows that no organism displays such health and that illness generates the most powerful creative energy. Nietzsche would say that this pattern is symptomatic of contemporary nihilistic thought: God has died but his place remains empty, tempting man to configure it anew. Decadence is resolutely antiteleological and antimetaphysical, yet it cannot do without the illusion of a telos, the mirage of a truth.

In the case of Freud's theory of sexual development, this telos is the so-called mature genital organization, when "the erotogenic zones become subordinated to the primacy of the genital zone [and] the sexual instinct is . . . subordinated to the reproductive function" (SE 7, 207). This notion of orderly subordination is reminiscent of Paul Bourget's description of the proper functioning of the social organism, to which each lesser organism contributes by dutifully subordinating its energy to the good of the whole. Decadence sets in when individuals begin to put their own pleasures first. Then the greater unit decomposes into its component parts. Freud envisions sexual development in similar terms but the other way around: the child begins as a decadent, one might say. His sexuality is "essentially autoerotic" and made up of component instincts, which are "disconnected and independent of each other in their search for pleasure" (SE 7, 197). So polymorphous is his sexual instinct that it can attach itself to any object. What is considered perversion in an adult is normal in a child—autoerotic stimulation of specific erotogenic zones, homosexuality, scopophilia, sadism, and more. Thus the perversions are not abnormal in man: on the contrary, they are innate, and it is the task of maturation to control them, combining "a number of im-

pulses of childhood into a unity, an impulsion with a single aim" (SE 7, 232). It is a heroic narrative: (phallic) form and (reproductive) purpose is given to a polymorphous chaos of instinctual drives.

But the story is an ideal fiction, as Freud is the first to point out. "The sexuality of neurotics," he remarks, "has remained in, or been brought back to, an infantile state" (SE 7, 172). Since the class of normals is next to nonexistent, this has to mean that we are all infantile as regards sexuality.[4] Moreover, if we were to make a successful transition to "mature" genital sexuality, the inhibiting demands of civilization are such that we would become neurotic in any case. The heroic narrative collapses, in plain sight, yet Freud does not abandon it. Indeed, he offers another version of the same story in *Civilization and Its Discontents* (1930). Here he develops an analogy between the development of civilization and the libidinal development of the individual. Civilization is constituted, he says, by the individual's sacrifice of power and instinctual satisfaction to the interests of the group and the rule of law. This process is "in the service of Eros, whose purpose is to combine single individuals, and after that families, then races, peoples and nations, into one great unity, the unity of mankind" (SE 21, 122). Working against this program, however, is the death instinct, especially the instinct of aggression. The death instinct strives to disintegrate and decompose the wholes that eros seeks to build. Civilization makes use of this instinct, when it is not needed for war, by forcing the individual to redirect its destructive energy from targets in the external world to an internal target, the ego itself. The superego, formed by introjection of parental prohibitions, becomes the agent of these repressive cultural demands, with the consequence, as Freud puts it, that "what began in relation to the father [guilt about the son's egotistic drives] is completed in relation to the group" (SE 21, 133). He summarizes the whole process by observing that "the price we pay for our advance in civilization is a loss of happiness through the heightening of the sense of guilt" (SE 21, 134).

But can one speak of an advance at all if the cultural superego is so punishing, so sadistic, that the ego can only become masochistic or develop some other neurosis or perversion? With his usual scrupulous

respect for logic, Freud does not dodge this line of thought. "If the development of civilization has such a far-reaching similarity to the development of the individual," he speculates at the end of his essay, "and if it employs the same methods, may we not be justified in reaching the diagnosis that, under the influence of cultural urges, some civilizations, or some epochs of civilization—possibly the whole of mankind—have become 'neurotic'?" (SE 21, 144). Freud goes on to recommend caution with analogies (though he has been using them to further his argument all through this essay) and notes the difficulty with this one that in an individual neurosis the starting point is "the contrast that distinguishes the patient from his environment, which is assumed to be 'normal,'" whereas in the case of a shared communal disorder "no such background could exist" (SE 21, 144). Here Freud fails to draw out the implications of his scare quotes around the words "normal" and "neurotic." The state of civilization as he has described it clearly is not normal in any normal sense of that word. The civilized environment is pathological because the death instinct has overwhelmed eros in the cultural superego, causing decomposition and disintegration both in the individual psyche and in the society at large. Freud has brilliantly demonstrated just this. Yet he cannot do without the "assumption" of normality, otherwise the conclusion would indeed be inescapable that the whole of contemporary mankind is "neurotic." The scare quotes around the two words that are at the center of Freud's entire diagnostic and therapeutic enterprise are evidence of the work of the death instinct within his thought. The crucial distinction decomposes and tends to dissolve. Yet just when one thinks that it is gone for good, there it is again. The return of the erased norm, the reerection of a telos, the insistence that the "ideal fiction" is sometimes realized.

It is this entire pattern in Freud's thought that I associate with decadence. He has little sympathy with the decadent traits that he diagnoses in contemporary civilization. Perverse sexualities, regressive fixations, nervous exhaustion, impotence—Freud finds none of the creative potential in such negative states that decadent writers extol. As far as he is concerned, these deviant modes sap energy that would

otherwise be available for culturally useful sublimation: symptoms are being formed instead of artworks. Moreover, he takes away much of the countercultural panache of the deviant poses dear to decadence by showing that they are no more than regressions to childhood—"an involution of sexual life to its infantile forms" (SE 9, 199). So, on the face of it, Freud is dead set against decadence. His repudiation of its scientific cornerstone, degeneration theory, may seem to be a sign of his liberation from the biological determinism that underlies so much decadent theorizing. Psychic illness, he claims, is not due to inherited degeneracy, but to too unrelenting an intolerance for impulses perceived to be degenerate, to too much morality rather than too little. Yet Freud's antidecadence, like Nietzsche's, has a decadent dimension: the place of judgment is not immune from contamination from below. Indeed, he admits that the idea that it is somehow above, and different from, what is decomposing and disintegrating below is a fiction, albeit a necessary one.

Nowhere is Freud's closeness to decadent thematics more apparent than in his theorization of sexual difference. Here again the norm is a fiction, universal masculinity, and difference from that norm is conceived in terms of the fundamental decadent trope, castration. Freud gives to that trope its triumphant theoretical formulation, whose impact, despite the massive critique directed against it, continues to be felt today. The etymology of the word is premonitory: the Indo-European word *kes,* to cut, generates in Latin both the verb *castrare,* to castrate, and the noun *castrum,* fortified (that is, separated) place. Indeed, castration has been like a bastion holding its own against the fierce attacks of numerous revisionist enemies. Like a fortified castle that separates the lord's subjects from his adversaries, castration derives its theoretical power from its ability to articulate the field of difference, defining presence and absence, wholeness and lack, masculine and feminine, desire and the law. Castration defensively secures the fortifications of Freud's science of the unconscious: without castration, psychoanalysis would lack its oedipal key to differential structures in the psyche, the family, and society. When read against

the background of the *fin de siècle,* however, castration's historicity becomes apparent. Freud's insistence on its universality marks him not only as a man of his time, but as a man whose "scientific" speculations endorse decadent fantasies.

In 1908 Freud proposed the hypothesis, largely on the basis of his analysis of Little Hans, that children of both sexes attribute a penis to all human beings. Although Freud's clinical evidence for this hypothesis was rather thin and almost all the examples in his early writings derive from the experience of male patients, the assumption that children share a sexual theory of anatomical sameness is never questioned in his work. He never imagines a boy seeing a girl's genitals and recognizing difference, or a girl seeing a boy's penis and being satisfied with the explanation of difference. Difference cannot be accepted as such by either boy or girl, this is Freud's premise, in many ways the founding premise of psychoanalytic theory. It is a kind of primal theoretical fantasy, a foundational "ideal fiction."

That the boy's failure to tolerate difference might be thought to suggest a disparagement of his mental abilities is a critique that Freud confronts directly in the Little Hans case. He acknowledges that his reader "might well feel horrified at such signs of the premature decay of a child's intellect" as Hans's refusal to "report what [he] really saw" (SE 10, 11), namely that a girl has no penis. Defending Little Hans's refusal to confront difference, Freud explains that it actually represents the contrary of a mental failure. It has occurred, says Freud, "due to [Hans's] having arrived by a process of careful induction . . . at the general proposition that every animate object, in contradistinction to inanimate ones, possesses a widdler [Hans's word for penis]" (SE 10, 11). Hans's staunch allegiance to his monosexual theory facilitates his continued theorizing. He decides that girls have very small penises, which will grow with time. Despite its falsity to perceived difference (or perhaps, as we shall see, precisely because of this falsity), Hans's theorizing "vindicates [his] honour" in Freud's eyes; Freud compares him to "a philosopher of the school of Wundt" (SE 10, 12) whose mistake is to attribute consciousness to all mental processes. Little Hans is an intrepid theoretician, a speculative

philosopher. That his theorizing is based on false premises, that it could be viewed as symptomatic of intellectual decay, this is completely forgotten as Freud goes on to adopt Little Hans's speculative hypotheses as his own.

"The youthful investigator" is not dismayed when later observations lead him to realize that no penis will grow on girls: "he has another remedy at his disposal," says Freud. This remedy, however, is of a peculiar nature, for it is also a horror: girls once had a penis "but it was cut off and in its place was left a wound" (SE 11, 95). Freud, in the essay on Leonardo da Vinci, calls this idea a "theoretical advance" (SE 11, 95), presumably because its explanatory power is less vulnerable to renewed observation than was the notion of an immature female penis that would eventually grow longer. Moreover, Freud assumes that by this time the personal experience of parental threats has rendered the notion of castration plausible to the little boy. But what is most striking here is the notion that "castration" is deemed an "advance," when it is in the service of a theory that regressively preserves the male refusal to accept sexual difference. This is a theoretical advance that serves epistemological decline. If castration offers an explanation of the reality of sexual difference, it does so in order to safeguard a false theory of sexual sameness.

Freud, however, allows phallocentric theoretical error to dictate his epistemology, thereby tilting his entire conceptualization of sexual difference in what I interpret as a decadent direction. "Probably no male human being is spared the fright of castration at the sight of the female genital," he observes in the late essay on fetishism (SE 21, 154). Here the supposed remedy for the "uncanny and intolerable idea" (SE 11, 95) of the missing penis is conflated with the trauma it is supposed to cure. It is as if "castration" were visible at the site of the female genitals, whereas it is, of course, no more than a theoretical construct. But Freud calls it a "fact," referring on many occasions to the necessity for woman to acknowledge "die Tatsache seiner Kastration" (the fact of her castration) (SE 19, 253; SE 21, 229). The only basis for such a claim to factuality is his own hypothesized sexual theory of children. Freud is another Little Hans, generating truth from within

theory. Thus the fundamental decadent fantasy that woman is castrated becomes a cornerstone of the psychoanalytic edifice.

Indeed, the theory of castration functions for Freudian theory much as Freud says a fetish functions for the sexual pervert. The purpose of the fetish, he explains, is to preserve the fantasy that all humans have a penis—the childhood theory of anatomical sameness—and simultaneously to represent a recognition, based on perception, that women lack this organ. By calling this lack "castration," however, Freud turns the fetish into a compromise not between fantasy and reality but between one fantasy and another. Moreover, the two fantasies are not in opposition to one another. "Castration" is simply a theoretical advance within the terms of the initial hypothesis. It is wrong to say, as Freud does, that the traumatic perception the fetishist has such trouble dealing with is "the unwelcome fact (*die unliebsame Tatsache*) of women's castration" (SE 21, 156). What has happened to Freud's own idea that "castration" is a welcome *remedy*, not a perception but a rationale invented to explain a perception? Insofar as the fetishist disavows castration, he does so in order to "preserve unaltered his belief that women have a phallus" (SE 21, 154); insofar as the fetishist admits the "fact" of castration, he does so for the same reason. Left behind entirely here is the actual reality of sexual difference, what Little Hans "really saw" and found "uncanny and traumatic." Freud argues that what is essentially neurotic about the fetishist's behavior is his use of the fetish object to deny or, to use the more precise psychoanalytic term, to disavow reality, i.e., female castration. But the term *Verleugnung* cannot be correctly applied here because it refers to a defense mechanism brought to bear against a true perception of external reality. Castration does not constitute such a perception. Its function, rather, is to falsify what has truly been seen. The entire theory of fetishism, with its idea that the fetish is "a token of triumph over the threat of castration and a protection against it" (SE 21, 154), serves Freud to triumph over the threat of the real and to protect his theorizing against it.

That Freud should associate the real with woman's sexual "nature" is entirely in line with decadent fantasies. It is characteristic of the

decadent imagination to welcome "the horror of castration" (SE 21, 154) as a remedy for the trauma of intolerable otherness. The idea that women are castrated men may be frightful in itself, but it functions within a larger framework where its role is fundamentally reassuring—for those in possession of a phallus, that is. It may cause the boy, as Freud says, to "tremble for his masculinity," but this anxiety is more than compensated for by a narcissistic gain: "he will despise the unhappy creatures on whom the cruel punishment has, as he supposes, already fallen" (SE 11, 95); he will feel "horror of the mutilated creature or triumphant contempt for her" (SE 19, 252). In 1923 Freud attributes these feelings specifically to the phallic stage of early libidinal organization, which follows the oral and anal stages, but nothing has really changed conceptually: the mature sexual organization, which recognizes a difference between maleness and femaleness rather than between phallic and castrated, inherits all the affective associations from the earlier theoretical distinction. "The fixation on the object that was once strongly desired, the woman's penis, leaves indelible traces on the mental life of the child. . . . In the years of puberty [a feeling of disgust] can become the cause of psychical impotence, misogyny and permanent homosexuality" (SE 11, 96).

These are, of course, major themes of decadent literature, as is fetishism, another consequence Freud mentions of what is, in his view, a perfectly normal disdain for women's constitutional lack. Freud does not exactly advocate these decadent attitudes, but he considers them to be the natural consequences of what are, in civilized terms, the perverse impulses of childhood. The seemingly unnatural is natural—once again it would appear that Freud is setting himself against decadence by normalizing its subversive thrust. But we must remember that the premise on which Freud's entire sexual theory is based, a premise that he never disclaims, denies nature. The fantasy of the woman's penis is pure artifice, phallic narcissism universalized. "Castration" is the reverse side of this fantasy, a compensation in the negative for the loss of the positive image. The fetish holds these two fantasies together. It makes woman up, acting as a cosmetic embellishment that at once re-members her purely imaginary wholeness

and serves as a reminder of her equally imaginary lack. Freud's theory is fetishistic in its advocacy of (male) artifice over (female) nature, of cosmetic disguise over mimetic reproduction, of the truth of lying over the revelation of truth. It veils the real that it supposedly discloses, making it seem that Freud is addressing real difference when he is actually constructing it. What Oscar Wilde says about art could be applied, in a similarly witty manner, to Freudian theory: it "takes life as part of [its] rough material, recreates it, and refashions it in fresh forms, is absolutely indifferent to fact, invents, imagines, dreams, and keeps between herself and reality the impenetrable barrier of beautiful style, of decorative or ideal treatment." Theory is Freud's decadent art. It constructs an aesthetic barrier between him and reality—at least, this is the function of his theorization of sexual difference.

Freud's ideas about the little girl's sexual development, elaborated only late in his career, reflect the persistence of decadent assumptions in his thought. His hypothesis is that the girl shares the boy's fantasy of universal maleness. "A female child does not understand her lack of a penis as being a sex character," writes Freud, "she explains it by assuming that at some earlier date she had possessed an equally large organ and had then lost it by castration" (SE 19, 178). Freud's premise is that the girl cannot understand her genital equipment prior to her adoption of the theory of castration. Confronted with the reality of anatomical difference, the girl, if she follows Freud's scenario for psychic health, immediately "acknowledges the fact of her castration, and with it, too, the superiority of the male and her own inferiority" (SE 21, 229). Freud imagines that the girl's sexual organ has no reality to her until she theorizes it. Theory teaches her in no time flat that she is lacking. "She makes her judgment and her decision in a flash. She has seen it and knows that she is without it and wants to have it" (SE 19, 252).

The little girl is not a budding philosopher like Little Hans, not a "youthful investigator" patiently developing a logical process of thought. For her the discovery of the anatomical distinction between the sexes produces an instantaneous flight to the explanatory power

of theory, which, in Freud's view, has only one possible message, "the fact of her castration." Now surely this scenario strains credulity to the breaking point. Once again it depends entirely on the hypothesis of the absolute priority of the penis in the child's theorizing about difference. It is as if one glimpse of the penis were sufficient to catapult the girl into the phallic stage. All evidence to the contrary, Freud denies that the girl has any knowledge of her vagina. The vagina does not come into play in the girl's acceptance of her castration. We are not asked to imagine her intellectual process as she tries to figure out how, when, and by whom her penis, which she cannot conceivably remember ever having had, was cut off. Masculine speculation is replaced in the girl by unmediated desire, the premise of that desire being the assumption of female lack. Here, in ovo, is the rapacious drive motivating the decadent femme fatale.

Perhaps the most implausible element of all in Freud's description of the girl's castration complex is the absence of any narcissistic advantage to her swift assumption of her inferiority. For the boy, castration theory confirms his organ as the norm for mankind. But what is in it for the girl? The answer, it seems to me, is that she gains male theory. This may sound absurd, if we imagine a four-year-old girl envying the power of theory. It is less absurd if we imagine Freud, a theoretical fetishist, imagining what little girls want. What they want is what he wants, the priority of a theory that denies difference over the perception of actual differences. The vagina must disappear so that the penis can become universal. Girls must accept castration as a "fact" so that male theory may continue to produce the "truth" of their femininity for them. If a girl refuses to grant theory the status of fact, she risks a loss of reality that "in an adult would mean the beginning of psychosis. Thus a girl may refuse to accept the fact of being castrated, may harden herself in the conviction that she *does* possess a penis, and may subsequently be compelled to behave as though she were a man" (SE 19, 253). The idea never occurs to Freud that a girl might reject the hypothesis of castration because it offends both her reason and her narcissism. In his view, if a girl rejects castration she loses the freedom to think as a woman and becomes driven un-

controllably to act like a man. She only attains the ability to reason once she has accepted her castration, that is, once she has accepted phallocentric theory as defining, negatively, the fact of her sexual identity.

But her reasoning is governed by a spirit of rebellion, which can take three forms according to Freud's analysis in the essay on "Female Sexuality" (1931): she can abandon her sexual life in disgust with her "organic inferiority" (SE 21, 232); she can "cling with defiant self-assertiveness to her threatened masculinity" (SE 21, 229); or she can embark on "the very circuitous path," through a prolonged preoedipal phase, that results in "the final normal female attitude" (SE 21, 230). Once again, it seems that normalcy is a rare and difficult achievement rather than a smooth evolution. The reason for the difficulty is what Freud calls the "underlying bedrock" (SE 23, 252) of the psychical field, that is, biology: woman's lack of a penis cannot help but lead to her lifelong desire to have one. Such is, of course, precisely the fantasy underlying the *fin de siècle* image of the insatiable femme fatale, embodied most spectacularly in Salome, who is portrayed in a lithograph by Julius Klinger (1909) as holding a gigantic penis before her in the place of John the Baptist's head. Everything related to the female Oedipus complex in Freud's analysis is focused on the continuing desire for the phallus. The "strongest motive" for the girl's turn away from her mother is that she now sees her as castrated and resents her for not having given her daughter "a proper penis" (SE 21, 234). She transfers her affection to her father in order to get the penis, or its second-best substitute, a baby. Some other man ultimately takes the place of the father but, as Freud puts it in a formula that demonstrates how fully his imagination is saturated with decadent archetypes, she only "puts up with the man as an appendage to the penis" (SE 17, 129). This is another way of saying that woman's desire castrates the man. He is merely a functionary; his individuality is not important. The woman wants his penis to complete her mutilated self-image, the rest of him is detritus. Any child she produces is, in her mind, exclusively her own, a bandage for her incurable narcissistic wound.

It is evident to us today that Freud's vision of female sexual development is just that, a vision. My point is that it is a vision inherited from the decadent imagination of the *fin de siècle:* woman is castrated and castrating, the male is her prey, she wants to make his phallus her own. There are, of course, many passages in Freud that sympathize with women's needs, and his desire to help his female patients to live happier, more fulfilled lives cannot be questioned. But the decadent virus, in the form of castration theory, enters his thinking at a fundamental level and skews all his assumptions. This goes for his description of the male Oedipus complex as well. Despite its supposedly having a maturational function, the oedipal crisis in boys actually depends on, and reinforces, the infantile fantasy of female castration. The father's threat in response to the son's incestuous desires is efficacious precisely because the son recognizes that castration has been carried out on women, a fate he wants to avoid at all costs. One might suppose that maturity for a boy would entail demystifying the lie of castration and exposing the emptiness of the father's threat made on its basis. But castration is Freud's theoretical fetish, and he refuses to let go of it.

As a consequence, he neglects the impact of social expectations and historical circumstances on the psychic formations that arise in the field of sexual difference. The many aspects of this neglect are not, however, my concern in the present context. For a well-reasoned, if unrealistically exigent, critique I refer my reader to John Brenkman's *Straight Male Modern,* which analyzes in detail how specific practices and cultural forms embodied in the Oedipus complex— such as "compulsory heterosexuality, male dominance, patriarchal symbols, male fantasy"—reflect norms that are not suprahistorical, as Freud claims, but are rather the ideological products of a particular social and political world.[5] Suffice it for the moment for me to take note of the impact that changed child-rearing practices in western industrialized countries have had on today's speculating Little Hans. Should the sexual theory that Freud ascribes to all children indeed arise in a child's mind today—and I do not intend to deny that it could—it would be subject to challenges it never encountered in

Vienna around 1900. The evidence against this theory now accumulates earlier and with more authority than it did in Freud's day (parents, preschool teachers, explicit illustrations in children's books). Whereas Freud imagines no obstacles in the path of the boy's "inducing" the truth of castration, today's budding philosopher is forced early on to confront significant opposition to his defensive speculations. And whatever insecurity the girl may feel about her genital equipment is generally countered in today's enlightened household by strong assurances as to its unique value.

But my goal is to show how Freud's thought inherits and elaborates decadent assumptions rather than to critique its ideological biases from our contemporary perspective. The closest convergence between Freud's writing and the imagery and thematics of literary decadence occurs in his biographical essay on Leonardo da Vinci (1910). He quotes a few sentences from Walter Pater's famous description of the Mona Lisa, a locus classicus for the decadent image of the femme fatale, and he relies for much of his information about Leonardo's life on the historical novel by the Russian symbolist-decadent writer Dmitri Merezhkowski. In many ways, Freud's essay is an extended commentary on Pater's assertion about the Mona Lisa that "from childhood we see this image defining itself on the fabric of his [Leonardo's] dreams," which, Freud remarks, "deserves to be taken literally" (SE 11, 110, 111). But just how can such an impressionistic statement be understood literally? My answer is that Freud equates the literal with the theoretical. For Freud to take Pater literally he transforms one kind of aesthetic impressionism into another, literalized, form, which wears the mask of psychoanalytic theory.

At the heart of the literal, Freud imagines a scene of happily satisfied perversion: Leonardo's mother, abandoned by his father (to whom she was not married), transfers her erotic needs onto her little son and thereby "kisses [him] into precocious maturity" (SE 11, 131). The Mona Lisa's mysterious smile, Freud argues, is a reproduction of this maternal look, containing "the promise of unbounded tenderness and at the same time sinister menace (to quote Pater's phrase)" (SE 11, 115). Although Freud warns Ernest Jones in a letter "not [to]

expect . . . the solution of the Mona Lisa puzzle"[6] and tells the reader of his essay that he will "leave unsolved the riddle of the expression of the Mona Lisa puzzle" (SE 11, 109), his oedipal urge to solve riddles pushes him to do just what he declares he won't: the smile, he claims, is that of the "perverse" (SE 11, 117) mother fondling her baby son, awakening his sexuality, and fixing it forever on her.

Confirmation for this fixation Freud finds in an account of a memory from early childhood that Leonardo jotted down in his notebooks. This memory, which Freud interprets as a fantasy of later date transposed to childhood, is of the child in its cradle being visited by a vulture, which opens his mouth with its tail and strikes the tail against his lips. Freud translates: tail equals penis, which is a replacement for the maternal nipple. Vulture equals exclusively female bird in Egyptian mythology, a "fact" cited as evidence for the Virgin birth by the church fathers so likely to have been familiar to Leonardo. Interpretation: Leonardo imagined himself as a vulture-child with a mother but no father. Consequence: he became a vigorous researcher concerning origins, an investigative drive that will later motivate his scientific explorations and interfere with his artistic creativity. But, in the absence of a father's oedipal prohibitions, he retained his fantasy of the phallic mother, identified with that fantasy, and, in adult life, loved young men narcissistically in the way his mother had loved him (so his homosexuality was a disguise for a premature heterosexuality). However, his fidelity to the original maternal image prevented him from realizing his homosexual tendencies, which found expression in the ambiguous smiles of his women and the androgynous look of his delicate young men.

The ambivalent heroine of this tale about a tail is the phallic mother. Freud retains her at considerable expense to (literal) truth. For instance, one of the biographies we know Freud consulted, by Gabriel Séailles (it was in his library, with the date 10.X.09 inscribed on the cover), contains a passage that he underlined claiming that Leonardo's father brought his son into his new household the year that he married his stepmother, which Freud thought to be the same year Leonardo was born.[7] Freud ignores this claim in order to con-

struct his fantasy of a prolonged *folie à deux* between a sexually starved, aggressively tender mother and her infant son (taken into his father's family only at age five, according to Freud's scenario). Equally damaging to Freud's analysis is the fact that the bird Leonardo mentions in his notebooks is a kite (Italian: *nibio*) not a vulture. "Vulture" is a mistranslation found in the 1903 version of Merezhkowski that Freud used. This error was pointed out already in 1923 in an article in a leading art historical journal, *Burlington Magazine,* but Freud took no account of it, even though he added notes to his text in 1923 and made a small change in 1925.[8]

If we cannot be sure that Freud was aware of his mistake, what is certain is that, in *The Interpretation of Dreams,* he recounts a dream from his own childhood that links his mother to birds: "I saw my beloved mother, with a peculiarly peaceful, sleeping expression on her features, being carried into the room by two (or three) people with birds' beaks and had laid upon the bed" (SE 5, 583). Freud's association of the bird-beaked people to illustrations in Phillipson's Bible of "gods with falcons' heads from an ancient Egyptian funerary relief" (SE 5, 583) parallels his association of Leonardo's vulture with the Egyptian goddess Mut (compare German: *Mutter,* mother), vulture-headed, with breasts and a phallus. The suggestion of sexual activity, Freud says in connection both with his dream and Leonardo's fantasy, arises from the connotations of the German word *vögeln,* to act like birds, related to the English "fuck." Thus it would appear, as Jack Spector maintains in his book on Freud's aesthetics, that the vulture-mother is an invention deriving from Freud's own fantasy life, especially as it concerned issues of separation from the mother and of homosexuality.[9] Indeed, the subjective meaning of the Leonardo essay has long been acknowledged: Jones notes that Freud's personal interest in Leonardo "in all probability had been derived from his self-analysis" (SE 2, 78), and Marthe Robert observes that "when he is writing about Leonardo da Vinci Freud is still speaking, in a whisper, about himself."[10]

Perhaps, then, the image that Pater says defined itself from childhood on the fabric of Leonardo's dreams deserves to be taken literally

because it is confirmed in the reality of Freud's own life. But I don't think that this would be quite the right way to phrase the hypothesis, for the reality that matters in Freud is not that of his biography but that of his theory. And what is literally true in that theory, as we have seen, is that children attribute a penis to women, to the mother in the first instance. The phallic mother is the kingpin of psychoanalytic theory, just as, in mythology, "the addition of a phallus to the female body is intended to denote the primal if creative force of nature" (SE 11, 94). In Freud, theory displaces nature to become the primal creative force, the force capable of defining what is literal, what is factual. Just as the vulture fantasy nourished Leonardo's ambition to fly, so theory, another fantasy creation, nourishes Freud's ambition to soar intellectually.

Freud, I am saying, is in (theoretical) love with the phallic mother, icon of the decadent imagination. This, I think, is what he is whispering to us in the Leonardo essay. This love has important consequences for his theorization of desire and sexuality, here and elsewhere. In the analysis of Leonardo, it often seems that his mother's "tender seductions" (SE 11, 131), perverse as they may have been, were beneficial agents of her son's excited curiosity about the world, which expressed itself through precocious scopophilia and *libido sciendi*. Prematurely eroticized and unimpeded at first by paternal inhibitions, Leonardo becomes curious about all the secrets of nature. As Leo Bersani, following Jean Laplanche, has stressed, Freud suggests that in Leonardo's case libido was sublimated without being repressed into the unconscious. That is, Leonardo's powerful instinct for research is driven by a sexuality that is not tied, in some symptomatic or compensatory manner, to infantile complexes. "The maternally derived traumatic model of sexuality," comments Bersani, "moves Freud toward a view of cultural symbolization as a continuation rather than a substitute for sexual fantasy."[11] This, it would seem, is the special gift of the phallic mother: she grants her speculating sons a kind of mobile, eroticized energy that extends her own "perverse" relation to them into their pleasurably perverse relation to the world ("even as an adult he [Leonardo] continued to play," Freud remarks,

"and this was another reason why he often appeared uncanny and incomprehensible to his contemporaries"—SE 11, 127; "uncanny and incomprehensible"—just the way psychoanalysis itself appeared, in Freud's view, to *his* contemporaries!).

But Freud was not entirely comfortable with the uncanny perversity of his muse, linked in Leonardo's case to the typically decadent themes of homosexuality and androgyny. Thus we find a normative standard of judgment asserting itself at various moments in the Leonardo essay, mostly in relation to the father: the presence of a strong father would have ensured that the son made "a correct decision in his choice of object, namely someone of the opposite sex" (SE 11, 99); had the father's prohibitive role been enforced, the boy's sexual researches would have come to a conclusion, and this conclusion would have provided a model for the completion of Leonardo's artistic projects (often left unfinished, Freud suggests, because of an intellectual restlessness insufficiently dominated by the internalized paternal law [called the superego in Freud's later terminology]). These references to oedipal norms, however, do not carry much authority in Freud's essay. Indeed, Leonardo's own refusal to submit to authority, be it of the ancients or of dogmatic religion, is praised by Freud, who sees this autonomy as a result, not of Leonardo's battles against his father, but of his having learned to do without a father (SE 11, 123). Thus we return to the phallic mother, the vulture fantasy, and the tail that is at once phallus and nipple, male and female, self and other. Freud measures the perverse against the normal—this is the duty of the scientist, he believes—and, without being explicit about his preference, demonstrates the greater imaginative mobility released by decadent fantasy.

Appendix: Outline of "Freud's Decadence"

Freud's analysis like Nordau's except in etiology—repression of sex instinct. Sex today equals an exhausted remnant (SE 11, 97).

Idea of neurotic civilizations.

He's a diagnostician of decadence.

But is he also a decadent diagnostician? Does he do away with appeal to a norm? It would appear so.

If basis for such is stigmatizing other as organically degenerate, atavistic, and ethically immoral, Freud breaks with this.

But he makes us all psychic degenerates.

1929 SE 21, 249: same drives today in men as in prehistoric times—so differences between races, languages, and countries are irrelevant.

No clear distinction between neurotic and normal (this is latent in Lombroso).

Degeneracy not due to atavistic biology but to atavistic perversity ("involution of sexual life to its infantile forms"—Civilized Sexual Morality, 199).

Not equally a matter of getting rid of sickies but of recognizing oneself ("in myself also")—Brunner, 32, thus places mind above the body.

Appendix

(Return of the norm)
Thus "sickness" also involves seeing all men as castrated.
Psychoanalytic theory as an "art" (fetish) based on misogyny (but
Brunner, 103)—bourgeois men would "get a good bargain."

Fantasy of phallic mother equals prototypical decadent femme fatale:
Mona Lisa—what does she do: overexcited child, precocious sexual-
ity. (Masochistic institution of sexuality.) ("shattered," traumatized—
Bersani). Kite's tail—essay as decadent fantasy: androgyne, vulture as
cock and breast.

Shattered sexuality: shattered death instinct—like Bourget.
Death instinct as tending toward abolition of history.
N. O. Brown, 104—connection between death and individuality (life
instinct preserves the immortality of species—aims of death instinct
equal separation, independence).

(Patients equal not degenerates biologically because they are psychi-
cally.)
Freud and Vienna *fin de siècle.*

Diagnostician or participant? Outside or inside?
Freud's Judaism.
Oedipus complex equals generalized degeneracy (Gilman, 199—con-
nection to Lombroso, 207, 212), sex crimes of Jews made part of
mind-set of all humans.

Constant denial of role of suggestion—yet likelihood that he *did* sug-
gest seduction scenario—Borch-Jacobsen, 27. Freud's position is that
patient's "state" is self-hypnotized, not influencible from outside (this
is Charcot not Bernheimer, 28–29).

(Freud's choice of theory is already present in his suggestion of se-
duction to patients . . . then creation of the Oedipus complex to jus-
tify this—cf. Borch-Jacobsen.)
Thirty-three Psychoanalysis equals product of feedback, the marginal
fulfillment of its own prophecy.

(Why did Freud suggest incest, etc. as source? To exonerate Jews from this stigma, make everyone degenerate.)

Hans's choice of theory of female castration equals an error (equals the mention of a norm [cf. Lauretis] that becomes a truth, an error that is fundamental to decadent view of male). Decadent misogyny generalized. Freud as fetishist of theory. (Laplanche and Pontalis: it was "theoretical value" of this concept that was of most importance to Freud.) Theory as playing role of art in decadence (but note how threatened it is—Dora's case: Freud's secret attraction to gaps and incompletions).

Death drive equals decadent keystone of theory: life is subordinate to death, pleasure principles serves death. Repetition, regression somehow soldered so that death can be lived in suspension (Sulloway, 404). Tries to preserve sexuality instincts but *both* are conservative manifestations of an impulse to stasis (an analogy within an opposition—Bersani, 63).

Analogy of work of death instinct (disintegrative) to description of decadent style in Bourget and its organic counterpart.
Connection between death instinct and ornament: Huysmans, Schor.

■ Abbreviations

AC Cesare Lombroso, *L'anthropologie criminelle et ses récents progrès* (Paris: Alcan, 1890).

ADW Cesare Lombroso, *After Death—What?* (Boston: Small, 1909).

AN Joris-Karl Huysmans, *Against Nature,* trans. Robert Baldick (New York: Penguin, 1959).

AR Joris-Karl Huysmans, *A rebours,* ed. Marc Fumaroli (Paris: Gallimard, 1977).

BGE Friedrich Nietzsche, *Beyond Good and Evil* (New York: Vintage, 1966).

BP Gustave Flaubert, *Bouvard et Pécuchet,* ed. Claudine Gothot-Mersch (Paris: Gallimard, 1970).

C Gustave Flaubert, *Correspondance,* ed. Jean Bruneau (Paris: Gallimard, Bibliothèque de la Pleiade, 1980 [vol. 2] and 1991 [vol. 3]).

CCR Cesare Lombroso, *Crime: Its Causes and Remedies* (1906; reprint, Montclair, N.J.: Patterson Smith, 1968).

CP Stéphane Mallarmé, *Stéphane Mallarmé: Collected Poems,* trans. Henry Weinfield (Berkeley and Los Angeles: University of California Press, 1994).

CW Friedrich Nietzsche, *The Case of Wagner* (New York: Vintage, 1967).

D Max Nordau, *Degeneration* (New York: Fertig, 1968).

DL Oscar Wilde, "The Decay of Lying," in *The Artist as Critic: Critical Writings of Oscar Wilde,* ed. Richard Ellmann (New York: Random House, 1969).

E Georges Bataille, *L'érotisme* (Paris: 10/18, 1957).

Abbreviations

EH	Friedrich Nietzsche, *Ecce Homo* (New York: Vintage, 1969).
ER	Joris-Karl Huysmans, *En rade* (Paris: Gallimard, 1984).
F	Emile Zola, *La faute de l'abbé Mouret* (Paris: Garnier-Flammarion, 1972).
FC	Cesare Lombroso and G. Ferrero, *La femme criminelle et la prostituée,* trans. Louise Meille (Paris: Alcan, 1896).
FF	Jacques Lacan, *The Four Fundamental Concepts of Psycho-Analysis* (New York: Norton, 1981).
GM	Friedrich Nietzsche, *On the Genealogy of Morals* (New York: Vintage, 1969).
GS	Friedrich Nietzsche, *The Gay Science* (New York, Vintage, 1974).
HC	Cesare Lombroso, *L'homme criminel* (Paris: Alcan, 1887).
HG	Cesare Lombroso, *L'homme de génie* (Paris: Alcan, 1889).
IR	E. H. Mikhail, ed., *Oscar Wilde: Interviews and Recollections,* vol. 1 (London: Macmillan, 1979).
JS	Octave Mirbeau, *Le jardin des supplices* (Paris: Gallimard, 1991).
M	Gilles Deleuze, "Coldness and Cruelty," in *Masochism* (New York: Zone Books, 1991).
MG	Cesare Lombroso, *The Man of Genius* (London: Walter Scott, 1895).
OCF	Gustave Flaubert, *Salammbô,* in *Oeuvres complètes de Gustave Flaubert,* vol. 2 (Paris: Club de l'Honnête Homme, 1974–75).
OCM	Stéphane Mallarmé, *Oeuvres complètes* (Paris: Pléiade, 1945).
OW	Oscar Wilde, *The Letters of Oscar Wilde,* ed. Rupert Hart-Davis (New York: Harcourt Brace, 1962).
S	Gustave Flaubert, *Salammbô* (Paris: Garnier-Flammarion, 1964).
SE	Sigmund Frued, *Standard Edition,* 24 vols. (London: Hogarth Press, 1953–73).

TI Friedrich Nietzsche, *Twilight of the Idols,* in *The Portable Nietzsche* (New York: Vintage, 1954).

UM Friedrich Nietzsche, *Untimely Meditations,* trans. R. J. Hollingdale (Cambridge: Cambridge University Press, 1983).

WP Friedrich Nietzsche, *The Will to Power* (New York: Vintage, 1967).

WS Oscar Wilde, *Salome: A Tragedy in One Act,* trans. from the French by Lord Alfred Douglas (New York: Heritage Press, 1945).

Notes

Introduction

1. Richard Gilman, *Decadence: The Strange Life of an Epithet* (New York: Farrar, Straus, and Giroux, 1979).

Nietzsche's Decadence Philosophy

1. Nietzsche refers to decadence as *décadence* throughout his later writings. This usage is erased in Walter Kaufmann's translations. I have reinstated the French in my citations from these translations, all published in New York by Vintage, which I have abbreviated as follows: BGE, *Beyond Good and Evil* (1966); CW, *The Case of Wagner* (1967); EH, *Ecce Homo* (1969); GM, *On the Genealogy of Morals* (1969); GS, *The Gay Science* (1974); TI, *Twilight of the Idols,* in *The Portable Nietzsche* (1954); WP, *The Will to Power* (1967).

2. Letter from Turin to Malwilda von Meysenbug, dated October 18, 1888. *Friedrich Nietzsche: Werke in drei Bänden,* ed. Karl Schlechta (Munich: Hanser, 1966), 3:1322. My translation.

3. Surprisingly, given Nietzsche's claims, few of his many commentators have devoted extended discussions to the role of *décadence* in his thought. Among recent book-length studies not mentioned elsewhere in these notes, those I have found most useful on this subject are Ofelia Schutte, *Beyond Nihilism: Nietzsche without Masks* (Chicago: University of Chicago Press, 1984); Henry Staten, *Nietzsche's Voice* (Ithaca, N.Y.: Cornell University Press, 1990); Leslie Paul Thiele, *Friedrich Nietzsche and the Politics of the Soul: A Study of Heroic Individualism* (Princeton: Princeton University Press, 1990).

4. Paul Bourget, *Essais de psychologie contemporaine* (Paris: Plon, 1920), 2:20.

5. In his massive condemnation of *fin de siècle* culture, Max Nordau

makes a point of stressing that the loss of self-restraint caused by the liberation of the instincts that Nietzsche advocates would destroy the organism's wholeness: "By the relaxation or breaking up of the mechanism of inhibition in the brain the organism sinks into irrecoverable anarchy in its constituent parts, and this leads, with absolute certainty, to ruin, to disease, madness and death" (*Degeneration,* with an introduction by George L. Mosse [New York: Howard Fertig, 1968]), 431–32.

6. So widely disseminated and indiscriminate is the discourse linking degeneration and modernity that we find Max Nordau, in his massive *Entartung* (*Degeneration;* Berlin: G. Dunkers, 1892–93), using all the same diagnostic tools to condemn Nietzsche as a degenerate decadent that Nietzsche had used himself, just a few years earlier, to condemn Wagner—the same tools, moreover, that Nordau repeats in his own vituperations against Wagner "in whom," he claims, "the stigmata of [degeneration] are united in the most complete and most luxuriant development"! (*Degeneration,* 171). Nordau goes on to spell out the stigmata in question: "[Wagner] displays in the general constitution of his mind the persecution mania, megalomania, and mysticism; in his instincts vague philanthropy, anarchism, a craving for revolt and contradiction; in his writings all the signs of graphomania, namely, incoherence, fugitive ideation, and a tendency to idiotic punning, and, as the groundwork of his being, the characteristic emotionalism of a colour at once erotic and religiously enthusiastic" (171–72).

7. Nietzsche to August Strindberg, December 31, 1888, in Friedrich Nietzsche, *Briefe, Januar 1887–Januar 1889,* ed. Giorgio Colli and Mazzino Montinari (Berlin: Water de Gruyter, 1984), 568. In the early months of his mental breakdown Nietzsche signed other letters "The Crucified" and "Dionysos." Steven T. Brown draws attention to these signatures in his "Untimely Meditations on Nietzsche's Physio-Psychology of Art." [Later published as "Aesthetics as 'Applied Physiology': Nietzsche and the Logic of Degeneration in Art," *Vanishing Point: Studies in Comparative Literature* 1 (1994): 127–43.—eds.] I am grateful to Professor Brown for giving me his illuminating article to read in manuscript.

8. Nietzsche, *Werke,* 3:809.

9. Friedrich Nietzsche, *Daybreak,* trans. R. J. Hollingdale (Cambridge: Cambridge University Press, 1982), 119.

10. Jeffrey Wallen, "Nietzsche's 'Décadence,' French Subjectivities" (paper delivered at the Modern Language Association convention, Toronto, December 1993), 5. I thank Professor Wallen not only for this

stimulating paper but also for his many insightful comments on this chapter in its first draft.

11. This aspect of Nietzsche's thought is well analyzed by David Wellbery in "Nietzsche—Art—Postmodernism: A Reply to Jürgen Habermas," *Stanford Italian Review* 6, nos. 1–2 (1986), especially 88–92.

12. On Nietzsche and hysteria, see Eric Blondel, *Nietzsche: The Body and Culture,* trans. Sean Hand (Stanford, Calif.: Stanford University Press, 1991) and Barbara Spackman, *Decadent Genealogies* (Ithaca, N.Y.: Cornell University Press, 1989).

13. Nordau, *Degeneration,* 419. Early reviewers of the English translation of Nordau's book (1895) observed that Nietzsche and Nordau actually have much in common. One wrote in *Nation* 62 (New York, June 11, 1896), 459: "Both Nietzsche and Nordau pride themselves on being physiological and psychological, although their 'science' is clearly only second-hand, not to say pseudo-scientific. Both excel in vituperation . . . both are anti-religious . . . both are deficient in humor . . . both have won notoriety by attacks upon the music of Wagner." Quoted in David Thatcher, *Nietzsche in England, 1890–1914* (Toronto: Toronto University Press, 1970), 29, 30.

14. Oscar Wilde, "The Decay of Lying," in *The Artist as Critic: Critical Writings of Oscar Wilde,* ed. Richard Ellmann (Chicago: University of Chicago Press, 1968), 301.

15. The Nietzsche-Wilde parallels, now widely noted, were not lost on that indefatigable diagnostician of decadence, Max Nordau. He remarks: "The passage in *Zur Genealogie der Moral* in which [Nietzsche] glorifies art, because 'in it the lie sanctifies itself, and the will to deceive has a quiet conscience on its side,' might be in the chapter in Wilde's *Intentions* on 'The Decay of Lying,' as, conversely, Wilde's aphorisms: 'There is no sin except stupidity'; 'An idea that is not dangerous is unworthy of being called an idea at all' " (*Degeneration,* 413–14). Given that Zola will later occupy our attention, I note here that Nietzsche and Wilde agreed entirely about him: "We don't want to be harrowed and disgusted with an account of the dealings of the lower orders," complains Wilde in "The Decay of Lying" (174); "The things they [Zola and the Goncourts] display are ugly," declares Nietzsche, "but *that* they display them comes from their *pleasure in the ugly*" (WP, 435; note dated 1888).

16. Wilde, "The Decay of Lying," in *The Artist as Critic,* 291.

17. Ibid., 320.

18. In a letter to Malwilda von Meysenbug dated October 4, 1888,

Nietzsche remarks that the style of his writing in *The Case of Wagner* is actually more French than German. See *Werke,* 3:1320. As it happened, *The Case of Wagner* was the first of Nietzsche's books to be translated into French, by Daniel Halévy and Robert Dreyfus, *Le cas Wagner: Un problème musical* (Paris: A. Schulz, 1893).

19. From a letter to Peter Gast dated February 26, 1888. In *Werke,* 3:1280.

20. Nevertheless, he claims to prefer this generation to that of its teachers, who have been "corrupted by German philosophy" (EH, 244). In a letter, however, he notes how well he would have fit in with that earlier generation, guests at the famous Magny diners, "Sainte-Beuve, Flaubert, Théophile Gautier, Taine, Renan, the Goncourts, Schérer, Gavarni, occasionally Turgenev," men characterized by "exasperated pessimism, cynicism, nihilism, alternating with a lot of exuberance and good humor." Then he adds, "I know these gentlemen by heart, so well that I am actually sick of them already" (from a letter to Peter Gast dated November 10, 1887, *Werke,* 3:1269).

21. Nietzsche's view of women has been the subject of much critical attention in the wake of the discussion of the subject by Derrida in *Spurs: Nietzsche's Styles,* trans. Barbara Harlow (Chicago: University of Chicago Press, 1979). Among recent books, the most interesting are the collection *Nietzsche and the Feminine,* ed. Peter Burgard (Charlottesville, Va.: University Press of Virginia, 1994) and Kelly Oliver, *Womanizing Nietzsche: Philosophy's Relation to the "Feminine"* (New York: Routledge, 1995).

22. Eve Kosofsky Sedgwick, *Epistemology of the Closet* (Berkeley and Los Angeles: University of California Press, 1990), 149.

23. Geoff Waite points this out in his article "Nietzsche's Baudelaire: The Posthumous Turn of Nietzsche's Political-Economic Thought," ms. p. 15.

24. Theodor Adorno, *Minima Moralia: Reflections from Damaged Life,* trans. F. N. Jephcott (London: New Left Books, 1974), 96. I am grateful to Silke Weineck for drawing this passage to my attention.

25. In his discussion of Nietzsche and women in "La question du style" (in *Nietzsche aujourd'hui,* vol. 1 of *Intensités* [Paris: 10/18, 1973]), Jacques Derrida completely ignores the first part of the passage we are examining here, in which Nietzsche speaks of his disgust with women's natural functions, and lays all his emphasis on the question of distance, thereby repeating Nietzsche's own phobic aversion. See my critique of

Derrida's article in "The Politics of Aversion in Theory" in *Men Writing the Feminine,* ed. Thaïs Morgan (Albany, N.Y.: State University of New York Press, 1994), 173–86.

26. Elsewhere Nietzsche observes that "the contemplative type is related to the feminine character: it consists of male mothers" (GS, 129). Steven Brown comments perceptively about this male mothering: "Nietzsche's Dionysianism stages a masculinist performance of androgenesis, of male self-insemination and pregnancy, which, rather than transgressing gender lines in the manner of the Greeks' androgynous version of Dionysus, manages to efface them altogether by sublating sexual difference into a metaphysics of masculine monosexuality" ("Untimely Meditations on Nietzsche's Physio-Psychology of Art," 16).

27. Geoff Waite, in an informative footnote concerning the question of Nietzsche's possible homosexuality ("Nietzsche's Baudelaire," 13–14), observes that the question was discussed by the Vienna Psychoanalytic Society in 1908. Waite notes that the most authoritative study of Nietzsche's medical conditions, Pia Daniela Volz, *Nietzsche im Labyrinth seiner Krankheit* (Würzburg: Königshausen and Neumann, 1990), tends to endorse the idea that Nietzsche was indeed gay. This thesis is tendentiously argued by Joachim Köhler, *Zarathustras Geheimnis: Friedrich Nietzsche und seine verschlüsselte Botschaft* (Nördlingen: Greno, 1989).

28. Sedgwick, *Epistemology of the Closet,* 168.

29. On Nietzsche's reception in France, see Geneviève Bianquis, *Nietzsche en France* (Paris: Félix Alcan, 1929) and Douglas Smith, *Transvaluations: Nietzsche in France, 1872–1972* (Oxford: Clarendon Press, 1996).

30. Wyzewa collected his articles on Nietzsche in *Ecrivains étrangers* (Paris: Perrin, 1898). The Scottish poet John Davidson translated (partially and badly) the first of Wyzewa's articles and published it under his name in 1891 and again in 1893, adding dismissive critiques of his own. See David Thatcher, *Nietzsche in England, 1890–1914* (Toronto: University of Toronto Press, 1970), 64–67. After Davidson actually began reading Nietzsche in 1896, his response to the philosopher became much more personal and complex.

31. Among the most interesting of these is *De Kant à Nietzsche,* published in 1900 by Jules de Gaultier, the author two years later of a book diagnosing "bovarysme" as the disease of mediated desire. Gaultier embraces what he sees as Nietzsche's antirationalism, nihilism, and perspectivism as part of a tragic yet lyrical outlook on life that has more in common with French than with German culture.

32. André Gide, *Prétextes* (Paris: Mercure de France, 1904), 181. This interesting early appreciation of Nietzsche appeared in the form of an open letter to a friend named Angèle, as one of a series of articles Gide wrote for the journal *L'Ermitage* from 1898 to 1900. Gide reads Nietzsche as the embodiment of a fundamental urge toward liberation that took the form in earlier ages of Jansenism or Protestantism (177).

33. Havelock Ellis, *Affirmations,* 2d ed. (Boston: Houghton Mifflin, 1916), 5.

34. Havelock Ellis, *Views and Reviews: A Selection of Uncollected Articles, 1884–1932* (London: D. Harmsworth, 1932), 148–49. Quoted in Thatcher, *Nietzsche in England,* 107.

35. See Thatcher, *Nietzsche in England,* 128–29, 140, 142–43.

36. See Patrick Bridgwater, *Nietzsche in Anglosaxony: A Study of Nietzsche's Impact on English and American Literature* (Leicester: Leicester University Press, 1972).

Flaubert's Salammbô: *History in Decadence*

1. Friedrich Nietzsche, *Ecce Homo* (New York: Vintage, 1969), 276.

2. Gustave Flaubert, *Correspondance,* ed. Jean Bruneau (Paris: Gallimard, Bibliothèque de la Pléiade, 1980 [vol. 2] and 1991 [vol. 3]). Abbreviated C hereafter. [Unless otherwise noted, all translations are the author's. —eds.]

3. Friedrich Nietzsche, *Untimely Meditations,* trans. Hollingdale (Cambridge: Cambridge University Press, 1983), 120. Hereafter abbreviated UM.

4. Algernon Swinburne, "Notes on Designs of the Old Masters in Florence," in *Essays and Studies* (1875), quoted in Mario Praz, *The Romantic Agony* (New York: Oxford University Press, 1970), 251.

5. The connection was noted by Jean Lorrain, among others. In *Sensations et souvenirs* (Paris: Charpentier, 1895) Lorrain writes: "The art of Gustave Moreau . . . makes us think, despite ourselves, of the art of another visionary, Gustave Flaubert, the Flaubert who conjured up refulgent nightmares in his *Tentation* and that awesome dream of Carthaginian power" (67).

6. See Charles Bernheimer, *Flaubert and Kafka: Studies in Psychopoetic Structure* (New Haven: Yale University Press, 1982), 92–101.

7. See, for instance, *Flaubert and Postmodernism,* ed. Henry Majewski and Naomi Schor (Lincoln, Nebr.: Nebraska University Press, 1984).

8. Friedrich Nietzsche, *The Will to Power,* ed. Walter Kaufmann (New York: Vintage, 1968), 66.

9. He made fun of this exoticism when inviting the Goncourts over to a reading of selections from his Carthaginian work-in-progress. The invitation the brothers received in late 1861 read: "At 7 o'clock, oriental dinner. You will be served human flesh, bourgeois brains and tigress clitorises sautéed in rhinoceros butter" (C3, 152).

10. References abbreviated OCF refer to the Club de l'Honnête Homme edition of *Salammbô,* which includes an appendix where the articles making up the famous "querelle de *Salammbô*" are brought together and the dossier of Flaubert's notes on his sources is made available.

11. Michel Butor, *Improvisations sur Flaubert* (Paris: Editions de la différence, 1984).

12. This feature of Flaubert's novel has received a good deal of attention. Among the most interesting studies are Veronica Forrest-Thomson, "The Ritual of Reading *Salammbô,* MLR 67, no. 4 (1972): 787–98 and Jonathan Culler, *Flaubert: The Uses of Uncertainty* (Ithaca, N.Y.: Cornell University Press, 1985).

13. Georg Lukács, *The Historical Novel* (Boston: Beacon Press, 1963), 177.

14. Sainte-Beuve criticizes just this myopic narrative stance in *Salammbô:* "The author does not maintain himself above his work," he observes, "he applies himself too closely, he's got his nose on top of it. . . . He never distanced himself enough from his work to adopt the point of view of his readers" (S, 436). Those readers, Sainte-Beuve suggests, want Flaubert to present history as a teleological narrative capable of explaining progress and decadence in terms of causes and effects. For an illuminating discussion of how Flaubert's novel subverts the positivist expectations of Sainte-Beuve and Froehner, see Andreas Wetzel, "Reconstructing Carthage: Archeology and the Historical Novel," *Mosaic* 21, no. 1 (1988): 13–23.

15. Gustave Flaubert, *Bouvard et Pécuchet,* ed Claudine Gothot-Mersch (Paris: Gallimard, 1970), 188. Hereafter abbreviated BP.

16. This point was first brought out forcefully by Jacques Neefs in his important article, "*Salammbô,* textes critiques," *Littérature* 15 (October 1974): 52–64.

17. Paul Bourget makes a similar point in his insightful analysis of Flaubert published in 1882, which has much in common with Nietzsche's

thinking. Bourget sees Flaubert as a victim of the decadence of the age, when such physiological deformations as "impoverished blood" and "exaggerated nervousness" are found everywhere. Flaubert, says Bourget, laments this situation, but he also exemplifies it by the way thought and intelligence triumph over feeling and will in his work. "An abundance of points of view, sign of a rich intelligence," he remarks, "destroys the will, because it produces the dilettantism and nervous impotence of those who are too comprehensive" (*Essais de psychologie contemporaine* [Paris: Plon, 1937], 1:149).

18. Friedrich Nietzsche, *Nietzsche contra Wagner,* in *The Portable Nietzsche,* ed. Walter Kaufmann (New York: Viking, 1954), 671.

19. Eugenio Donato, *The Script of Decadence: Essays on the Fictions of Flaubert and the Poetics of Romanticism* (New York: Oxford University Press, 1993), 19. As a tribute to Eugenio, whose wonderful essay on *Salammbô* has inspired many aspects of my thinking, I would like to tell a story here that invokes his memory.

I owe to Eugenio what was perhaps my most intimate encounter with Flaubert. Many years ago, I took twenty pictures of his death mask in the Musée Carnavalet in Paris. The mask was not on exhibit. It had to be brought up from storage in the cellar. I had initially been misdirected by a guard to the museum's second floor, where I found "le masque funéraire de Voltaire," a mistake Flaubert would have relished. Since it was a rather gray day and no flash was permitted, I placed the plaster mask on a chair near the window and shot pictures from as many angles as possible. I felt strange. I had spent many years of my life thinking about this man—undergraduate and graduate seminars, my doctoral thesis, my first published article, half of my first book, a long chapter in my second. And there he was, in the flesh as it were; every wrinkle visible; the bulging eyes closed; the great expanse of forehead, the walrus moustache, the fleshy cheeks, all molded from life—or, rather, death. How could I get closer to his living presence than this?

There was something uncanny, I reflected, about my feeling the master's presence in the cast representing his death. I had argued in my first book that Flaubert's revolutionary power as a writer was due to his having molded the principle of death into literary representation. I thought of his many declarations that art can be produced only by detaching oneself from life, of his desire to write a novel about nothing, of his admiration for a totally blank wall of the Acropolis. Flaubert's goal as a verbal craftsman was effacement, his own authorial self-effacement but also the

effacement of the world's differences, so that his reader, carried along on
the opaque surface of words, would dream of an unsayable absence. As I
hovered over and around Gustave's plaster face, its very lifelikeness re-
minded me of how even the most realistic effects of his prose were func-
tions of his ambition to efface reality. He was a great negator, a master of
nihilism. Living with him for as long as I have has not always been easy.

I was not in the Musée Carnavalet on my own account. My friend
and fellow Flaubertiste, Eugenio Donato, had asked me to take the pic-
tures for him, one of which he intended to use on the cover of his pro-
jected book on Flaubert and decadence. No one understood Flaubert's
relation to death in a more radical way than Eugenio. In an essay entitled
"The Crypt of Flaubert" (in *Flaubert and Postmodernism,* 30–45), he
quotes from letters in which Flaubert describes sitting at the wakes of his
sister and of his close friend Alfred Le Poittevin. In both cases, Flaubert
is fascinated with the corpse, especially with its face—he gets up period-
ically and lifts the veil covering Alfred's face to see it more closely. Be-
tween periods of contemplation, he reads, Montaigne during his sister's
wake, Creuzer's *Les religions de l'antiquité,* a major source for both *La ten-
tation de saint Antoine* and *Salammbô,* during Alfred's. And he has
"flashes of untranslatable ideas" and "feels the need to say incomprehen-
sible things" (C1, 493). Donato interprets these scenes as staging the
birth of Flaubertian representation, the introjected, encrypted corpse be-
ing the untranslatable inspiration of his writing. Glossing Derrida's com-
mentary on the work of the French psychoanalysts Abraham and Torok,
Donato concludes, "Representation, and hence literature, is the effect of
the occultation of the 'ultimate referent' which can only be evoked as
'The Thing' which lies buried in the crypt" (43).

A photo of Flaubert's death mask would indeed be perfect for the
cover of Eugenio's book, I thought to myself. Faced with this uncanny
object, I felt obscurely that what it evoked was an unspeakable and un-
locatable elsewhere—death somehow made present as the pure efface-
ment of any presence. The mask puts authorship in question in an en-
tirely Flaubertian manner, I reflected. No "artist" is named as the creator
of this work, which was modeled directly on nature rather than from it.
Should Flaubert be credited with this posthumous autosculptural work?

When I had completed my "shoot," I returned Flaubert's head to the
museum curator. She presumably consigned it once again to the cellar,
where I imagine its being joined, during the next renovation of the
rooms, by Voltaire's mortuary impression. Voltaire, Flaubert—same dif-

ference, when the matter is plaster. I forwarded my roll of film to Eugenio in California and waited for him to send me back the one print I had requested from the lot. That never happened. I never saw the results of that bizarre attempt to capture the profile of Flaubert's death. In 1983 Eugenio died. No one besides us knew what the film contained. It was no doubt discarded by his executors. Ten years later, a book entitled *The Script of Decadence* by Eugenio Donato was published. The cover is a solid dark blue.

20. Anne Green, *Flaubert and the Historical Novel: Salammbô Reassessed* (Cambridge: Cambridge University Press, 1982), 114.

21. Oswald Spengler would claim that these two moments are actually "contemporaneous," a term that he uses to designate "two historical facts that occur in exactly the same—relative—positions in their respective Cultures, and therefore possess exactly equivalent importance" (*The Decline of the West*, 2 vols. in 1 [New York: Knopf, 1939], 1:112). According to Spengler's organicist theory (which he claims to derive from Goethe and Nietzsche), his own epoch represents the end of a cycle, which is homologous in its inner structure to the final stage of other cultures.

22. The best reading of the deconstructed logic of opposition in the novel is the chapter on *Salammbô* in Michal Ginsburg, *Flaubert Writing: A Study in Narrative Strategies* (Stanford, Calif.: Stanford University Press, 1986).

23. Gustave Flaubert, *Salammbô* (Paris: Garnier-Flammarion, 1964), 220. Hereafter abbreviated S.

24. In her brilliant anlysis of the novel, Françoise Gaillard comments on what she calls its "démotivation historique" ("La révolte contre la révolution [*Salammbô:* Un autre point de vue sur l'histoire]," *Gustave Flaubert: Procédés narratifs et fondements epistémologiques,* ed. Alfonso de Toro [Tübingen: Gunter Narr Verlag, 1987]), 47. See also Annie Goldmann, "*Salammbô,* ou L'histoire absente," *Revue de l'institut de sociologie* 3–4 (1973): 613–24.

25. Flaubert's aestheticization of violence and cruelty is still capable of eliciting moral outrage on the part of readers. At a meeting of the Modern Language Association in 1994, Myra Jehlen chose the example of *Salammbô* to question the critic's responsibility toward a work that practices "an enhancement of beauty through evil" and takes an immoral pleasure in pain ("Flaubert's Nightmare," paper presented at the Modern Language Association convention, San Diego, Calif., 1994).

26. Granted, Flaubert veils this act in such a way that one cannot be entirely sure that it occurred, but the degree of this uncertainty can be overstated. Under Mâtho's passionate kisses, Salammbô feels "as if swept up in a hurricane, caught [prise, a word with strong sexual connotations] in the power of the sun" (S, 211). Immediately after the encounter, Giscon claims to have overheard the princess shamelessly "moaning with love like a prostitute" (S, 214). Moreover, the chainlet linking her feet and symbolizing virginity breaks in the embrace. As extratextual evidence of Flaubert's intention, one can cite, first, his explanation to Sainte-Beuve that Salammbô's "indecent" scene with the snake was a deliberate "rhetorical precaution" to attenuate the shock of the scene in Mâtho's tent (OCF, 447), and, second, his many crude references, in both scenarios and letters, to his protagonists' *baisade*.

27. Naomi Schor, *Breaking the Chain: Women, Theory, and French Realist Fiction* (New York: Columbia University Press, 1985), 120.

28. On clothing and fetishism in the novel, see Sima Godfrey, "The Fabrication of *Salammbô:* The Surface of the Veil," *MLN* 95 (1980): 1005–16.

29. For a study of the novel that shows how Flaubert universalizes fetishism while simultaneously recognizing the interpreter's desire for an orientalizing difference, see E. L. Constable, "Critical Departures: *Salammbô's* Orientalism," *MLN* 111 (1996): 625–46.

30. In the scenario for the second volume of *Bouvard et Pécuchet,* Flaubert summarized the meaning of the clerks' activities as follows: "equality of everything, of the good and the bad, the Beautiful and the ugly, the insignificant and the characteristic" (BP, 443).

Decadent Naturalism/Naturalist Decadence

1. This has been recognized by the best critics of the period. In his comprehensive overview entitled *The Decadent Imagination, 1880–1900* (Chicago: University of Chicago Press, 1981), Jean Pierrot speaks of the "relative symbiosis" that existed between naturalism and symbolism and maintains that "decadence constitutes the common denominator of all the literary trends that emerged during the last two decades of the nineteenth century" (7). See also the overly long analysis by Sylvie Thorel-Cailleteau, *La tentation du livre sur rien: Naturalisme et décadence* (Paris: Editions InterUniversitaires, 1994).

2. This novel has not received extensive attention from critics. Still

the most illuminating discussion is in the brilliant book by Jean Borie, *Zola et les mythes, ou de la nausée au salut* (Paris: Seuil, 1971).

3. Emile Zola, *La faute de l'abbé Mouret* (Paris: Garnier-Flammarion, 1972), 65. Hereafter abbreviated F. The best English translation is by Sandy Petrey, *The Sin of Father Mouret* (Englewood Cliffs, N. J.: Prentice-Hall, 1969).

4. Georges Bataille, *La part maudite* (Paris: Minuit, 1967), 70.

5. Gilles Deleuze, "Coldness and Cruelty," in *Masochism* (New York: Zone Books, 1991), 100. Hereafter abbreviated M.

6. Joris-Karl Huysmans, *A rebours,* ed. Marc Fumaroli (Paris: Gallimard, 1977), 107. Hereafter abbreviated AR.

7. Arthur Symons, "J.-K Huysmans," *Fortnightly Review,* March 1892. Quoted in Robert Baldick, *The Life of J.-K. Huysmans* (Oxford: Clarendon Press, 1955), 78.

8. Quoted in Robert Baldick, *The Life of J.-K. Huysmans* (Oxford: Clarendon Press, 1955), 104, from a letter of June 1887.

9. Joris-Karl Huysmans, *En rade* (Paris: Gallimard, 1984), 41. Henceforth abbreviated ER.

10. Alain Buisine, "Le taxidermiste," *Revue des sciences humaines* 43, nos. 170–71 (April–September 1978): 63. Other articles of value on *En rade* are Jean Borie's preface to the folio edition (Paris: Gallimard, 1984) and Françoise Gaillard, *"En rade,* ou Le roman des énergies bloquées," in *Le naturalisme: Colloque de Cérisy* (Paris: 10/18, 1978).

11. See Georges Didi-Huberman, *Invention de l'hystérie: Charcot et l'iconographie photographique de la Salpêtrière* (Paris: Macula, 1982).

12. Quoted by Jean Starobinski, "Sur la chlorose," *Romantisme 11,* no. 31 (1981): 127.

13. For an excellent discussion of the role of dreams in Huysmans, see Françoise Carmignani-Dupont, "Fonction romanesque du récit de rêve: L'exemple d'*A rebours,*" *Littérature* 43 (October 1981): 57–74.

14. Gaston Bachelard, *La terre et les rêveries de la volonté* (Paris: Corti, 1948), 205–20.

15. Joris-Karl Huysmans, *Là-bas* (Paris: Garnier-Flammarion, 1978), 170.

16. The indifference seems to have been mutual: I have found no references one to the other in their correspondences and the major biographies make no mention of the other.

17. Gillian Beer's essay "Hardy and Decadence," in *Celebrating*

Thomas Hardy: Insights and Appreciations, ed. Charles Pettit (London: Macmillan, 1996), 90–102, appeared after I had completed this chapter. Although this interesting essay suggests Hardy's affinities with decadence, its argument is quit different from mine.

18. Thomas Hardy, *Tess of the d'Urbervilles,* ed. Juliet Grindle and Simon Gatrell (Oxford: Oxford University Press). All subsequent citations are to this edition.

19. David Lodge, "Tess, Nature, and the Voices of Hardy," in *Language of Fiction* (London: Routledge, 1966), 182.

20. Even when winter is at its most chilling, nature does not close off its vitalizing connection to female energy. Thus, on a snowy day at Flintcomb-Ash, Tess and Marian venture out and are "twisted and spun eccentrically, suggesting an achromatic chaos of things" (298). Although the sun is nearly rubbed out in this hostile environment, the sky having "a white vacuity of countenance with the lineaments gone" (277), the destabilizing eccentricities of nature are still in the essentially feminine mode of productive excess. In the face of winter's blasting chaos, the women, we are told, "were fairly cheerful" (281).

21. D. H. Lawrence, *Study of Thomas Hardy,* ed. Bruce Steele (London: Cambridge University Press, 1985), 95. The two subsequent quotes are on the same page.

22. *The Collected Letters of Thomas Hardy,* ed. Richard Little Purdy and Michael Millgate (Oxford: Clarendon Press, 1980), 2:99. Letter dated November 20, 1895. Contemporary critics, however, did commonly link Hardy (especially *Tess* and *Jude*) to Zola, and in 1893 a journalist for *The World* regretted that Hardy had failed to attend an Authors' Club dinner in honor of Zola since this "deprived his fellow-writers of a fine opportunity of mentally comparing the author of *Tess* with the author of *Nana.*" *The World,* October 4, 1893. Quoted in a note to *The Collected Letters,* 2:36. One of Hardy's biographers suggests that Hardy stayed away from this event because his wife did not want her husband's name linked with that of Zola, associated in her mind with pornographic licentiousness (F. B. Pinion, *Thomas Hardy: His Life and Friends* [New York: St. Martin's Press, 1992], 249).

23. Quoted from a letter to Mrs. Henniker in Martin Seymour-Smith, *Hardy* (London: Bloomsbury, 1994), 596. In a subsequent letter to the same correspondent Hardy said that Zola was "no artist, and too material" (also quoted by Seymour-Smith, 596).

24. See, for instance, the last chapter of Gillian Beer, *Darwin's Plots* (London: Routledge, 1983) and Peter R. Morton, *The Vital Science: Biology and the Literary Imgination* (London: Allen and Unwin, 1984).

25. Wilde, "The Critic as Artist," in *The Artist as Critic: Critical Writings of Oscar Wilde,* ed. Richard Ellmann (Chicago: University of Chicago Press, 1968), 382–83, 384.

26. This theme has been treated from a deManian point of view by Elisabeth Bronfen, "Pay as You Go: On the Exchange of Bodies and Signs," in *The Sense of Sex: Feminist Perspectives on Hardy,* ed. Margaret Higonnet (Urbana, Ill.: University of Illinois Press, 1993), 66–86.

27. Kaja Silverman, "History, Figuration and Female Subjectivity in *Tess of the d'Urbervilles,*" in *New Casebooks: Tess of the d'Urbervilles,* ed. Peter Widdowson (London: Macmillan, 1993), 129–46.

28. J. Hillis Miller, "*Tess of the d'Urbervilles:* Repetition as Immanent Design," in *Fiction and Repetition* (Cambridge: Harvard University Press, 1982), 116–46.

29. The point that Alec does not deserve to be killed is forcefully argued by Laura Claridge, "Tess: A Less than Pure Woman Ambivalently Presented," in *New Casebooks,* 63–79.

30. Hardy tells the story of this face in *The Well-Beloved,* written in a first version in 1892, immediately after *Tess,* and radically revised in 1897. In this peculiar novel, the hero, a sculptor named Jocelyn, falls in love with his cousin Avice, then twenty years later with her daughter, also named Avice, then, after another twenty years have passed, with the granddaughter, the third Avice. Not only do they repeat each other, all three Avices are already a part of a series—"one in a long, long row," as the first Avice remarks, echoing Tess, when she discovers love letters from Jocelyn's many previous beloveds (*The Well-Beloved,* New Wessex edition [London: Macmillan, 1975], 206. Quoted in Hillis Miller's illuminating chapter on this novel in *Fiction and Repetition,* 157). Jocelyn sleeps with none of the Avices, whose bodies, merely the "temporary residences" of the ideal, become "a corpse" in his eyes once the spirit has left them. The compulsion to repeat is thus linked to the desire to produce women as corpses and to observe death's effects on the female other. The link between this morbid production and artistic creation is made explicit in the novel's ending, when Jocelyn marries a nonbeloved and immediately loses his talent as a sculptor.

31. Jennifer Birkett, *The Sins of the Fathers: Decadence in France, 1870–1914* (London: Quartet Books, 1986), 247.

32. Charles Baudelaire, *Le peintre de la vie moderne,* in *Oeuvres complètes,* ed. Claude Pichois (Paris: Gallimard, 1961), 1183.

33. Octave Mirbeau, *Le jardin des supplices* (Paris: Gallimard, 1991), 46. Hereafter abbreviated JS.

34. Emily Apter, *Feminizing the Fetish: Psychoanalysis and Narrative Obsession in Turn-of-the-Century France* (Ithaca, N.Y.: Cornell University Press, 1991), 157-58.

35. In a second essay on Mirbeau, Apter develops her interpretation of decadent parody in Mirbeau. See Emily Apter, "Sexological Decadence: The Gynephobic Vision of Octave Mirbeau," in *The Decadent Reader: Fiction, Fantasy and Perversion from Fin de Siècle France,* ed. Asti Hustvedt (New York: Zone Books, 1998), 962-78.

36. Here is another statement of this vision: "There is only putrescence and manure, there is only impurity at the origin of life. Spread out in the road under the sun, the decaying carcass swells up with splendid life; the droppings in the dry pasture hold wonderful future realizations in store. It is in the infection of pus and the venom of corrupt blood that forms are hatched, through which our dream chants and enchants" (quoted in Pierre Michel and Jean-François Nivet, *Octave Mirbeau: Biographie* [Paris: Séguier, 1990], 607, from an article titled "Sur un livre" that appeared in *Le Journal* for January 9, 1895).

37. Quoted by Michel and Nivet, 473-74, who identify an article signed Jean Maure titled "Lilith" that appeared in *Le Journal* for November 20, 1892, as actually written by Mirbeau.

38. In the matter of colonialism, as in that of anti-Semitism, Mirbeau spoke out of both sides of his mouth in the course of his career. From February to April, 1885, he wrote eleven articles for *Le Gaulois* that purported to be accounts of a trip to India, where in actuality he had never been. The articles were based on the confidential reports of a diplomat named François Deloncle, whose strong advocacy of expanding France's imperial domain Mirbeau echoed in his faked "Lettres de l'Inde." This fact was drawn to my attention by Dorothy Figueira, "*Le jardin des supplices:* Roman philosophique, utopique et orientaliste," in *Seminari Pasquali di analisi testuale* (Pisa: Edizioni ETS, 1993), 8:5-16.

39. Georges Bataille, *L'érotisme* (Paris: 10/18, 1957), 66. Hereafter abbreviated E.

Visions of Salome

1. Bram Dijkstra, *Idols of Perversity: Fantasies of Feminine Evil in Fin-de-Siècle Culture* (New York: Oxford University Press, 1986), 398. On the Salome theme in literature and the arts, see the volume I edited with Richard Kaye, *The Queen of Decadence: Salome in Modern Culture* (Chicago: University of Chicago Press, 1998), which includes an extensive bibliography. The classic treatment of the theme of the femme fatale is Mario Praz, *The Romantic Agony,* trans. Angus Davidson (New York: Meridian Books, 1956). More recent studies of merit are Jean Pierrot, *The Decadent Imagination, 1880–1900,* trans. Derek Coltman (Chicago: University of Chicago Press, 1981) and Mireille Dottin-Orsini, *Cette femme qu'ils disent fatale: Textes et images de la misogynie fin-de-siécle* (Paris: Cramer, 1993). I discuss all these in my introduction.

2. Ortega y Gasset repeats this idea in his chapter on Salome in *On Love: Aspects of a Single Theme,* trans. Toby Talbot (London: Jonathan Cape, 1957). He notes that Salome's virginity is one of the persistent themes of her legend and remarks that "in a woman, extreme physical virginity, an immoderate preoccupation with prolonging the state of maidenhood, usually appears in conjunction with a masculine nature" (174).

3. Emile Richard, *La prostitution à Paris* (Paris: Baillière, 1890), 23. In 1902 the director of the Institut Pasteur considered that there were a million contagious syphilitics in French society. See Alain Corbin, *Women for Hire: Prostitution and Sexuality in France after 1850,* trans. Alan Sheridan (Cambridge: Harvard University Press, 1990).

4. Stéphane Mallarmé, *Correspondance, 1862–1871,* ed. Henri Mondor (Paris: Gallimard, 1959), 137.

5. Stéphane Mallarmé, *Les noces d'Hérodiade,* ed. Gardner Davies (Paris: Gallimard, 1959), 51. Mallarmé's name change has a venerable history. The daughter of Hérodias is not named in the two gospels in which she appears, Mark and Matthew. The name Salome originates with the Jewish historian Flavius Josephus, who wrote at the end of the first century A.D. But this appellation did not stick: already in the next century the Christian philosopher Origen claimed that Herodias's daughter had been given her mother's name. And the confusion persisted through the ages, the form "Hérodiade" being popular in France, while "Herodias" was preferred in England and Germany. Heinrich Heine used the name Hérodias in his ironic narrative poem *Atta Troll,* which Mallarmé knew

in Heine's own translation (1847), to designate a figure in whom characteristics of mother and daughter are fused.

6. Ibid., 154.

7. Stéphane Mallarmé, *Oeuvres complètes* (Paris: Pléiade, 1945), 45. Hereafter abbreviated OCM.

8. Jacques Lacan, *The Four Fundamental Concepts of Psycho-Analysis* (New York: Norton, 1981), 96. Hereafter abbreviated FF.

9. Translation by Henry Weinfield, *Stéphane Mallarmé: Collected Poems* (Berkeley and Los Angeles: University of California Press, 1994), 34. Hereafter abbreviated CP.

10. In a letter of 1866, Mallarmé wrote in a similar vein that "the words in a poem, already enough themselves not to receive any more impressions from outside, reflect one on another until they no longer seem to have their own color but to be only the transitions of a scale" (*Correspondance,* 234).

11. There is a suggestion at the end of "Scène" that Hérodiade may be ready to allow some "chose inconnue" to release her from her specular fascination. Interpreters have read this potential release as an opening to sexuality. But Mallarmé's notes indicate that the "thing" in question would have been the saint's head, with which the princess was to contract marriage (*Les noces d'Hérodiade,* 16). According to one draft, he planned to have Hérodiade, after her nuptials, throw the head out the window and dance for herself alone (ibid., 275, 295).

12. In a poem of 1909, the Russian symbolist poet Alexander Blok refers to Salome in a similar mode. He pictures himself lying in dejection by the lion column in Venice and seeing Salome pass by with his head on a platter. The orphic head, liberated through Salome's good graces from the body's conflicted desires, stares into the gloom that its poetic vision will soon illuminate (see Olga Matich, "The Russian Salome: Femme Fatale as Palimpsest," in *The Queen of Decadence*).

13. In his early poem "Fleurs," Mallarmé had already associated Hérodiade with a flower: "Et, pareille à la chair de la femme, la rose / Cruelle, Hérodiade en fleur du jardin clair, / Celle qu'un sang farouche et radieux arrose!" (OCM, 34). Arthur Symons, in *Studies in Seven Arts* (London: Martin Secker, 1906), follows Mallarmé in seeing the female dancer as an embodiment of the modern ideal: "The dancer, with her gesture, all pure symbol, evokes, from her mere beautiful motion, idea, sensation, all that one need ever know of event. There, before you, she

exists, in harmonious life; and her rhythm reveals to you the soul of her imagined being" (234).

14. Lest Mallarmé's conception seem totally isolated and idiosyncratic, I want to allude here to the strikingly similar use that the Irish poet William Butler Yeats made of the Hérodiade figure. In 1910, Yeats chose the image of Herodiade to define the nondiscursive quality of the art he aspired to create "as separate from everything heterogeneous and casual, from all character and circumstance, as some Herodiade of our theatre, dancing seemingly alone in her narrow luminous circle" (W. B. Yeats, "The Tragic Generation," in *Autobiographies* [London: Macmillan, 1973], 321). Inspired by Mallarmé, Yeats imagines Herodiade as an emblem of the perfectly achieved work of art. Although he never created a Herodiade equal to his vision of her symbolic meaning, the figure of the dancer reappears throughout Yeats's work and takes center stage in the late symbolist dance plays influenced by Japanese No drama, *A Full Moon in March* (1935) and *The Death of Cuchulain* (1939). In the prologue to the latter, Yeats's alter ego voices his sense of being the last figure in a tradition. He admits to feeling "out of fashion and out of date," yet continues to rehearse "the antiquated romantic stuff" that has been his inspiration. "There must be severed heads," he meditates, "severed heads for her to dance before" (*The Collected Plays of W. B. Yeats* [New York: Macmillan, 1953], 694). When the play's protagonist does undertake her dance, the head is represented as a mere black parallelogram.

15. Joris-Karl Huysmans, *A rebours* (Paris: Gallimard, 1977), 331–32. English translation by Robert Baldick, *Against Nature* (New York: Penguin, 1959), 199. Hereafter abbreviated AN. Future references will be given in the text, the first number referring to the French text, the second to the Baldick translation. I have, however, made my own translations, so the text I cite may differ somewhat from Baldick's version.

16. The oil was bought by Louis Mante, whose family kept it until 1956; the watercolor changed hands a number of times before Charles Hayem presented it to the French national museums in 1898, the year of Moreau's death. Huysmans no doubt saw the paintings in 1876 and 1878, but at the time he wrote his descriptions all he had available to him to jog his memory were black-and-white reproductions of the images. In a letter to Mallarmé of November 1882, he announces that he has bought "a very beautiful and very large photoengraving by Goupil of the *Salome* [and] a perfectly acceptable etching, a beautiful artist's print on rice paper, of *The Apparition*" (cited by Marc Eigeldinger, "Huysmans inter-

prète de Gustave Moreau," in *Huysmans: Une esthétique de la décadence* [Geneva: Slatkine, 1987], 207). Huysmans did not actually meet Moreau in person until he was introduced by Jean Lorrain in June 1885. However, they did not become close, as is evident from the draft of a letter Moreau wrote to Huysmans, dated October 4, 1891: "I have never thanked you— and yet what do I not owe you?—you who have given me one of the most precious rewards of my working life. Your sympathy as an artist, you who have so magnificently probed into and elucidated my modest inventions, and who have as it were created them anew with your marvelous and incomparable tool. But really I had always hesitated, fearing to be unable to express my gratitude to you as I should have wished. Finally, smitten with remorse at being so behindhand with you, I come today, sir, and offer you all my thanks, from the bottom of my heart, for so many tokens of your benevolent sympathy, and assuring you of the admiration and high esteem which I have for your talent and your character." Quoted by Pierre-Louis Mathieu, *Gustave Moreau* (Boston: New York Graphic Society, 1976), 280 n.815.

17. Redon's visual interpretation of Moreau's image, in a charcoal drawing of 1883 entitled *Apparition*, offers a Mallarméan reading of the picture. Stripping the scene of the theatricality and ornamental detail with which Moreau had infused it, Redon focuses on the relation not between the head and its beheader but between the head and a mysterious sphere floating next to it. Whether this sphere threatens to eclipse the head's radiance or the head has already survived that threat is indeterminable. Redon evacuates psychology from the scene. The princess merely stands by, a material witness—defined by her fleshly embodiment—to a strange spiritual event, rather than the guilty victim of a terrifying hallucination.

18. Jean Lorrain, *Monsieur de Phocas* (Paris: La Table Ronde, 1992), 18. Subsequent references will be given in the text. On Lorrain's Salome obsession, see Daniel Sangsue, "Lorrain et le mythe de Salomé," *Revue des Sciences Humaines* 230 (April–June 1993): 33–54. This entire issue is dedicated to Lorrain and has excellent articles by Charles Grivel, Franc Schuerewegen, and Alain Buisine, among others. See also the chapter on Lorrain in Jennifer Birkett, *The Sins of the Fathers: Decadence in France, 1870–1914* (London: Quartet, 1986).

19. Despite his own flamboyantly homosexual public persona, Lorrain refrains from making the homosexual implications of his text explicit, suggesting instead that Phocas is an assiduous, if disgusted, fre-

quenter of brothels (in one of which he finds Izé Kranile degraded into a common whore).

20. Welcôme tells a story about an "enchanted moment" in which this desire was perfectly fulfilled. Descending the Nile by boat, he saw a boy's adolescent form, in a pose at once royal and servile, standing against the shoulder of a sphinx. Upon closer scrutiny, he realized that the head, invisible in the shadow but no doubt "delicious" (136), had been severed at the neck.

21. This sameness has been discussed in terms of Julia Kristeva's notion of the "abject" in an excellent article by Micheline Besnard, "Le masque de la morte verte: Jean Lorrain et l'abject," *Romantisme* 79, no. 1 (1993): 53–72.

22. Oscar Wilde, *Salome: A Tragedy in One Act,* trans. from the French by Lord Alfred Douglas (New York: Heritage Press, 1945). Henceforth referred to as WS in the text. A young Guatemalan writer named Gomez Carrillo tells the story of Wilde's being invited to Lorrain's house for dinner, admiring there the gory bust of a decapitated woman on prominent display, and identifying it as Salome's head. Wilde explained his identification by referring to a story told in a certain apocryphal Nubian gospel discovered by Jules Boissière: the princess sent her own head to a young philospher she loved who, in a supercilious moment, had requested it instead of the gift she had offered him of the Baptist's capital member. The assembled company, says Carrillo, found this tale so compelling that they encouraged Wilde to write it up, which he apparently started to do, entitling the story "The Double Beheading," but then he abandoned the project. See *Oscar Wilde: Interviews and Recollections,* ed. E. H. Mikhail (London: Macmillan, 1979), 1:193–94. Hereafter abbreviated IR. Boissière's text can be found in *Fumeurs d'opium* (Paris: Flammarion, 1896), 151. The Greek poet Cavafy used this text almost word for word to create a poem he wrote in 1896 (see C. P. Cavafy, "Salome," in *Secret Poems, 1877?–1923* [Athens: Ikaros, 1993]).

23. Letter to the editor of *The Speaker,* December 1891, in *Letters of Oscar Wilde,* ed. Rupert Hart-Davis (London: Harcourt, Brace and World, 1962), 299.

24. W. Graham Robertson, with whom Wilde discussed the decor of the play in 1892, says that Wilde wanted to have "scented clouds rising [from braziers of perfume] and partly veiling the stage from time to time" (quoted from W. Graham Robertson, *Time Was* [London: Hamilton, 1931], 125–26 by William Tydeman, and Steven Price, *Wilde: Salome*

[Cambridge: Cambridge University Press, 1996], 21). This cloudy veil would have doubled Salome's veil of words.

25. Kate Millett, *Sexual Politics* (New York: Doubleday, 1970), 152.

26. Katharine Worth, *Oscar Wilde* (London: Macmillan, 1983), 58, 70.

27. This point was first made by Gail Finney in her illuminating discussion of the play in *Women in Modern Drama* (Ithaca, N.Y.: Cornell University Press, 1989).

28. Elliott Gilbert, "'Tumult of Images': Wilde, Beardsley, and *Salome*," *Victorian Studies* 26, no. 2 (1983): 156.

29. Indeed, decadence was first identified in France as a literary school through parody. In 1885, a little volume of parodies appeared entitled *Les déliquescences: Poèmes décadents d'Adoré Floupette* written by two minor writers of the day, Gabriel Vicaire and Henri Beauclair. According to its exemplary exaggerations, decadence was identifiable by the exotic obscurity of its vocabulary and the acrobatic virtuosity of its syntax, the grotesque excess of its attitudes (pessimism, perversion, narcissism, neurosis, ennui), and the predictability of its obsessions (perfumes, flowers, gems). Thus decadence became defined as such insofar as it leant itself, from the outset, to parodic treatment. As if to illustrate how close the parodies were to their targets, Floupette's verse was published initially in a journal, *Lutèce,* that featured the work of just those authors *Les déliquescences* mocks. And in the subsequent critical debates, Floupette was often cited as a typical representative of the decadent school (see Louis Marquèze-Pouey, *Le mouvement décadent en France* [Paris: Presses Universitaires de France, 1986], 150).

30. Gomez Carrillo (see note 22) says that Wilde was obsessed with Salome lore in fall 1891, reciting passages from Flaubert, Mallarmé, and Huysmans; claiming to be "mad just like Des Esseintes" (IR, 195); vacillating passionately in his judgment of Salome, considering her chaste and innocent at one moment, shameless and cruel at the next; evoking countless paintings of the princess but finding that "only the painting of Gustave Moreau rendered clearly his dreams of the soul of the legendary dancer-princess" (IR, 195). (But had Wilde actually seen either of the famous Moreaus? One may well wonder. He did not visit Paris in either 1876 or 1878, when the paintings were available for public viewing.)

It is also unclear to what extent Wilde was influenced by Jules Laforgue's parodic story "Salomé," written in 1885 and included in the volume *Moralités légendaires* (*Moral Tales*), published in 1887, the year of Laforgue's death at age twenty-seven. Laforgue parodies many of the

same texts Wilde does, but in deliberately outrageous, often nearly un-readable style, full of punning wordplays, hermetic in-jokes, bewildering anachronisms, esoteric references, syntactical obscurities, and mystifying self-mockery. At once decadent and antidecadent, this story illustrates a kind of radical parody that has no normative standard not subject to its mockery. Such, I am arguing, is also Wilde's parodic mode.

31. Beardsley made a caricature of Wilde at work surrounded by his sources for Salome, with a legend that alludes to the thematics of the gaze in the play, "il ne faut pas le regarder" ("one should not look at him").

32. *Oscar Wilde: The Critical Heritage,* ed. Karl Beckson (London: Routledge and Kegan Paul, 1970), 136.

33. Responding to a friend's remark that his *Salome* reminded him of Flaubert's "Hérodias," Wilde quipped, "Remember, *dans la littérature il faut tuer son père* [in literature one must always kill one's father]." From Richard Ellmann, *Oscar Wilde* (New York: Knopf, 1987), 375.

34. *The Letters of Oscar Wilde,* ed. Rupert Hart-Davis (New York: Harcourt Brace, 1962). Hereafter referred to as OW. Even Wilde's desire to have Sarah Bernhardt play Salome is, in a sense, plagiarized. Jean Lor-rain had already identified Bernhardt with Gustave Moreau's Salomes in an article in *L'événement,* November 7, 1887: "Yes, the enigmatic Sarah is certainly the daughter of Gustave Moreau, the sister of Muses carrying decapitated heads, of Orpheus and of slim and bloody Salomes" (quoted in Thibaut d'Anthonay, *Jean Lorrain, barbare et esthète* [Paris: Plon, 1991], 94).

35. The ploy worked. Upon seeing the *Studio* drawing, Wilde sent Beardsley—whom he had had met in 1891 at the house of the latter's mentor, Edward Burne-Jones—a copy of the French edition of the play, inscribed "For the only artist who, besides myself, knows what the dance of the seven veils is, and can see that invisible dance" (*The Letters of Os-car Wilde,* 348 n.3). Knowing Wilde's enthusiasm, his friend Robert Ross arranged with the publisher of the 1894 Bodley Head edition, John Lane, for the commission to go to Beardsley. Wilde, however, felt ambivalent about the illustrations, possibly because he thought that they threatened to upstage his text. To the illustrator Charles Ricketts, he complained about the difference between Beardsley's "Japanese" style and his own "Byzantine" conception: "My Herod is like the Herod of Gustave Moreau, wrapped in his jewels and sorrows. My Salome is a mystic, the sister of Salammbô, a Sainte Thérèse who worships the moon" (quoted in OW, 376).

Not only did Beardsley want to illustrate the play, he also wanted the translation to be his. Knowing Wilde to be displeased with his lover Alfred Douglas's translation, Beardsley eagerly undertook to make his own (in November 1893). Wilde, however, found it no better than Douglas's and, in order to patch up relations with his lover, revised that version himself (see OW, 403–4).

36. *The Letters of Aubrey Beardsley,* ed. Henry Maas, J. L. Duncan, and W. G. Good (Rutherford: Farleigh Dickinson University Press, 1970), 218.

37. See, among others, Ian Fletcher, *Aubrey Beardsley* (Boston: Twayne, 1987), 77–78; Elaine Showalter, *Sexual Anarchy* (New York: Penguin, 1990), 152–54; Richard Dellamora, "Traversing the Feminine in Oscar Wilde's *Salome,*" in *Victorian Sages and Cultural Discourse,* ed. Thais Morgan (New Brunswick, N.J.: Rutgers University Press, 1990), 256; Chris Snodgrass, *Aubrey Beardsley: Dandy of the Grotesque* (New York: Oxford University Press, 1995), 276–80; Lorraine Kooistra, *The Artist as Critic: Bitextuality in Fin-de-Siècle Illustrated Books* (Gower House: Scolar Press, 1995), 141–44.

38. "The Decay of Lying," in *The Artist as Critic: Critical Writings of Oscar Wilde,* ed. Richard Ellmann (New York: Random House, 1969). Henceforth abbreviated DL in the text. Beardsley's title page for *Salome* declares that it is "pictured by" him rather than the usual "illustrated by." When he became art editor of *The Yellow Book,* he insisted that the journal's policy allow the artwork to stand on its own rather than illustrate particular contributions. See Snodgrass, *Aubrey Beardsley,* 247.

39. The story of the *John and Salome* being replaced by *The Black Cape* is told by Stanley Weintraub, *Aubrey Beardsley: Imp of the Perverse* (University Park, Pa.: Pennsylvania State University Press, 1976), 72.

Decadent Diagnostics

1. Daniel Pick, *Faces of Degeneration: A European Disorder, c.1848–c.1918* (Cambridge: Cambridge University Press, 1989), 8, 7. On the constitution and influence of degeneration theory, see also the excellent analysis in Robert Nye, *Crime, Madness, and Politics in Modern France: The Medical Model of National Decline* (Princeton: Princeton University Press, 1984). An overview of the concept as it operated in different fields of thought can be found in Edward Chamberlin and Sander L. Gilman, eds., *Degeneration: The Dark Side of Progress* (New York: Co-

lumbia University Press, 1985). Of particular interest from the literary perspective is Jean Borie, *Mythologies de l'hérédité au XIXe siècle* (Paris: Galilée, 1981).

2. Cesare Lombroso, *The Man of Genius* (London: Walter Scott, 1895), 5–6. Hereafter abbreviated MG.

3. Richard von Krafft-Ebing, *Psychopathia Sexualis,* trans. Franklin Klaf (New York: Stein and Day, 1965), 3–4.

4. Cesare Lombroso, introduction to the work of his daughter, Gina Lombroso-Ferrero, *Criminal Man* (New York: Putnam's, 1911), xiv. The excerpt below appears on the same page.

5. In a moving petition to the home secretary written on July 2, 1896, after he had been in jail for more than a year, Oscar Wilde referred to the theories of Lombroso and of Nordau from just this point of view. His offenses, he claimed, were "forms of sexual madness . . . , diseases to be cured by a physician rather than crimes to be punished by a judge." Nordau, he wrote, "had devoted an entire chapter to the petitioner as a specially typical example of this fatal law" (by which he meant "the intimate connection between madness and the literary and artistic temperamant"). *Selected Letters of Oscar Wilde,* ed. Rupert Hart-Davis (Oxford: Oxford University Press, 1979), 142.

6. Enrico Ferri, *Criminal Sociology* (New York: D. Appleton and Company, 1897), 166–67. Quoted by Stephen Jay Gould, *The Mismeasure of Man* (New York: Norton, 1981), 138.

7. Pick, *Faces of Degeneration,* 41. "The purpose of Italian criminology," Pick observes, "can be found in the attempt to construct an ordered language for the containment of disorder and, through that language, to formulate the definition of a political subject by elaborating ever more closely the criteria for political exclusion" (138–39).

8. Hermann Mannheim, ed., *Pioneers in Criminology* (Montclair, N.J.: Patterson Smith, 1972), 264

9. Cesare Lombroso and Guillamo Ferrero, *La donna delinquente: La prostituta e la donna normale* (Turin: L. Roux, 1893), 262. Quoted in Barbara Spackman, *Decadent Genealogies: The Rhetoric of Sickness from Baudelaire to D'Annunzio* (Ithaca, N.Y.: Cornell University Press, 1989), 24.

10. I quote from the French edition, Cesare Lombroso, *L'homme criminel* (Paris: Alcan, 1887), 667–68. Hereafter abbreviated HC.

11. Bram Stoker identifies Dracula's primitive heredity in just these terms: "The Count is a criminal and of criminal type. Nordau and Lom-

broso would so classify him, and qua criminal he is of imperfectly formed mind" (*Dracula* [New York: New American Library, 1965], 346). It has also been pointed out that many of the physical traits Jonathan Harker attributes to Dracula at the beginning of the novel precisely echo Lombroso's stigmata of the born criminal (see Leonard Wolf, *The Annotated Dracula* [London: New English Library, 1975], 300).

12. Cesare Lombroso, *L'anthropologie criminelle et ses récents progrès* (Paris: Alcan, 1890), 13. Hereafter AC.

13. Charles Baudelaire, *Le peintre de la vie moderne,* in *Oeuvres complètes,* ed. Claude Pichois (Paris: Pléiade, 1961), 1183.

14. Cesare Lombroso, *L'homme de génie* (Paris: Alcan, 1889), 92. Hereafter abbreviated HG.

15. Cesare Lombroso and G. Ferrero, *La femme criminelle et la prostituée,* trans. Louise Meille (Paris: Alcan, 1896). Hereafter abbreviated FC.

16. Hilde Olrik, "Le sang impur: Notes sur le concept de prostituée-née chez Lombroso," *Romantisme* 31 (1981): 167–78.

17. Spackman, *Decadent Genealogies,* 30.

18. Cesare Lombroso, *Crime: Its Causes and Remedies* (Montclair, N.J.: Patterson Smith, 1968 [1906]), 443. Hereafter abbreviated CCR.

19. Quoted by Spackman, *Decadent Genealogies,* 31, from the 6th Italian edition of *L'uomo de genio* (Turin: Fratelli Broca, 1894), xii.

20. Cesare Lombroso, *After Death—What?* (Boston: Small, 1909), 68. Hereafter abbreviated ADW.

21. Jean Pierrot tells of this event, and of Richet's occultist activity, in *The Decadent Imagination, 1880–1900* (Chicago: University of Chicago Press, 1981), 100.

22. Max Nordau, *Degeneration* (New York: Fertig, 1968), ix. Hereafter abbreviated D.

23. George Bernard Shaw, "A Degenerate's View of Nordau," in *Selected Non-Dramatic Writings of Bernard Shaw,* ed. Dan Laurence (Boston: Houghton Mifflin, 1965), 375. This essay was subsequently published in slightly modified form as *The Sanity of Art.* Another notable refutation of Nordau was penned by William James, "Psychological Literature and Genius: Review of *Degeneration* by Max Nordau," *Psychological Review* 2, no. 3 (May 1895): 289–90.

24. See Mosse's introduction to the edition of *Degeneration* cited above and his article "Max Nordau, le libéralisme, et le 'nouveau juif,'" in *Max Nordau (1849–1923),* ed. Delphine Bechtel, Dominique Bourel,

and Jacques Le Rider (Paris: Cerf, 1996), 11–29. Also of relevance is the essay by Mark Anderson in this collection, "Typologie et caractère. Max Nordau, Cesare Lombroso et l'anthropologie criminelle," 121–31.

25. Joris-Karl Huysmans, *A rebours* (Paris: Gallimard, 1977), 98.

26. Indeed, Lombroso actually chastised his disciple in the introduction to the sixth edition of *The Man of Genius* (1894) for refusing to recognize that the products of true genius "[are] all the more sublime as the body [is] sicker" (see note 17 above).

27. For a comparison of Nordau and Nietzsche that analyzes both similarities and differences, see Steven Aschheim, "Max Nordau, Friedrich Nietzsche et *Dégénerescence,*" in *Max Nordau (1849–1923),* 133–47.

28. For a discussion of the distaste for synesthesia shared by Nordau and Nietzsche, see Jacques Le Rider, "L'oeuvre d'art totale comme symptôme de 'dégenerescence.' Nordau, le wagnérisme français et Nietzsche," in *Max Nordau (1849–1923),* 69–77.

29. It is interesting that both Lombroso and Nordau, when explicitly writing about Jews, continue to use the language of degeneration. In *L'antisemitismo e le scienze moderne* (Turin: L. Roux, 1894), 107, Lombroso takes Jews to task for holding on to antiquated rituals, such as "that savage wounding that is circumcision, [and] those multiple fetishes of sacred writing [tefillin]" (quoted in her own translation by Nancy Harrowitz, *Antisemitism, Misogyny, and the Logic of Cultural Difference: Cesare Lombroso and Matilde Serao* [Lincoln, Nebr.: Nebraska University Press, 1994], 49). Judaism, he is claiming, is atavistic—which, to be sure, does not justify violence against Jews, but does suggest, to this advocate of a liberal bourgeois cultural sameness, that Jews should abandon their "primitive" rituals and assimilate. As to Nordau, his Jewish self-consciousness was greatly intensified by the Dreyfus affair, and he became an early Zionist and close associate of Theodor Herzl. Even in his Zionist writings, however, he continued to use the rhetoric of degeneration in reference to Eastern European Jews, whom he considered backward and passive, mentally irrational and physically weak. What was needed, he argued, was a "new Jew," of muscular body, tough mind, and iron will, capable of overcoming the trauma of the ghetto and of founding a new Jewish state (see for instance Nordau's article "Muskeljudentum," written for the *Jüdische Turnzeitung* in 1900 and reprinted in *Max Nordaus Zionistische Schriften,* ed. Zionistisches Aktionskomitee [Cologne: Jüdischer Verlag, 1909], cited by Hans-Peter Söder, "Disease and Health as Contexts of Modernity: Max Nordau as a Critic of Fin-de-

Siècle Modernism," *German Studies Review* 14 (1991): 487, and the article by George Mosse cited in note 22). Carl Schorske points out that Herzl's own vision of the promised land was less a Jewish utopia than a liberal, even aristocratic, one (see *Fin-de-Siècle Vienna* [New York: Vintage, 1980], 172–75).

30. See most pertinently Sander L. Gilman, "The Madness of the Jews," in *Difference and Pathology: Stereotypes of Sexuality, Race, and Madness* (Ithaca, N.Y.: Cornell University Press, 1985), 150–62.

31. Charcot made this statement in his seminar on October 23, 1888, as recorded in J. M. Charcot, *Leçons du mardi à la Salpêtrière* (Paris: Progrès médical, 1889), 2:11–12. Cited by Gilman, *Difference and Pathology*, 155.

32. See Frank Sulloway, *Freud, Biologist of the Mind: Beyond the Psychoanalytic Legend* (New York: Basic Books, 1979), 423.

33. Richard Krafft-Ebing, *Text-Book of Insanity*, trans. Charles Chaddock (Philadelphia: F. A. Davis, 1905), 143. Quoted in Gilman, *Difference and Pathology*, 155.

34. Günther Höfler shows how this mirroring operates by showing the similarity of Nordau's ideas to those of an anti-Semite named Adolph Wahrmund in "La naissance de la 'nervosité' issue de l'esprit de la modernité technologique," in *Max Nordau (1849–1923)*, 149–60. Both Nordau and Wahrmund critique the speed of change characteristic of modernity, which Wahrmund imagines to be congenial to Jews because of their hereditary nomadism and affinity for capitalism.

Freud's Decadence

1. Ernest Jones, *The Life and Work of Sigmund Freud* (New York: Basic Books, 1953), 1:188.

2. All references abbreviated SE are to the *Standard Edition* of Freud's works published in London by Hogarth Press, 24 vols., 1953–73.

3. Teresa de Lauretis, "Freud, Sexuality, and Perversion," in *Discourses of Sexuality: From Aristotle to AIDS,* ed. Domna Stanton (Ann Arbor, Mich.: Michigan University Press, 1992), 229.

4. In their extremely useful *The Language of Psycho-analysis,* trans. Donald Nicholson-Smith (New York: Norton, 1973), J. Laplanche and J.-B. Pontalis make a similar point: "The evolution of Freud's ideas regarding psychosexual development pushed him constantly in the direction of an equation of infantile and adult sexuality. All the same his original conception does not disappear" (187).

5. John Brenkman, *Straight Male Modern: A Cultural Critique of Psychoanalysis* (New York: Routledge, 1993), 123.

6. Jones, *Life*, 2:347.

7. See Jack Spector, *The Aesthetics of Freud: A Study in Psychoanalysis and Art* (New York: Praeger, 1972), 58.

8. See ibid., 56.

9. See ibid., 57–62.

10. Marthe Robert, *The Psychoanalytic Revolution: Sigmund Freud's Life and Achievement,* trans. Kenneth Morgan (New York: Harcourt, Brace, 1966), 281.

11. Leo Bersani, *The Freudian Body: Psychoanalysis and Art* (New York: Columbia University Press, 1986), 45.

Index

Page numbers in italics refer to illustrations.

Library of Congress Cataloging-in-Publication Data

Bernheimer, Charles, 1942–1998.

Decadent subjects : the idea of decadence in art, literature, philosophy, and culture of the fin de siècle in Europe / Charles Bernheimer ; edited by T. Jefferson Kline and Naomi Schor.

p. cm. — (Parallax)

Includes bibliographical references and index.

ISBN 0-8018-6740-1 (alk. paper)

1. Aesthetics, European—19th century. 2. Degeneration—History—19th century. 3. Decadence (Literary movement). 4. Decadence in art. I. Kline, T. Jefferson (Thomas Jefferson), 1942– II. Schor, Naomi. III. Title. IV. Parallax (Baltimore, Md.)

BH221 .E853 B47 2002

111.85′09409034—dc21 2001050319